Images 23

the best of British illustration

RotoVision

Images 23 published by Rotovision SA
Rue Du Bugnon 7
CH-1299 Crans-Près-Céligny
Switzerland

Exhibitions and Events Officer:
Emily Glass
Telephone: 0171 733 2955

Book Design: Nicole Griffin

Production in Singapore by
Provision Pte. Ltd.
Telephone: +65 334 7720
Fax: +65 334 7721

Rotovision SA
Editorial & Sales Office
Sheridan House
112/116A Western Road
Hove BN3 1DD
England
Tel: +44 (0)1273 72 72 68
Fax: +44 (0)1273 72 72 69
E-mail: creative@rotovision.com

Association of Illustrators
1-5 Beehive Place
London SW9 7QR
Tel: +44 (0)171 733 9155
Fax: +44 (0)171 733 1199
E-mail: sb@a-o-illustrators.demon.co.uk
Website: www.aoi.co.uk

Acknowledgements
We are grateful for the support of many
organisations and individuals who
contributed to the Images exhibition and
annual as follows:
• Our 38 judges on the judging panel for
 applying their expertise to the difficult
 task of selecting this year's work
• The Royal College of Art for hosting
 the Images 23 exhibition
• Moshe Gerstenhaber and Nigel Toplis
 at Kall Kwik for sponsoring the AOI/Kall
 Kwik Illustrator Award and Kall Kwik
 Print and Design Award
• Waterstone's Booksellers, Winsor &
 Newton, Transworld Publishers Ltd,
 Hawkins Innovation Network and
 Daler Rowney for their generosity in
 sponsoring awards for *Images 23*
• Janet Woolley for the use of her
 illustration on the Call for Entry form
• Ruth Gladwin of Stephens Innocent
 Solicitors, for legal advice
• All our volunteers for their invaluable
 assistance with the competition and
 exhibition
• AOI Manager Stephanie Smith
• AOI Managing Council: Francis Blake
 (Chair), Michael Bramman, Derek
 Brazell, Stuart Briers, Ruth Gladwin,
 Adam Graff, Geoff Grandfield, James
 Marsh and Bee Willey
• Nicole Griffin for her design
• Derek Brazell for his photography

Contents

Foreword

by Francis Blake / AOI Chairman

It would be easy to assume that this page is the least read part of the entire publication. This is not just self deprecation regarding my ability to entertain you with witty prose; it is a simple admission of the power of illustration. Who would struggle with the difficulties of reading print when they could allow their senses to be bathed by all that colour, all those beguiling shapes, all that excitement?

The great power of illustration is that it has an instant power to attract and to be understood at a glance without a great deal of effort and expense of time. How often have you been persuaded to read an article because the illustration has drawn you to the text, intrigued you and explained the text to you before you have read a word? How often has your enjoyment of books been enhanced by 'Phiz' or E.H. Shepard? As Alice says 'What is the use of a book without pictures . . . ?'

One of the functions of the AOI is to promote illustration. The *Images* annual and accompanying exhibition is one of our most successful ways of doing this. *Images* has for 23 years occupied a unique place in the field of illustration in the UK. It is still the only source book which you cannot buy your way into. This means that those included have the admiration of their peers as well as leading clients and commissioners in the illustration industry.

Over the 23 issues, *Images* has grown in stature and influence and in the regard of the industry. *Images* is valued not only as a prime source for anyone looking for individuality and innovation, but also as an inspiration.

Images 23 tour
Tour venues will include:
• Royal College of Art, London
• European Illustration Collection, Hull • Duncan of Jordanstone College of Art, Dundee • Kent Institute of Art and Design • Nuneaton Museum and Art Gallery • Aberystwyth Arts Centre.

Introduction to the AOI

The AOI was established in 1973 to advance and protect illustrators' rights and encourage professional standards. The AOI is a non-profit making trade association dedicated to its members' professional interests and the promotion of illustration.

Members consist primarily of freelance illustrators as well as agents, clients, students and lecturers. The AOI is run by an administrative staff responsible to a Council of Management.

The AOI is the only body to represent illustrators and campaign for their rights in the UK. It has successfully increased the standing of illustration as a profession and improved the commercial and ethical conditions of employment for illustrators.

Campaigning

The AOI is a member of the British Copyright Council and the Creators Copyright Coalition. It helped set up the secondary rights arm of DACS, the UK visual arts collecting society.

The AOI was responsible for establishing the right of illustrators to retain ownership of their artwork and continues to campaign against loss of copyright control, bad contracts and exploitative practices. We will expose companies who consistently abuse illustrators' rights.

Information and support services

Portfolio advice

Members are entitled to a free annual consultation with the AOI's portfolio consultant. Objective advice is given on portfolio presentation and content, suitable illustration markets and agents.

Journal

The AOI Journal (*Illustrator*) is distributed monthly to members, keeping them informed about exhibitions, competitions, campaigns and activities in the profession.

Hotline advice

Members have access to a special Hotline number if they need advice about pricing commissions, copyright and ethics problems.

Publications

The AOI publishes **Rights: The Illustrator's Guide to Professional Practice** a comprehensive guide to the law for illustrators. It provides detailed advice on how to protect against exploitative practices and contains a model contract for illustrators to use. We also produce **Survive: The Illustrator's Guide to a professional Career** which is a comprehensive practical guide to beginning and continuing a career as a professional illustrator. **Survive** includes information about marketing, ethics, agents and a guide to fees. These publications are available to members at reduced rates.

Client directories

The AOI currently has two illustration client directories which are only available for purchase by members. The **Editorial Directory** has details of over 120 contacts in the newspaper and magazine industries. The **Publishing Directory** is a comprehensive list of important contacts in book publishing.

Business advice

Members are entitled to a free consultation with the AOI Chartered Accountant, who can advise on accounting, National Insurance, tax, VAT and book-keeping.

Regional groups

The contact details of regional representatives are available to members who organise social activities for regional members and provide an important support network.

Discounts

Members receive discounts on a range of services, including a number of art material suppliers nationwide.

Portfolio insurance

The AOI has a portfolio insurance scheme designed specifically and exclusively for its members.

Legal advice

Full members receive advice on ethics and contractual problems, copyright and moral right disputes.

Return of artwork stickers

Available to AOI members only. These stickers help safeguard the return of artwork.

Students & new illustrators

Our seminars and events, combined with the many services we offer, can provide practical support to illustrators in the early stages of their career.

Image file

Members can promote their work to clients visiting the AOI office via the *Image File* containing copies of members' work.

Events

The AOI runs an annual programme of events which include one day seminars, evening lectures and thematic exhibitions. These cover subjects such as talks by leading illustrators, children's book illustration, aspects of professional practice, new technologies and illustrators' agents. AOI members are entitled to discounted tickets.

To request further information or a membership application form please telephone 0171 733 9155

The AOI patrons

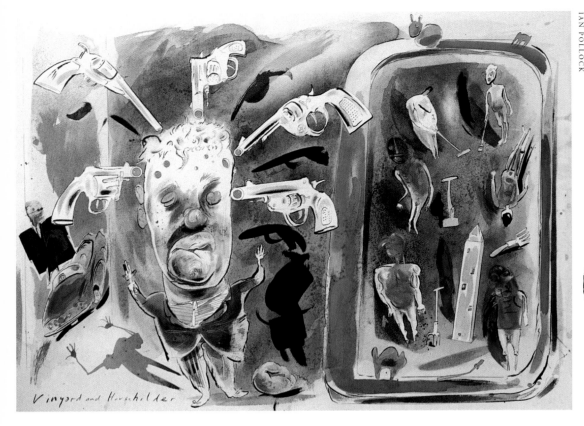

IAN POLLOCK

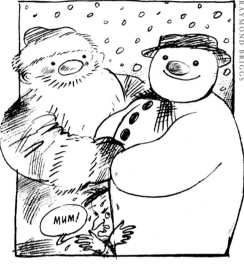

RAYMOND BRIGGS

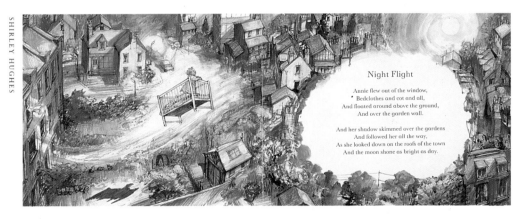

SHIRLEY HUGHES

Night Flight

Annie flew out of the window,
Bedclothes and cot and all,
And floated around above the ground,
And over the garden wall.

And her shadow skimmed over the gardens
And followed her all the way,
As she looked down on the roofs of the town
And the moon shone as bright as day.

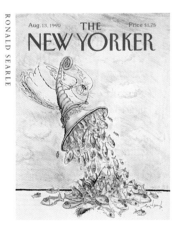

RONALD SEARLE

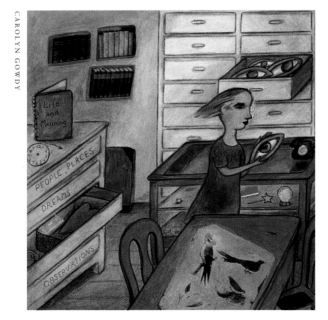

CAROLYN GOWDY

CHLOE CHEESE

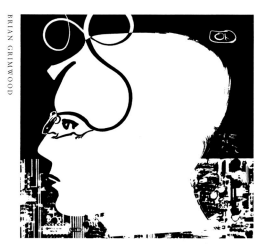

BRIAN GRIMWOOD

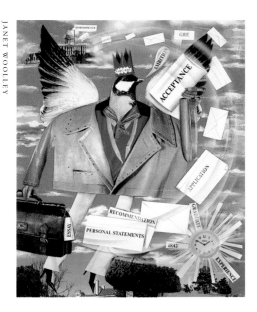

JANET WOOLLEY

Raymond Briggs

Raymond Briggs was born in 1934. He studied painting at Wimbledon School of Art and the Slade School and has been illustrating since 1957 and writing since 1961. His best known books include *Father Christmas*, 1973, *Fungus the Bogeyman*, 1977, *The Snowman*, 1979, and *When the Wind Blows*, 1982 (book, radio play, stage play and feature film). His most recent work, a strip-cartoon biography of his parents *Ethel and Earnest* has also become a best seller.

Ian Pollock

Pollock, 48, bearded and bitter, left the RCA in 76 and has freelanced ever since, mostly in the area of editorial, though he has had ten books published and many one-man exhibitions. His work appeared in the very first AOI annual. He is a vociferous campaigner against the 'rough' which he sees has removed the 'sting' and reduced him to an obsequious hack.

Brian Grimwood

Brian Grimwood has been credited by Print magazine as having changed the look of British illustration. He has worked for most of the major publications in the UK and Europe and has become one of Britain's most innovative and influential illustrators.

In 1983 he co-founded the Central Illustration Agency that now represents 45 of London's most prestigious illustrators.

As well as exhibiting in numerous group shows, he has had five one-man exhibitions, the next one being at the Coningsby Gallery, London in May/June 1999.

Janet Woolley

I have been working as an illustrator since leaving the Royal College of Art in 1976.

I work mostly in the areas of editorial and advertising both in Europe and the USA.

I am a visiting tutor at Central St Martins College of Art, where I am also Professor of Illustration.

Shirley Hughes

Shirley Hughes has freelanced as an illustrator since the 1950s and has worked on a great many books by other authors before she began to write and design her own picture books. One of these, *Dogger* won the 1977 Kate Greenaway medal and in 1984 she was presented with the Eleanor Farjeon Award for services to children's literature. Her books, particularly the *Alfie* series are in co-edition world-wide.

Ronald Searle

Ronald Searle, born Cambridge 1920, began freelancing almost immediately and is still at it. Has contributed to the *New Yorker* magazine on and off since 1966 and, more recently, has become an editorial cartoonist to the French newspaper *Le Monde*.

Chloe Cheese

I left the R.C.A. in 1976 and work as an illustrator and printmaker. I have exhibitions of my paintings and prints. To work as a freelance illustrator is a pleasure; it is a voyage of discovery starting, for me, with patissserie in Paris and at the moment alighting at children's books and teaching illustration in Beirut.

Carolyn Gowdy

My pictures all seem to have a mind of their own but are also flexible enough to adapt to the structure of commissions.

Art that communicates in a meaningful way and that is accessible has the most resonance for me. I like to think that everyone can taste the food I cook at some level, that it is not reserved only for an elite few. I mix various ingredients together, endeavouring also to sprinkle in some magic. Then I let the image simmer. I continue to stir and listen carefully all the while for the moment when they tell me they are ready. Once the pictures are cooked, I know its time to be brave, to let them go. Ha! Now they are ready to step out into life, to serve . . . perhaps on a page in a newspaper, magazine, a book, a poster, or in a frame on a person's wall.

Essentially my life is a gift and each day is spent with the creation and presentation of the next feast in mind. If, by chance, I hear that one of my images has touched someone or ushered forth a smile, my heart just sings. Work is play and play is work.

Glen Baxter

Glen Baxter was born in the tiny Northern hamlet of Hunslet. After a series of educational errors he was removed and installed in a crumbling Victorian manor house in Camberwell, where his condition is said to be 'almost stable.'

He is the author of *The Impending Gleam*, *Cranireons ov Botya*, *The Wonder Book of Sex* and *Glen Baxter's Gourmet Guide*.

His drawings have been exhibited in Paris, New York, Venice, Tokyo, Sydney, Amsterdam and Ikley. Forthcoming exhibitions for '98-'99 include the Modernism Gallery, San Francisco, Galerie de la Chatre, Paris and a retrospective at the French National Print Center.

Tony Ross

Tony Ross was born in London and lives and works with his family in Cheshire. He studied at Liverpool Art School and went on to work in graphic design and advertising, cartoon drawing and animated film. He also lectures.

Since 1983 he has illustrated around 350 books and written about 70. These have been mainly published by the Anderson Press in England, and others including Harper Collins, Penguin, Orchard, Random Century and Heinemann.

Peter Blake

I am very proud to be the only artist who is both a Royal Academician as a painter and a Royal Designer to Industry as an illustrator.

Quentin Blake

Quentin Blake read English at Cambridge University, and Education at London University, before becoming a part-time student at Chelsea School of Art and a full-time freelance illustrator simultaneously, just about 40 years ago. He taught in the illustration department of the Royal College of Art, which he ran for several years.

His recent work includes John Yeoman's *Up with the Birds!* and an illustrated edition of *The Hunchback of Notre Dame* for the Folio Society, as well as two books of his own, *The Green Ship* and *Zagazoo*.

Simon Stern

Simon Stern was born in 1943 and worked as a designer for some years before turning to writing and illustrating children's books and later to general illustration. He has made a special study of the legal issues associated with illustration, wrote the AOI publication *Rights* and is a director of DACS, the visual arts collecting society. He has been a keen supporter of the AOI since 1975 and believes it to be a vital organisation at a time when 'rights grabs' by clients are an increasing threat to illustrators livelihoods.

Ralph Steadman

Ralph Steadman became a freelance cartoonist and illustrator after attending the London College of Printing and Graphic Arts in the early 1960s, working for *Punch*, *Private Eye*, *The Telegraph*, *New York Times* and *Rolling Stone Magazine*.

He has written and illustrated books on Sigmund Freud, Leonardo Da Vinci, *The Big I Am* (the story of creation and its aftermath), and *Tales of The Wieirrd* (a collection of eccentrics and obsessive characters in history). He has illustrated *Alice in Wonderland*, *Alice Through The Looking Glass* and *The Hunting of The Snark*, *Treasure Island*, the works of Flann O'Brien and, most recently, the anniversary edition of *Animal Farm* in 1995.

Having travelled the world's vineyards and distilleries for Oddbins, he has illustrated and written two books of his journeys – *Grapes of Ralph* and *Still Life With Bottle*.

For the past few years he has been working on a series of etchings and silkscreen prints exploring the theme of 'leaders and writers' with Peacock Printmakers, Aberdeen. These works have been exhibited in Aberdeen, Denver and Aspen in the US.

In 1987, Ralph Steadman was the recipient of the W.H. Smith Illustration Award for the best illustrated book of the past five years (for *I Leonardo*) and the BBC Design Award for postage stamps. He also won the Italian Critica in Erba Prize and the Black Humour Award in France. He is a Fellow of the Kent Institute of Art and design, and in 1995 was awarded an Hon.D.Litt. by the University of Kent.

TONY ROSS

RALPH STEADMAN

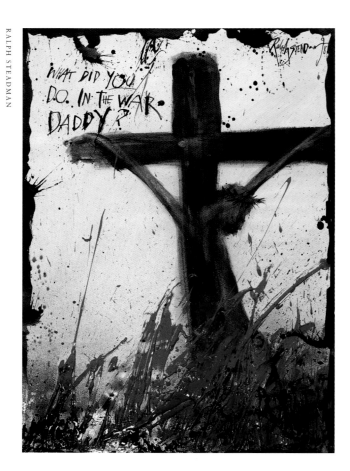

QUENTIN BLAKE

GLEN BAXTER

ROBIN NOTICED THE PROBLEM
ALMOST IMMEDIATELY

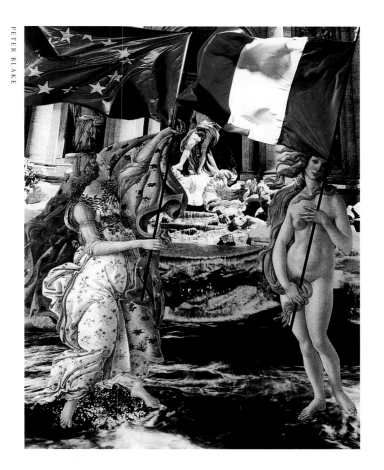

PETER BLAKE

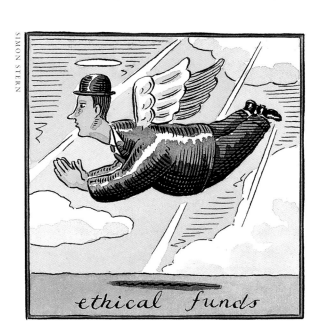

SIMON STERN

ethical funds

The AOI/Kall Kwik Illustrator Award

★ award winner: Marc Craste

Interview by Ali Pellatt

Dear Illustrator

Although we already live in an extremely competitive world – the likelihood is that the trend for an ever greater local and international competition is going to continue. This is good news for the illustrator. Competitive pressures dictate that all products and services have to be differentiated in the market place, how else will the customer be able to decide which of the multitude on offer they are going to buy? Each will have to be given a strong graphic persona. The opportunity for the creative illustrator is almost unlimited.

By understanding the product/service characteristics and its intended market positioning and through the focused application of imagination, creativity, wit and technical skills – the illustrator is able to add enormous value to the ultimate success of the client.

The Kall Kwik extensive network of Print, Copy and Design Centres is dedicated to the delivery of excellence. Therefore, Kall Kwik is both proud and pleased to continue its association with the AOI and in helping it to deliver its own message of creative excellence and illustration quality via the Annual Awards and *Images 23*.

Moshe Gerstenhaber

Founder and Chairman
Kall Kwik Printing (UK) Limited

Marc Craste was completely shocked to learn that 'Reception' had won the AOI/Kall Kwik Illustrator Award and wondered at first whether there had been a mistake. He was commissioned by Steve Little and Tim Robinson at WCRS to produce a series of animated films highlighting enhanced reception for Orange mobile telephone users and was given a free range to use his own style. 'The only creative requirements were to use the colours orange, black and a little bit of white'. The client was so pleased with the original commercials that a subsequent press advertisement was launched and the rest is illustration history. Marc is particularly delighted with the award, his first to date, as he considers 'Reception' to be his best work yet. Using acrylic paint and ink, the feel of the illustration is 'dark and spooky-looking which is exactly what I like to do.'

Marc was born in London but grew up in Australia where he left school literally armed with a portfolio of personal drawings and the ambition to work in animation in Sydney. Five years and several studios later he began to direct commercials. Then without any formal art training but a fascinating history working and travelling through Europe he arrived full circle back in London to take up the job of Animation Director at AKA Pizazz.

Aside from a career in animation Marc wrote and illustrated a children's book in 1994 called *Benjamin the Lonely Dragon* which sold over 22,000 copies in Australia. He has also been working for some time on a short film with Nick Cave. Over the years clients in advertising have included Nescafe, Toyota and Sony and, at the time of interview, he is making another ad for Orange.

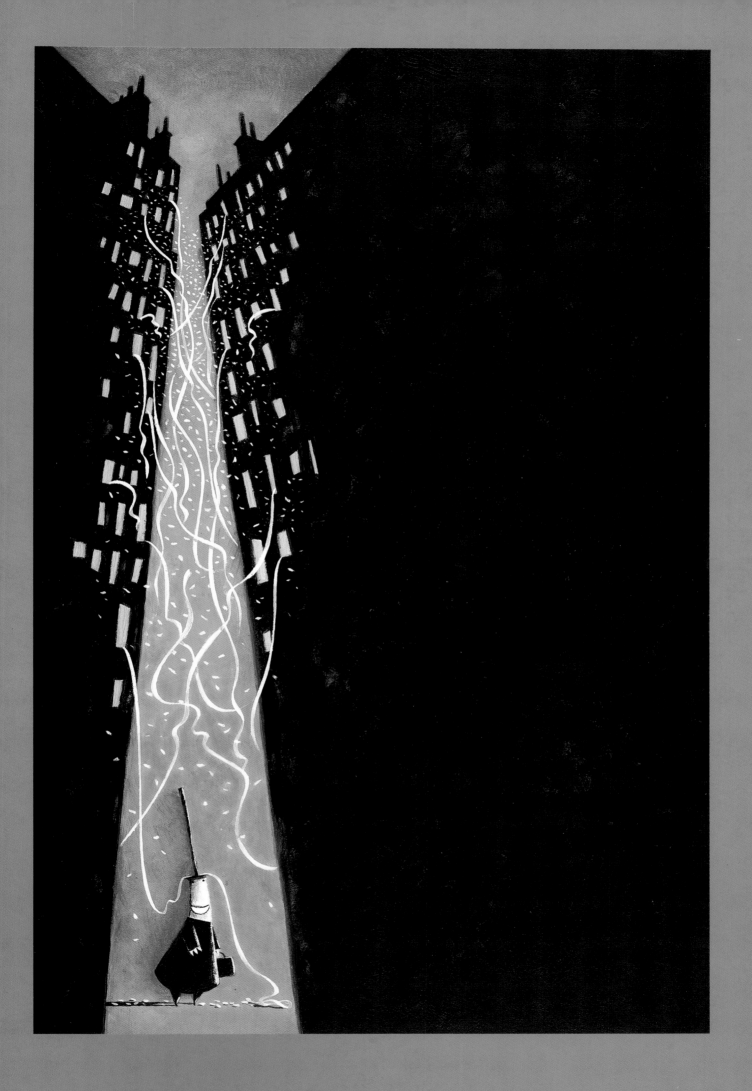

Images 23 award winners

 The AOI/Kall Kwik Illustrator Award (1)

Marc Craste: *Orange Reception*
£1000 and a free page awarded to the illustrator with
the maximum overall marks from the judging panel.

 The Kall Kwik Print & Design Award (2)

Matilda Harrison: *I am my Inspiration*
£500 awarded to the highest scoring illustration in the
Print & Design section.

 AOI Client Award (3)

John Belknap/Anne Braybon of *The European* for:
Pop Opera by Jason Ford
£400 awarded to the commissioning editor who
submitted illustrations which received the highest marks
from the judging panel

 Waterstone's Booksellers Award (4)

Peter Gudynas: *Diaspora*
£500 of book vouchers for the illustration with the
highest marks from the judging panel in the General
Books section.

 The Transworld Children's Book Award (5)

Bee Willey: *Pear Tree*
£250 for the illustration with the highest marks from the
judging panel in the Children's Books section.

(6)
 Hawkins Innovation Network Student Award

Stephen Waterhouse: *The Bird Market*
£500 for the illustration with the highest marks from the
judging panel in the Student section.

(7)
 The Daler-Rowney Award

Stuart Briers: *Judge Not*
£100 worth of art materials for the best use of
traditional materials.

(8)
 The Winsor & Newton Award

Damian Quayle: *Tiger*
£100 worth of art materials for the best use of
traditional materials.

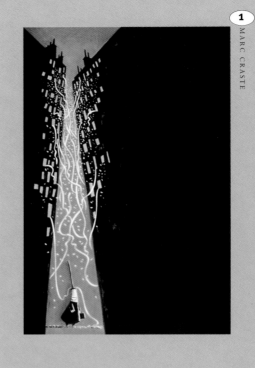

MARC CRASTE

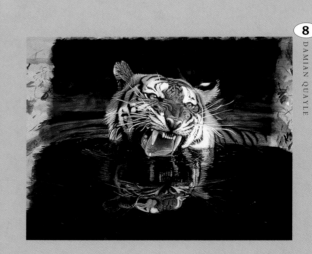

DAMIAN QUAYLE

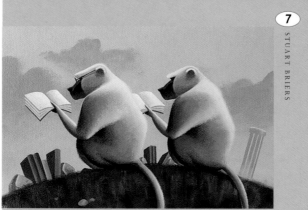

STUART BRIERS

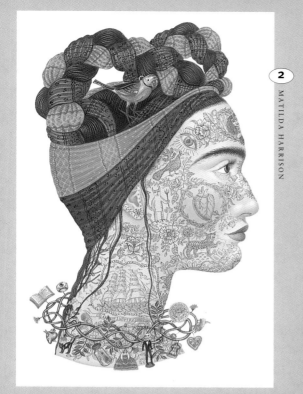

MATILDA HARRISON

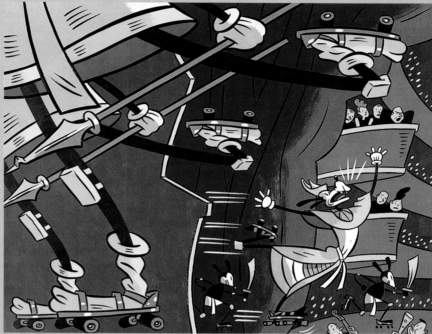

JASON FORD

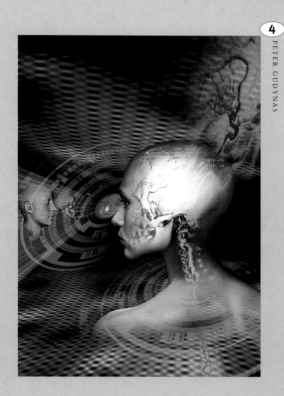

PETER GUDYNAS

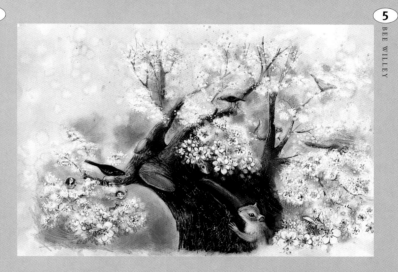

BEE WILLEY

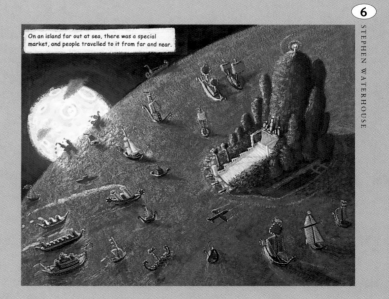

STEPHEN WATERHOUSE

IMAGES 23 AWARD WINNERS

judges

Henry Rossiter **art director** Ogilvy Mather
Sally Bide **head of art buying** BMP DDB
Jim Landen **creative director** Barkers Advertising
David Hughes **illustrator**

AOI · KallKwik PRINT COPY DESIGN

★ award winner: *The AOI*
Kall Kwik Illustrator Award
★ Advertising section winner

marc craste

a.k.a Pizazz Ltd
30 Berwick Street
Soho
London W1V 3RF

t. 0171 434 3581
f. 0171 437 2309
email. info@studioaka.co.uk

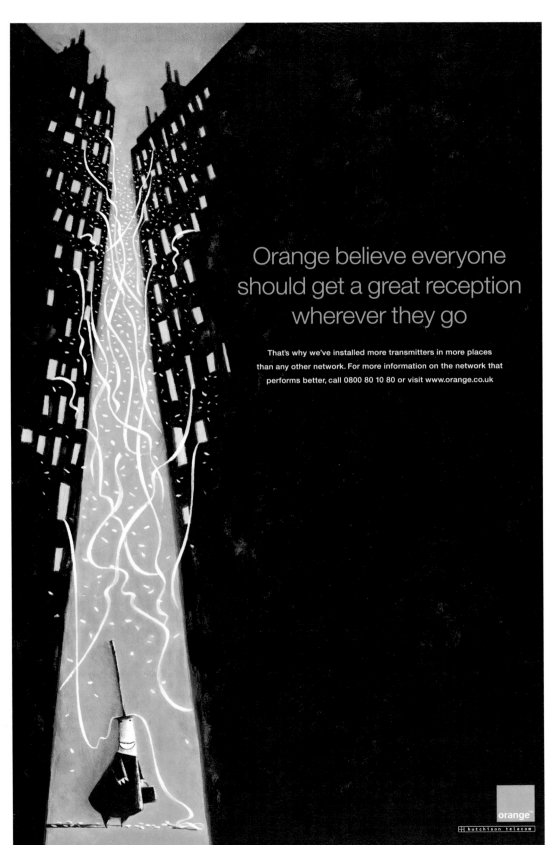

title
Orange Reception
medium
Acrylics on card
purpose of work
Advertising
brief
To show that
Orange are
installing more
transmitters

commissioned by
Steve Little/Tim
Robertson
company
WCRS
client
Orange
agent
a.k.a Pizazz Ltd
30 Berwick Street
London W1V 3AF
t. 0171 434 3581

philip hunt

a.k.a. Pizazz Ltd
30 Berwick Street
Soho
London W1V 3RF
t. 0171 434 3581
f. 0171 437 2309
email. philip@studioaka.co.uk

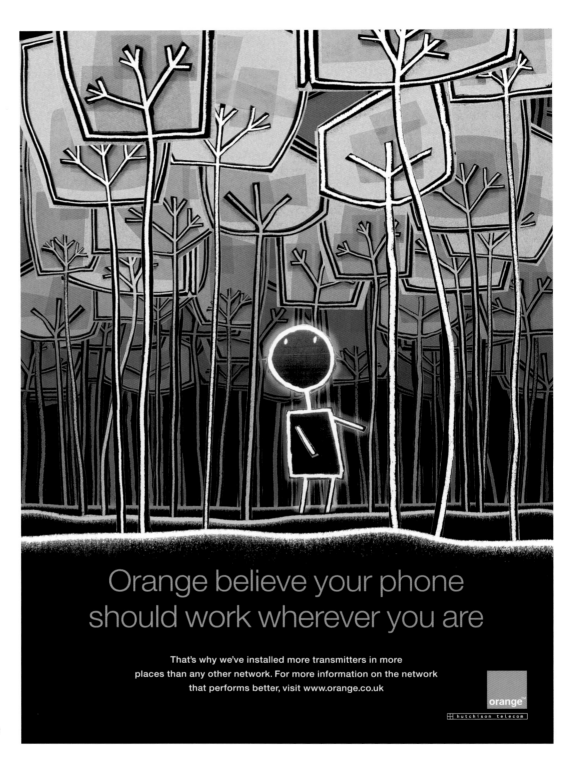

title	**commissioned by**
Hills	Steve Little/Tim Robertson
medium	
Mixed media / Digital	**company**
	WCRS
purpose of work	**client**
Advertising	Orange
brief	**agent**
To show that Orange works, wherever you are	a.k.a. Pizazz Ltd 30 Berwick Street London W1V 3AF t. 0171 434 3581

The Dairy
5-7 Marischal Road
London
SE13 5LE

t. 0181 297 2212
f. 0181 297 2212

Original Design Illustration

Broadcast Image

title
Words
medium
Mixed
purpose of work
Design for
television
commercial

brief
Depict script in a
visually arresting
and witty fashion
commissioned by
a.k.a. Pizazz Ltd
client
Orange

veronica bailey

188 Langham Road
Turnpike Lane
London
N15 3NB

t. 0181 888 0606
f. 0181 374 1891

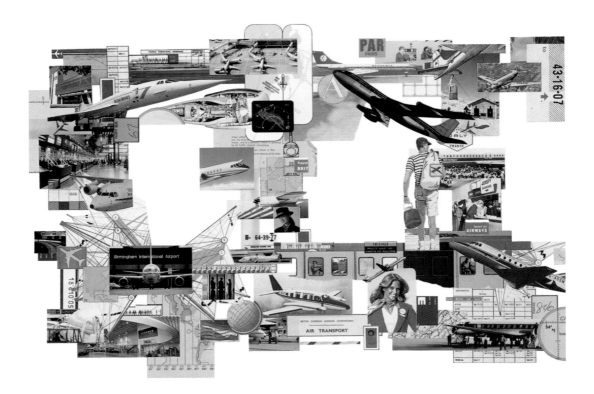

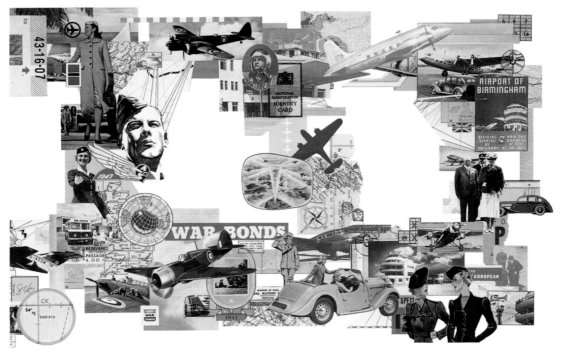

title
History of
Birmingham Airport

medium
Collage

purpose of work
Mural for airport
visitors centre

brief
Illustrate the
history of
Birmingham airport
from 1939 to the
year 2000

commissioned by
Stuart Richie

company
Cole Hansle

client
Birmingham Airport

agent
Debut Art
30 Tottenham
Street, London
W1 9PN
t. 0171 636 1064

stephen bliss

Flat 4
110 Edith Grove
London
SW10 0NH

t. 0171 352 7686
f. 0171 376 8727

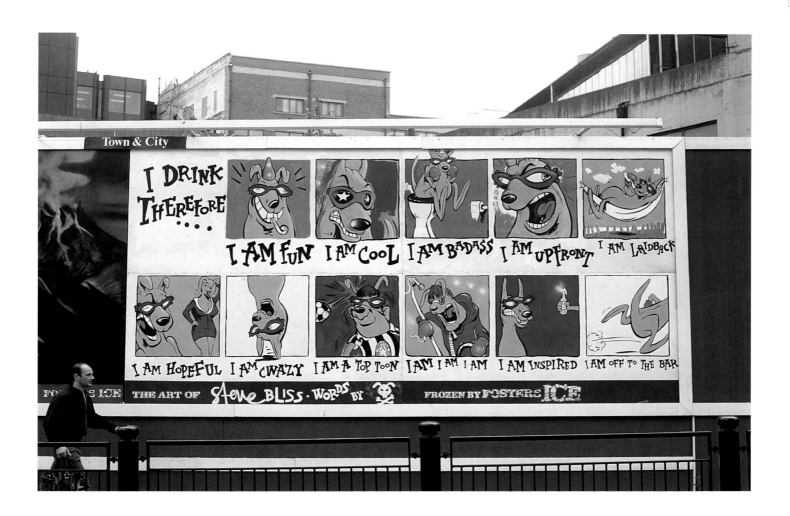

title
I Drink Therefore I Am

medium
Acrylic on Billboard

purpose of work
Advertising

brief
To advertise the fun aspects of drinking Foster's Ice beer and to paint directly onto the billboard

commissioned by
Paul Tully

company
Paul Tully & Co

client
Foster's Ice for Scottish Courage

mick brownfield

24 Richmond Hill
Richmond
Surrey TW10 6QX

t. 0181 940 1303
f. 0181 332 1451

title
Four Over Par
medium
Press/posters/
postcards/t-shirts
purpose of work
Advertising the
Murphy's Irish
Open 1997

brief
Promote brand and
Irish Open;
support TV
campaign;
challenge target's
preconception
about golf and
Murphy's
commissioned by
Fleur Jerome
company
Bartle Bogle
Hegarty
client
Murphy's Brewery,
Ireland

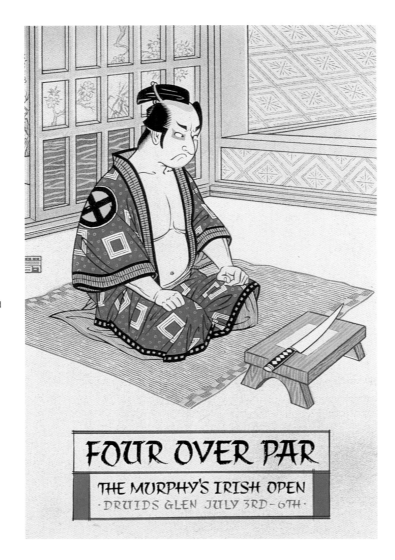

adrian johnson

5 Ridley Road
London
NW10 5UB

t. 0181 965 8918
f. 0181 965 8918
mobile. 0958 670750

title
Hedgehog
medium
Train panels and
press
purpose of work
To encourage
people to make a
humorous
connection
between Frisk and
their enhanced
personal
performance

brief
Frisk sharpens you
up
commissioned by
Fiona Curzon
company
Bartle Bogle
Hegarty
client
Perfetti

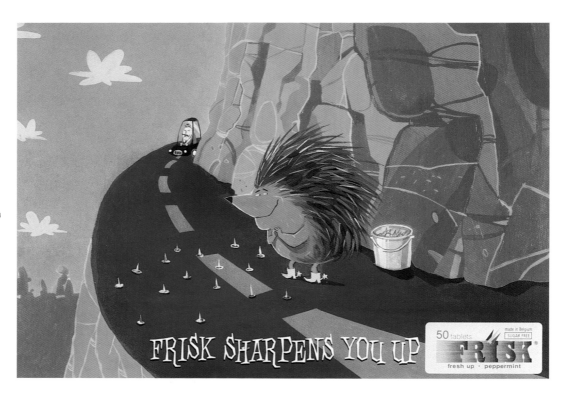

max ellis

See Agent

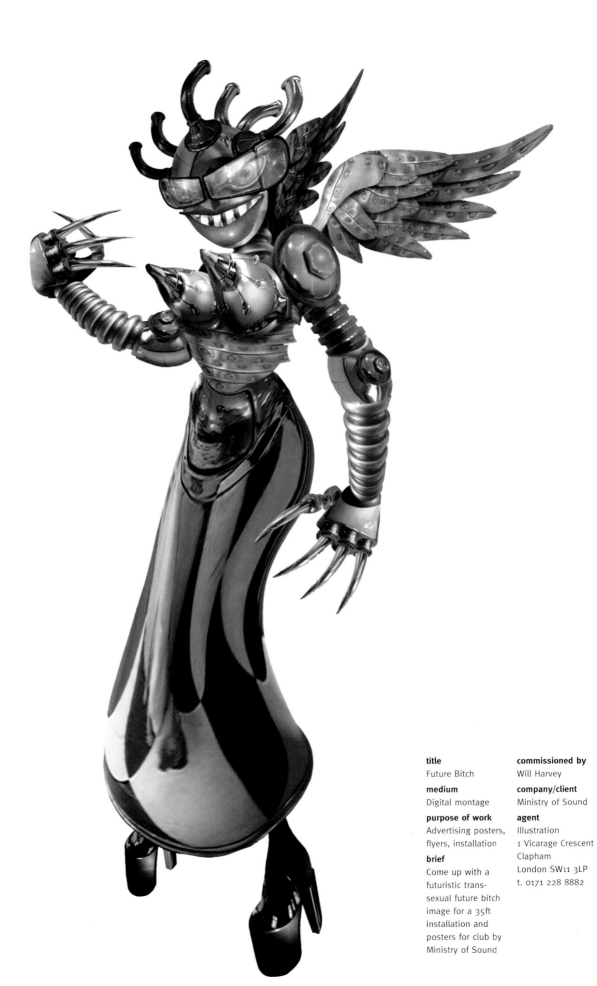

title
Future Bitch

medium
Digital montage

purpose of work
Advertising posters,
flyers, installation

brief
Come up with a
futuristic trans-
sexual future bitch
image for a 35ft
installation and
posters for club by
Ministry of Sound

commissioned by
Will Harvey

company/client
Ministry of Sound

agent
Illustration
1 Vicarage Crescent
Clapham
London SW11 3LP
t. 0171 228 8882

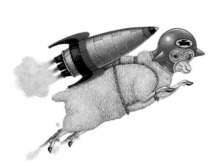

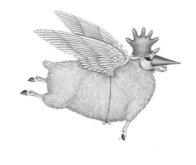

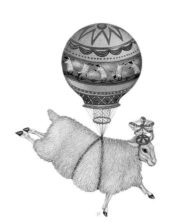

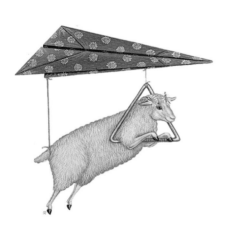

title	brief	agent
IBM Flying Sheep	"We weren't sleeping, only dreaming". play on the idea of counting sheep	Arena 144 Royal College Street Camden London NW1 0TA t. 0171 267 9661
medium		
Acrylics		
purpose of work		
Advertising Campaign for Germany	**commissioned by** Christina Hufgard	
	company Olgilvy & Mather Frankfurt	

chuan khoo

27 Whitmore Street
Maidstone
Kent
ME16 8JX

t. 01622 721 987
f. 01622 721 987

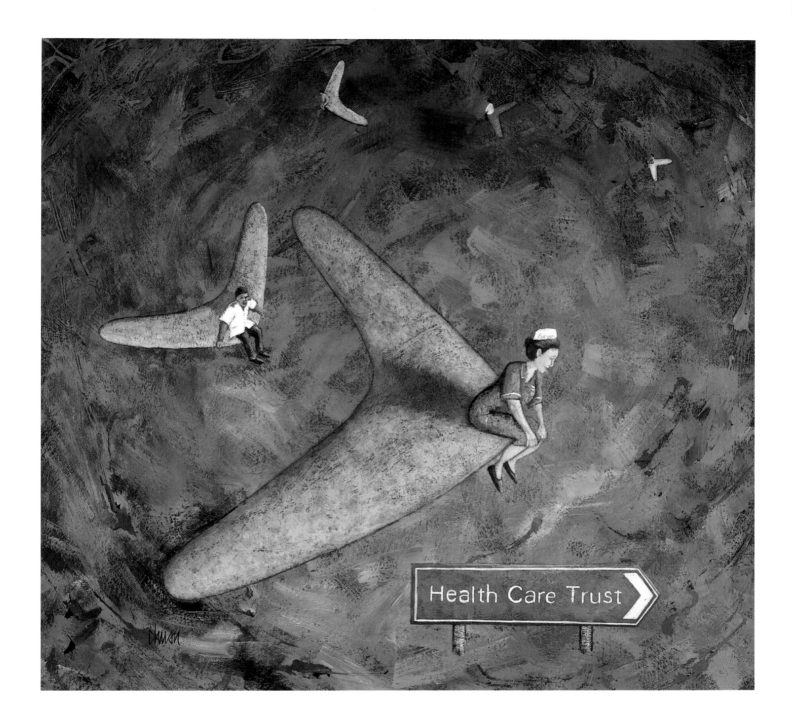

title
Return to Nursing
medium
Acrylic and
gouache
purpose of work
Poster
advertisement and
flyer

brief
Produce attractive
illustration aimed
at encouraging
former health
workers and nurses
to attend refresher
courses in order to
return to the
nursing profession
commissioned by
Henry Giddings
company/client
Middlesex
University

alison lang

Suite 7
24 Warwick Road
London
SW5 9UD

t. 0171 598 1037
f. 0171 598 1037

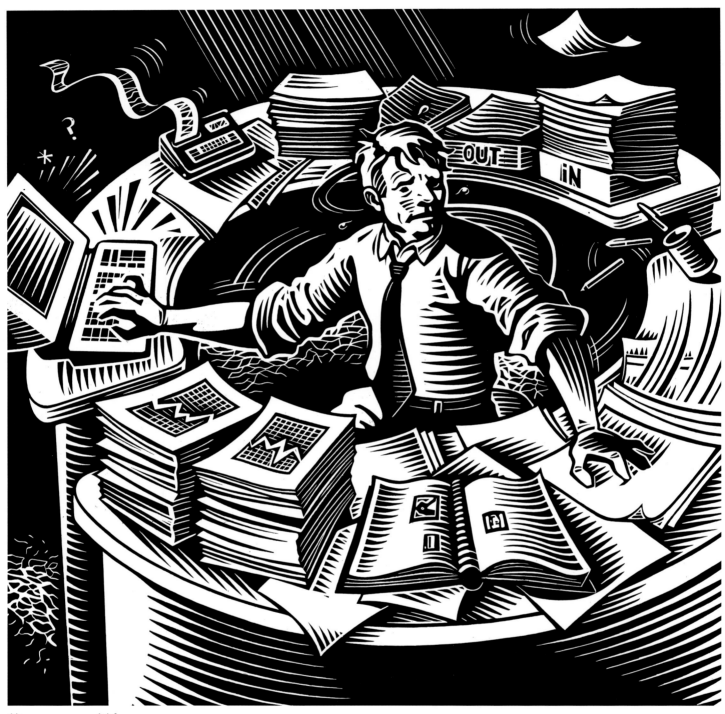

title
Career on the
Circle Line
medium
Scraperboard
purpose of work
To appear on tube
station posters
promoting Kall
Kwik

brief
To show
exasperated man
working in circles
commission by
Andy Bull
company
Three Blind Mice
client
Kall Kwik

frank love

The Dairy
5-7 Marischal Road
London
SE13 5LE

t. 0181 297 2212
f. 0181 297 2212

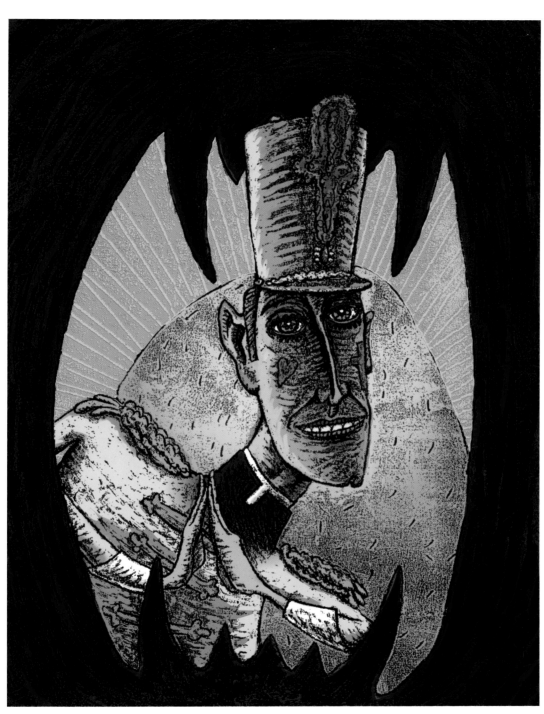

title
Cat Man's Tale

medium
Mixed media

purpose of work
Theatre poster /
postcard /
pamphlet

brief
Portray central
character: a priest
who loses faith and
who is redeemed
through lion taming

commissioned by
Simon Williams

company
Tangerine Ltd

client
Opera Circus

agent
Eastwing
98 Columbia Road
London
E2 7QB
t. 0171 613 5580

clare mackie

21a Ursula Street
London
SW11 3DW

t. 0171 223 8649
f. 0171 223 4119

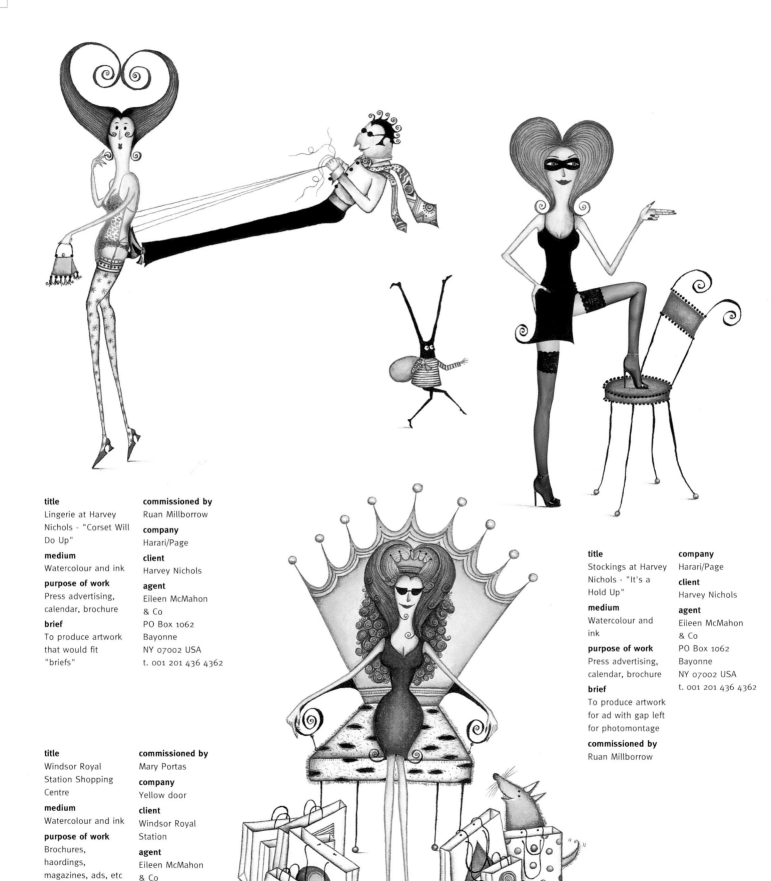

title
Lingerie at Harvey
Nichols - "Corset Will
Do Up"
medium
Watercolour and ink
purpose of work
Press advertising,
calendar, brochure
brief
To produce artwork
that would fit
"briefs"

commissioned by
Ruan Millborrow
company
Harari/Page
client
Harvey Nichols
agent
Eileen McMahon
& Co
PO Box 1062
Bayonne
NY 07002 USA
t. 001 201 436 4362

title
Windsor Royal
Station Shopping
Centre
medium
Watercolour and ink
purpose of work
Brochures,
haordings,
magazines, ads, etc
brief
To produce an
image that was
vaguely royal and all
about shopping

commissioned by
Mary Portas
company
Yellow door
client
Windsor Royal
Station
agent
Eileen McMahon
& Co
PO Box 1062
Bayonne
NY 07002 USA
t. 001 201 436 4362

title
Stockings at Harvey
Nichols - "It's a
Hold Up"
medium
Watercolour and
ink
purpose of work
Press advertising,
calendar, brochure
brief
To produce artwork
for ad with gap left
for photomontage
commissioned by
Ruan Millborrow

company
Harari/Page
client
Harvey Nichols
agent
Eileen McMahon
& Co
PO Box 1062
Bayonne
NY 07002 USA
t. 001 201 436 4362

james marsh

21 Elms Road
London
SW4 9ER

t. 0171 622 9530
f. 0171 498 6851

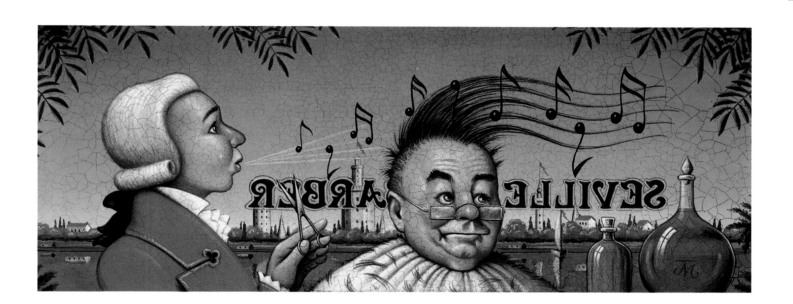

title
The Barber of
Saville

medium
Acrylic on canvas
board

purpose of work
Advertisement for
insurance company

brief
To illustrate copy
'Mozart would have
been a terrible
barber'

commissioned by
Alicia Tyson

company
ACC, Canada

client
Starr Excess

ian pollock

171 Bond Street
Macclesfield
Cheshire
SK11 6RE

t. 01625 426205
f. 01625 261390

30
GB

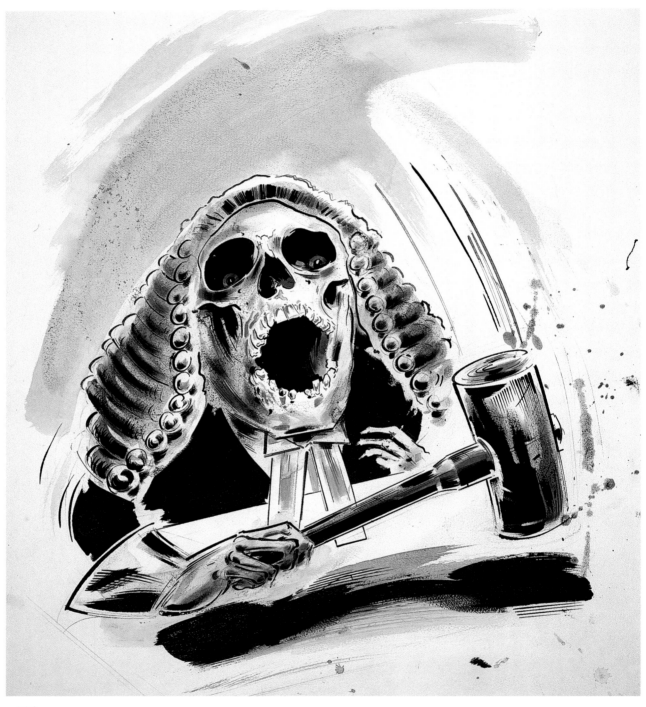

title
Now Worse than
Ever

medium
Watercolour ink
and gouache

purpose of work
Poster

brief
Poster for the
London Dungeon

commissioned by
Roger Sealey

company
DMB&B

agent
The Inkshed
98 Columbia Road
London
E2 7QB
t. 0171 613 2323

simon spilsbury

36 Wellington
Street
London
WC2

t. 0171 836 1090
f. 0171 836 1090

title
Five Children and It
medium
Ink and Acrylic

purpose of work
To persuade
children to read
more through
intrigue

brief
To illustrate banner
poster on 'Five
Children and It'
commissioned by
Duncan Moore

company
Moore Lowenhoff

peter till

11 Berkeley Road
London
N8 8RU

t. 0181 341 0497
f. 0181 341 0497

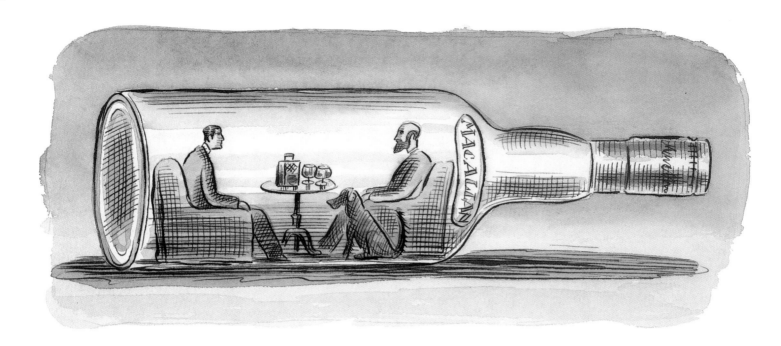

title
Och!
medium
Pen, ink and
watercolour
purpose of work
Press and poster
ad
brief
To illustrate an
anecdote about the
Macallan
commissioned by
Jim Downie
company
Faulds Advertising
client
Macallan

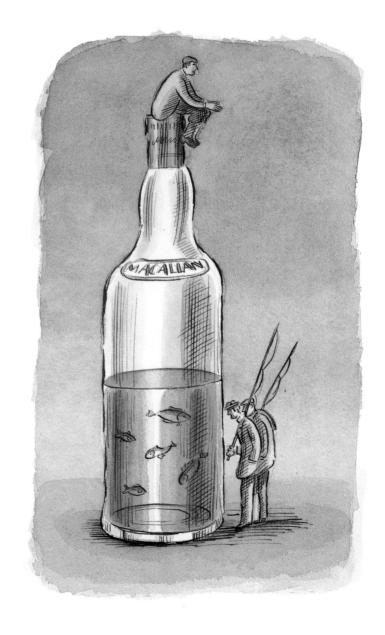

title
Nae Fish
medium
Pen, ink and
watercolour
purpose of work
Press and poster
ad
brief
I was given an
anecdote about the
Macallan
commissioned by
Jim Downie
company
Faulds Advertising
client
Macallan

david webster

60 Parfett Street
London
E1 1JR

t. 0171 375 1440
f. 0171 375 1440

title	**commissioned by**
Daihatsu 'The Grand Move'	Banks Hoggins O'Shea
medium	**client**
Ink	Daihatsu
purpose of work	**agent**
Advertise the new Daihatsu 'Move'	Artbank International
brief	8 Woodcroft Avenue
To produce drawings for five different 96 sheet billboard advertisements / national press ads. The billboard advertisements were printed in fluorescent inks	London t. 0181 906 2288

judges

Claire Bond **art director** Hodder Children's Books
Ann Glenn **children's art director** MacMillan Children's Books
Laura Cecil **literary agent**
Allan Drummond **illustrator**
Shireen Nathoo **director** Shireen Nathoo Design

children's books

Transworld Publishers Ltd

★ winner in children's book section
★ winner: *Transworld Children's Book Award*

bee willey

6 Beck Road
London
E8 4RE

t. 0181 986 5933

title
The Pear Tree

medium
Mixed media, ink, pencil, oil pastel

purpose of work
To depict the life around the pear tree throughout the seasons

brief
May: to depict the joys for Spring blossom
August: to depict sultry heat in English Summer

commissioned by
Alison Green

company/client
Macmillan

agents
(Children's Books)
Caroline Walsh /
David Higham
5-8 Lower John Street
W1
0171 437 7888
(General Illustration)
Jacquie Figgis
Eel Brook Studios
125 Moore Park Road
SW6 4PS
t. 0171 610 9933

christina balit

Pym Lodge
Soles Hill Road
Shottenden
Kent
CT4 8JU

t. 01227 730029
f. 01227 730029

title
Zoo in the Sky
(Series of 3)

medium
Watercolour and
gouache and silver
foil

purpose of work
To illustrate full
children's book
"Zoo in the Sky"

brief
To illustrate the
animal
constellations in
the night sky - non-
astrological and
astrological for a 3-
8 age group. A
very accurate guide
that can be held
up.

commissioned by
Frances Lincoln

zafer & barbara baran

47 Kings Road
Richmond
Surrey
TW10 6EG

t. 0181 948 3050
f. 0181 948 3050

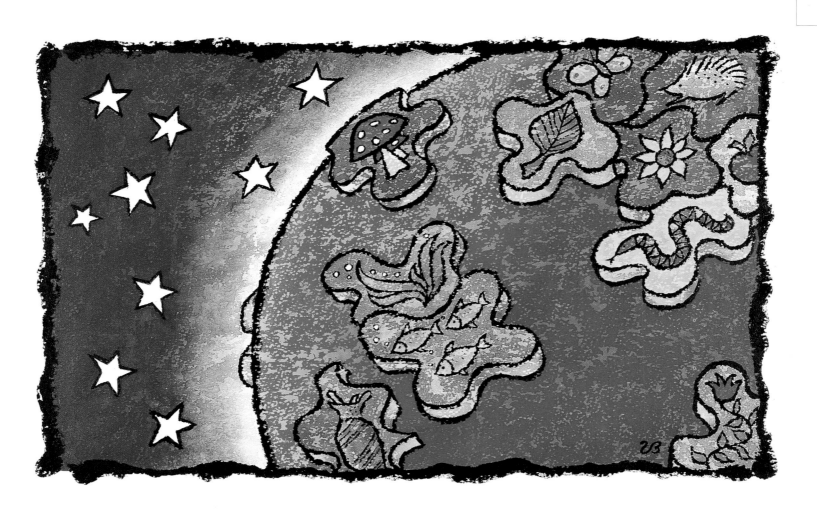

title
The Diversity of
Life

medium
Liquid watercolour
and ink

purpose of work
Children's book
illustration

brief
To illustrate piece
on bio-diversity
published in
'Anthology for the
Earth'

commissioned by
Jim Bunker

company/client
Walker Books

simon bartram

See Agent

title
Pinocchio

medium
Acrylics

purpose of work
Illustrated picture
book

brief
To illustrate
Pinocchio, keeping
to the original
Italian text

commissioned by
Jane Thomas

company
Dorling Kindersley
Children's Fiction

agent
Arena
144 Royal College
Street
Camden
London
NW1 oTA
t. 0171 267 9661

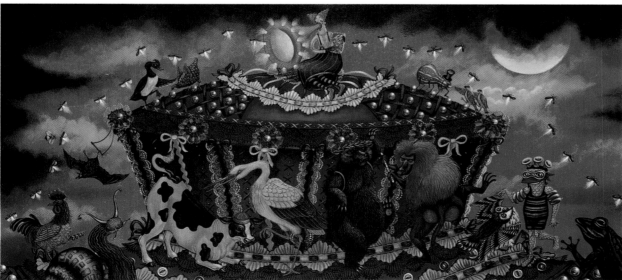

title
Bisky Bats and
Pussy Cats

medium
Acrylics

brief
To illustrate the
nonsense rhymes
and poetry of
Edward Lear

commissioned by
Sarah Odedina

company
Bloomsbury
Children's Books

agent
Arena
144 Royal College
Street
Camden
London
NW1 0TA
t. 0171 267 9661

greg becker

41 Whateley Road
East Dulwich
London
SE22 9DE

t. 0181 693 6120
f. 0181 693 6120

CHILDREN'S BOOKS

title
1. Hook and Smee
2. The Lost Boys
3. Mr Darling's New
 Home

medium
Acrylic paint

purpose of work
Book Illustration

brief
To provide five full
pages and ten
smaller colour
pictures for 'Peter
Pan' by JM Barrie

commissioned by
Amy McKay

company
Antique Collectors
Club Ltd

cecilia fitzsimons

Woodstock Lodge
25 Hazelgrove
Clanfield
Nr Waterlooville
Hants PO8 0LE

t. 01705 597076
f. 01705 597076
e-mail. ceciliafitzsimons@compuserve.com

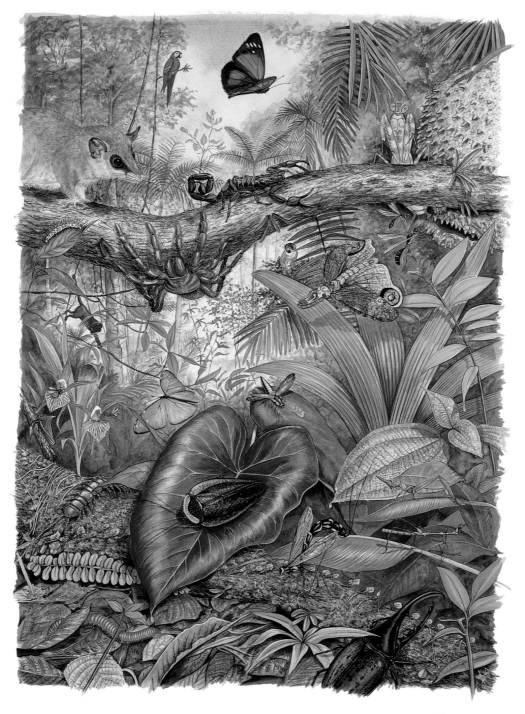

title	commissioned by
Rainforest bugs	David West
medium	**company**
Watercolour and gouache	David West Children's Books
purpose of work	**agency**
Double page spread for giant bugs book	Wildlife Art Studio 16, Muspole Workshops
brief	25-27 Muspole Street
Very realistic. South American jungle scene, detailed insects, not "picked out" - blend as holistic scene. Research all species	Norwich NR3 1DJ

peter gudynas

Zap Art
89 Hazelwell Crescent
Stirchley
Birmingham
B30 2QE

t. 0121 459 0080
f. 0121 459 0080
e-mail. peter@zapart.demon.co.uk

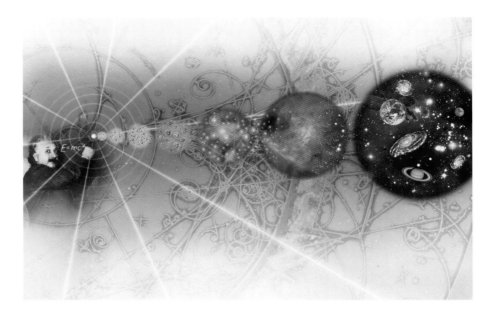

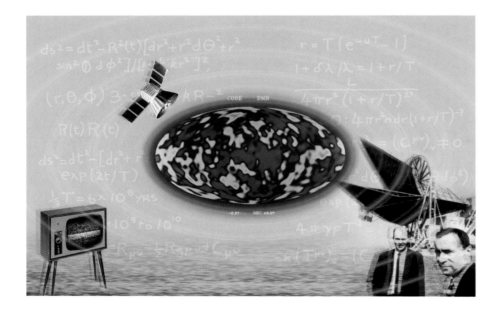

title
The Big Bang
Echoes of Creation
The Search for ET

medium
Digital

purpose of work
Illustrations for the
Kingfisher Book of
Space, an
educational
children's book and
for anyone who has
ever looked up in
wonder at the night
sky and imagined
what lies beyond
planet Earth

brief
Illustrating themes
concerned with
space and physics,
the big bang, the
creation of the
universe, and the
search for extra-
terrestrial lifeforms

commissioned by
Sue Aldworth and
Clive Wilson

company/client
Kingfisher
Publications plc

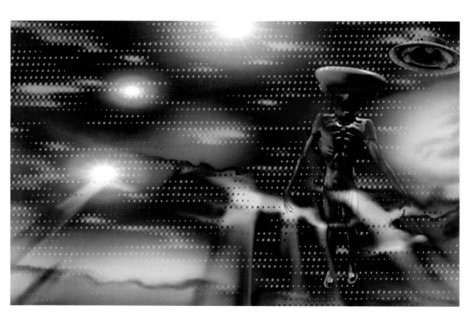

bernard gudynas

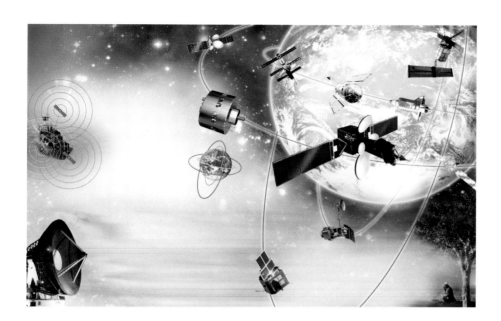

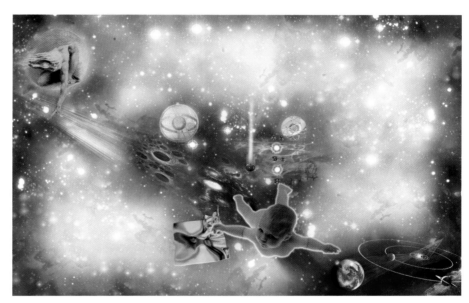

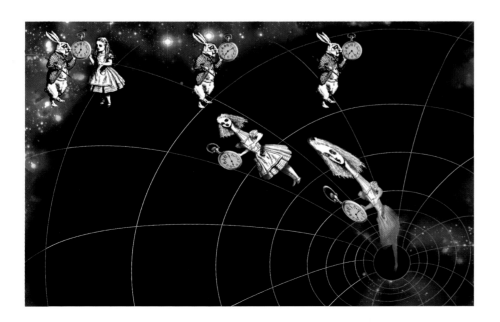

Zap Art
Studio 4
59 Nevill Road
Stoke Newington
London N16 8SW

t. 0171 923 3618
f. 0171 249 2775
email: bernie@zapart.demon.co.uk

title
Using Space
Impossible
Questions
Black Holes

medium
Digital

purpose of work
Illustrations for the
Kingfisher Book of
Space, an
educational
children's book and
for anyone who has
ever looked up in
wonder at the night
sky and imagined
what lies beyond
planet Earth

brief
To show the
different types of
satellites and their
orbits and to
explain some of
their uses

Why are we here?
What lies beyond
the Universe?
What were the
circumstances that
made life and the
universe possible?

To explain the
theory of black
holes digitally re-
using Tenniel's
Alice and the white
rabbit

commissioned by
Sue Aldworth and
Clive Wilson

company/client
Kingfisher
Publications plc

teresa flavin

WASPS Studios
3rd Floor,
22 King Street
Glasgow
G1 5QP

t. 0141 552 2251
f. 0141 552 2251

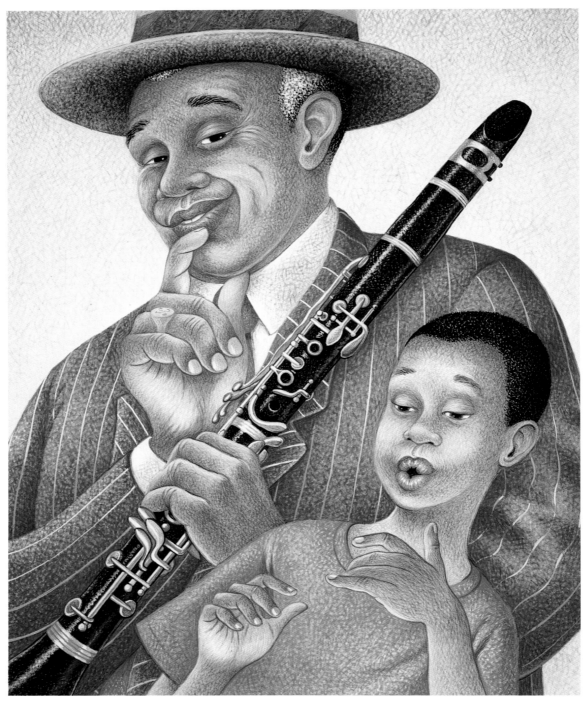

title
The Old Cotton
Blues

medium
Gouache

purpose of work
Children's picture
book

brief
Illustration for a
story set in New
York City

commissioned by
Ann Bobco

company
McElderry Books /
Simon & Schuster

agency
Publishers'
Graphics (North
America only)
251 Greenwood
Avenue
Bethel,
CT 06801-2400
USA

teri gower

Little Talland
Firle
East Sussex
BN8 6NT

t. 01273 858193
f. 01273 858193
Internet contact-uk.com/terigower

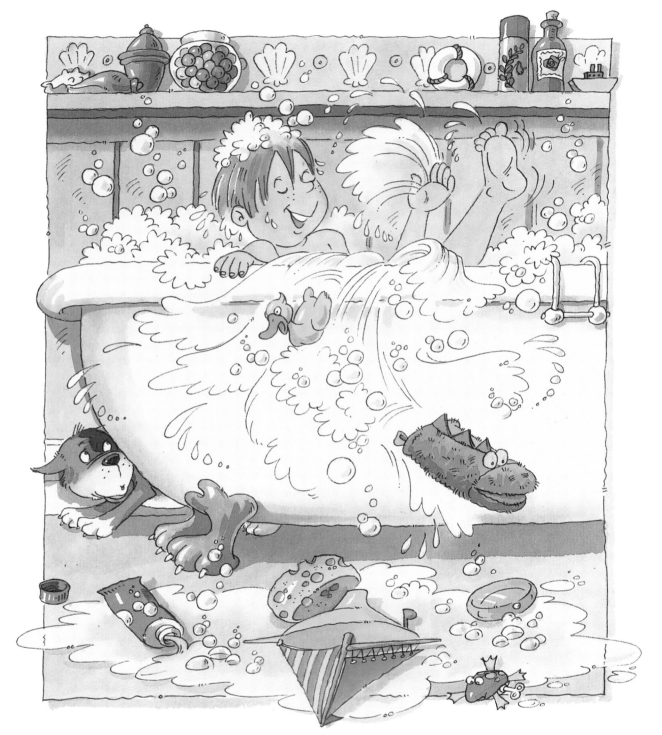

title
Sometimes I am
Naughty

medium
Line and wash

purpose of work
Children's book

brief
Completely open
brief requiring fun,
bright, child
friendly illustrations

commissioned by
Brimax

agent
Malcolm Sherman
Little Talland
Firle
East Sussex
BN8 6NT

david wyatt

St Caverne
South Zeal
Okehampton
Devon
EX20 2JP

t. 01837 840710

title
General
Beauregard's
Haunted House

medium
Magazine and
eventually to book

purpose of work
Haunted World
Pages of Spine
Chiller Magazine

brief
To visualise and
illustrate from text
supplied - must
have a spooky
atmosphere and fit
with style of
magazine

commissioned by
Art Director : Bob
Hook; Art Editor :
Chantal Newell
Designer : Jessica
Watts

company
Eaglemoss
Publications

agent
Sarah Brown
10 The Avenue
Ealing, London
W13 8PH
t. 0181 998 0390

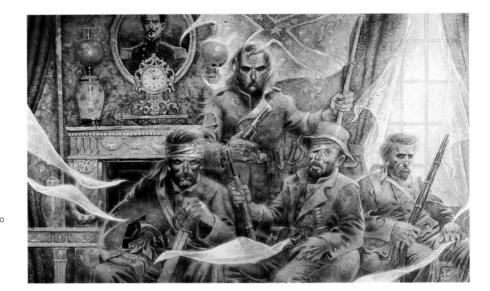

simoni boni

via Montebello 39
50123 Florence
Italy

t. 0039 552 302816

title
Dinosaurs

medium
Magazine and book

purpose of work
Puzzle Strand of
spine chiller
magazine

brief
To illustrate text as
supplied in a
dramatic interesting
manner

commissioned by
Art Director : Bob
Hook
Art Editor : Chantal
Newell
Designer : Andy
Archer

company
Eaglemoss
Publications

agent
Virgil Pomfret
Agency
25 Sispara Gardens
London
t. 0181 785 6167

leo hartas

41 Lincoln Street
Brighton
East Sussex
BN2 2UG

t. 01273 388172

title
Under the Sea

medium
Magazine and
eventually to book

purpose of work
Puzzle Strand of
Spine Chiller
Magazine

brief
To illustrate within
the style of the
magazine

commissioned by
Art Director : Bob
Hook
Art Editor : Chantal
Newell

company
Eaglemoss
Publications

danuta mayer

51 Sunnyhill Road
London
SW16 2UG

t. 0181 677 7043

title
Rikki-tikki-tavi

medium
Gouache

purpose of work
Children's book
illustrations

brief
To illustrate new
pocket-sized
edition of Rudyard
Kipling's classic,
'Rikki-tikki-tavi'

commissioned by
Amelia Edwards

company/client
Walker Books

clare mackie

21a Ursula Street
London
SW11 3DW

t. 0171 223 8649
f. 0171 223 4119

50
GB

title
Michael Rosen's
Book of Nonsense -
Cover

medium
Watercolour and
ink

purpose of work
Children's Book

brief
To illustrate the
poetry of Michael
Rosen

commissioned by
Wendy Knowles

company/client
Macdonad Young
Books

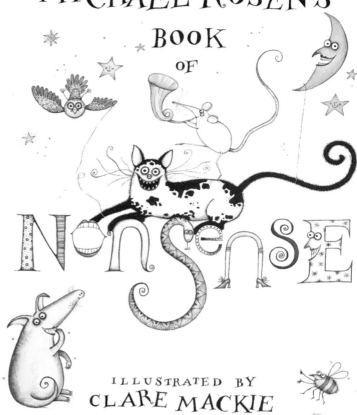

title
Michael Rosen's
Book of Nonsense -
"More, More,
More"

medium
Watercolour and
ink

purpose of work
Children's Book

brief
To illustrate the
poetry of Michael
Rosen

commissioned by
Wendy Knowles

company/client
Macdonad Young
Books

title
Michael Rosen's
Book of Nonsense -
"The Bus"

medium
Watercolour and
ink

purpose of work
Children's Book

brief
To illustrate the
poetry of Michael
Rosen

commissioned by
Wendy Knowles

company/client
Macdonad Young
Books

lydia monks

64 Frankfurt Road
Herne Hill
London
SE24 9NY

t. 0171 274 4158
f. 0171 274 4158

title
Bad Bad Cats

medium
Mixed

purpose of work
Illustrate a book of
poems

brief
To illustrate a book
of poems by Roger
McGough in black
and white

commissioned by
Ronnie Fairweather

company
Puffin Books

agent
Hilary Delamere /
The Agency
24 Pottery Land
London
W11 4LZ
t. 0171 727 1346

daniel pudles

8 Herschell Road
London
SE23 1EG

t. 0181 699 8540
f. 0181 699 8540

52
GB

title
Twice my size

medium
Print from woodcut

purpose of work
A series of 12
illustrations for a
picture book

brief
To illustrate a
poem by Adrian
Mitchell

commissioned by
Sarah Odedina

company
Bloomsbury
Children's Books

liz pyle

29 London Fields
East Side
London
E8 3SA

t. 0171 275 7973
f. 0171 275 7973

title
Somewhere Out
There
medium
Pastel
purpose of work
Children's Book

brief
To illustrate the
children's book
'Somewhere Out
There' by Jonathan
Meres
commissioned by
Caroline Roberts

company
Hutchinson's
Children's Books

olivia rayner

29 Collett Road
London
SE16 4DJ

t. 07071 226 296
pager. 04325 239493

title
North American
Myths and Legends
medium
Acrylics and mixed
media
purpose of work
Children's Book:
Storybook/Anthrop
ological
brief
To illustrate a
native American
myth: "Black Bird,
Bright Skies"

helen stephens

Flat 2
295 King Street
Hammersmith
London
W6 9NH

t. 0181 563 8919
f. 0181 563 8919

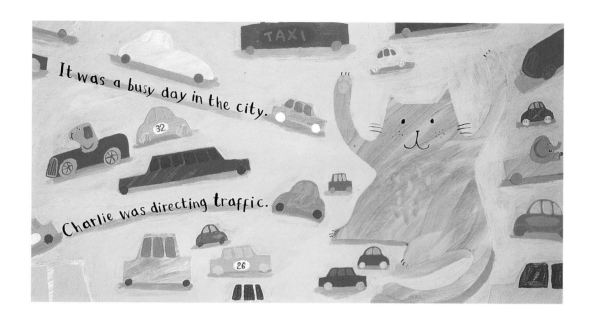

It was a busy day in the city.

Charlie was directing traffic.

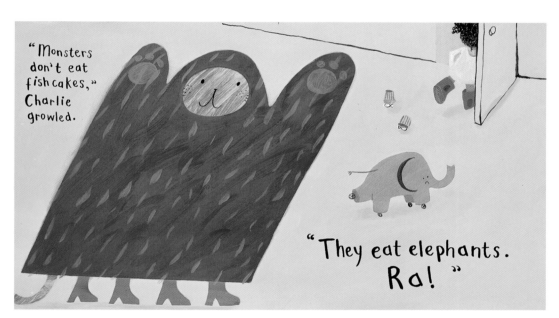

"Monsters don't eat fishcakes," Charlie growled.

"They eat elephants. Ra!"

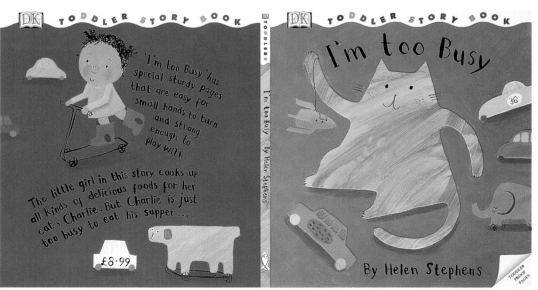

'I'm too Busy' has special sturdy pages that are easy for small hands to turn and strong enough to play with.

The little girl in this story cooks up all kinds of delicious foods for her cat, Charlie. But Charlie is just too busy to eat his supper...

£8·99

I'm too Busy

By Helen Stephens

title
I'm Too Busy

medium
Acrylic

purpose of work
Children's Book

brief
To write and illustrate a children's book for Dorling Kindersley's Toddler series

commissioned by
Fiona Macmillan

company/client
Dorling Kindersley, Children's Fiction

CHILDREN'S BOOKS

peter warner

Peter Warner's Studio
Hillside Road
Tatsfield
Kent
TN16 2NH

t. 01959 577270
f. 01959 541414
mobile. 0958 531538
www.contact-uk.com/Peter Warner

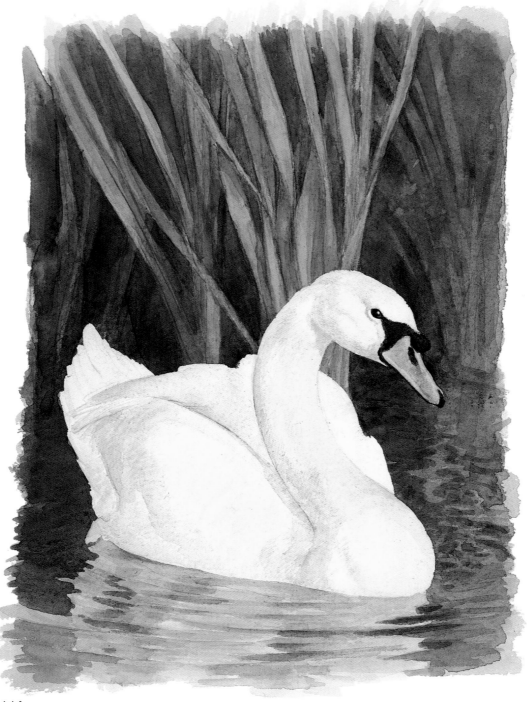

title
Swan in the Swin

medium
Watercolour

purpose of work
Book Jacket design
for one of a series
of children's books

brief
Emphasis is on
animal appeal and
drama. The direct,
loose, spontaneous
approach was
devised for the
series, now very
successful.
Preparatory
drawings are
minimal.

commissioned by
Claire Sutton

company
Hodder Children's
Books

peter warner

Peter Warner's Studio
Hillside Road
Tatsfield
Kent
TN16 2NH

t. 01959 577270
f. 01959 541414
mobile. 0958 531538
www.contact-uk.com/Peter Warner

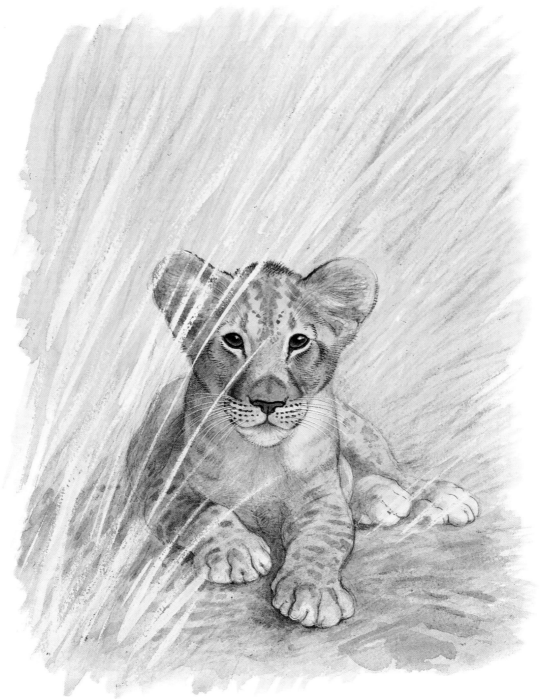

title
Lion by the Lake
medium
Watercolour
purpose of work
Book Jacket design
for one of a series
of children's books

brief
Emphasis is on
animal appeal and
drama. The direct,
loose, spontaneous
approach was
devised for the
series, now very
successful.
Preparatory
drawings are
minimal.
commissioned by
Claire Sutton

company
Hodder Children's
Books

judges

Justin Colby **senior designer** FHM
Wayne Ford **art director** Observer Life Magazine
Ian Whadcock **illustrator**
Paula Hickey **art editor** Sunday Telegraph Magazine
Suzanne Davies **senior designer** You Magazine

editorial

jason ford

2nd Floor
No 1 Tysoe Street
London
EC1R 4SA

t. 0171 278 8522

★ editorial section winner
★ award winner: *AOIClient Award*

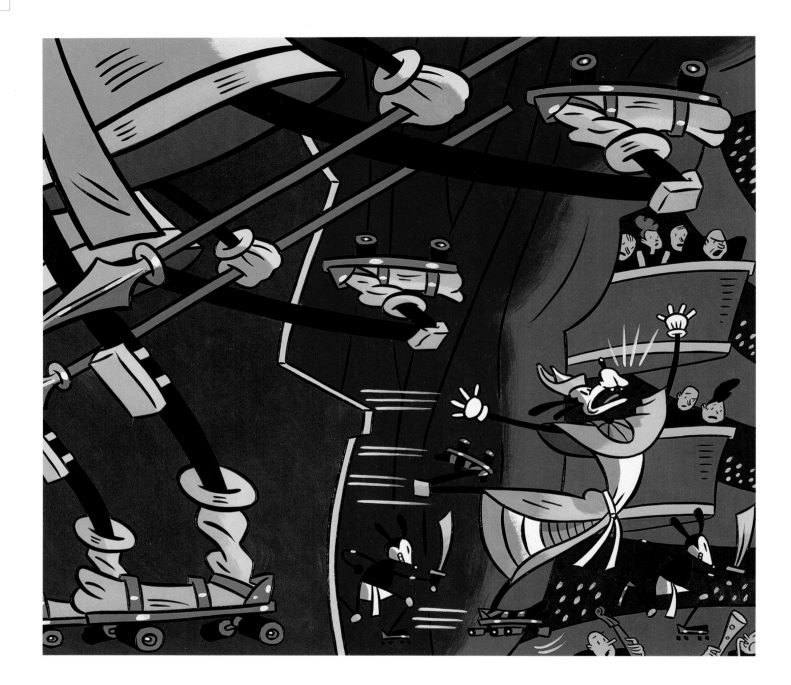

title
Pop Opera
medium
Ink and acrylic
purpose of work
Illustrate magazine
article

brief
Popularisation of
opera
commissioned by
John Belknap /
Anne Braybon
company
The European

jason ford

2nd Floor
No 1 Tysoe Street
London
EC1R 4SA

t. 0171 278 8522

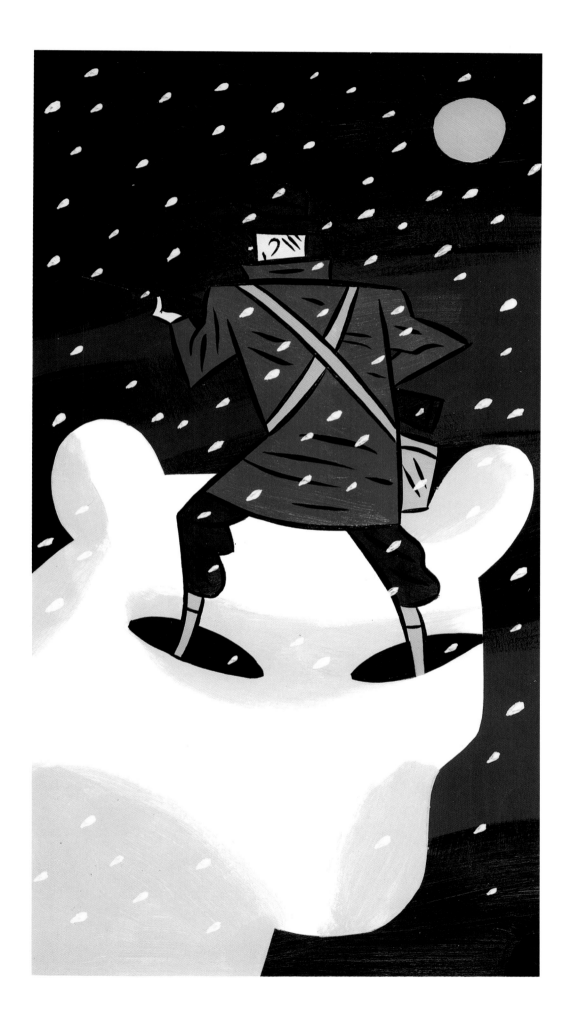

title
Hollywood
Christmas

medium
Acrylic and ink

purpose of work
Illustration for
classic Radio 2
drama programme

brief
In the radio remake
of the 1954 film
'The Track of the
Cat', a settler in
the mountains of
Nevada ignores the
warnings of local
Indians and sets
out to track down
a rogue cougar

commissioned by
Matthew Bookman

company
Radio Times

agent
Heart
t. 0171 833 4447

christopher corr

62
GB

27 Myddelton Street
London
EC1

t. 0171 833 5699

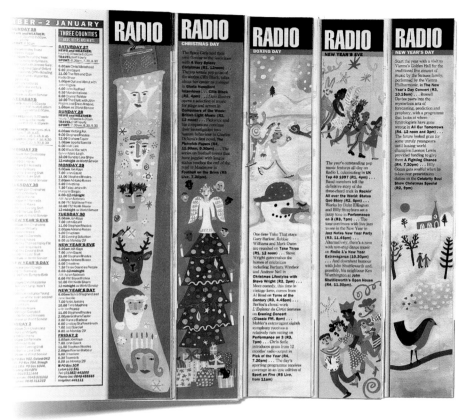

title
Christmas Livery
medium
Gouache on paper
purpose of work
To decorate the
five 'name' days
during Christmas

brief
Set of five
illustrations each
themed around the
days they appear
on, eg Christmas
Day, Boxing Day,
etc
commissioned by
Jonathan Christie
company
Radio Times

andy bridge

See Agent

title
Deceit
medium
Mixed media
purpose of work
Illustration for
Radio 4 programme
brief
A former MP
disappears from his
yacht. His wife is
convinced he is
dead, but becomes
drawn into a web
of speculation and
gossip

commissioned by
Matthew Bookman
company
Radio Times
agent
The Inkshed
98 Columbia Road
London
E2
t. 0171 613 2323

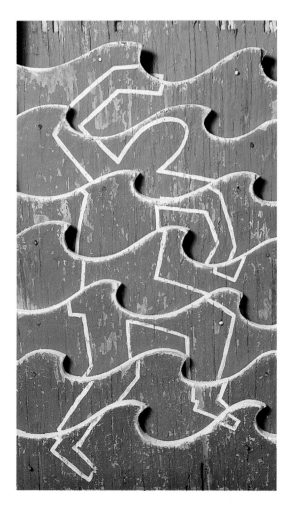

debbie lush

Top Flat
10 Shipka Road
Balham
London
SW12 9QP

t. 0181 673 5100

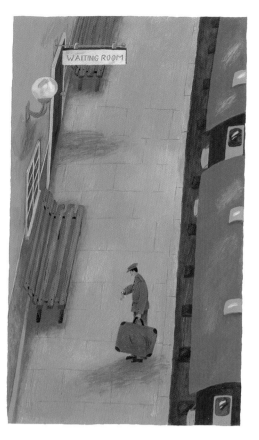

title
Fighting over
Beverley
medium
Acrylic
purpose of work
Illustration for
Radio 4 programme
brief
When Beverley
accompanies her
new American
husband home in
wartime, she left
behind a Yorkshire
man whom she had
promised to marry,
half a century on,
Archie decides to
win her back

commissioned by
Matthew Bookman
company
Radio Times
agent
The Inkshed
98 Columbia Road
London
E2 7QB
t. 0171 613 2323

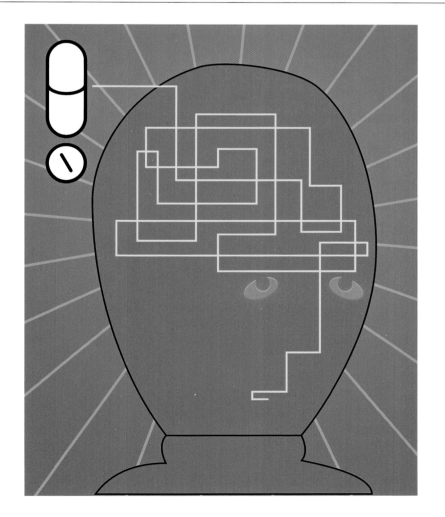

kam tang

t. 0171 737 1113

title
Headaches From
Hell
medium
Computer
generated
purpose of work
Illustration for
Radio Times Health
Page

brief
Modern migraine
remedies can bring
relief - just ask
your GP
commissioned by
Nathan Gale
company
Radio Times

geoff grandfield

30 Allen Road
London
N16 8SA

t. 0171 241 1523

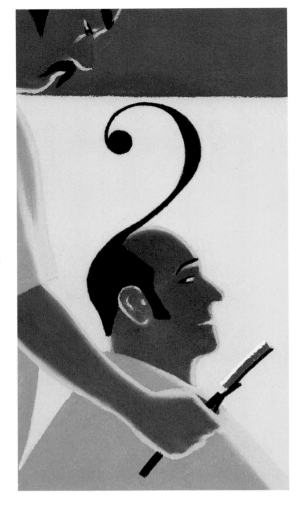

title
Sweeney Todd

medium
Chalk pastel

purpose of work
Illustration for
Radio 3 concert
programme

brief
Sondheims grisly
musical tells of a
19th century street
barber who slits his
customer's throats
and turns their
bodies over to the
inventive Mrs
Lovett to bake into
pies

commissioned by
Matthew Bookman

company
Radio Times

agency
Heart
t. 0171 833 4447

sean lee

72 Promenade
Portobello
Edinburgh
EH15 2DX

t. 0131 657 4369

title
'Ready, Steady,
Cook!'

medium
Gouache

purpose of work
Illustration of
Ainsley Harriott

brief
Caricature of
exuberant, fast
talking chef,
Ainsley Harriott, for
his appearance on
BBC1's 'Ready,
Steady Cook!'

commissioned by
Mark Taylor

company
Radio Times

carolyn gowdy

2c Maynard Close
Off Cambia Street
London
SW6 2EN

t. 0171 731 5380

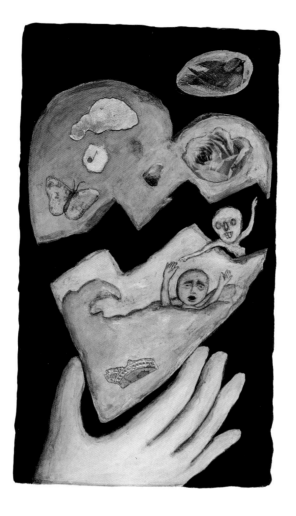

title
The Trick is to keep
Breathing

medium
Mixed media

purpose of work
Illustration for
Radio 4 programme

brief
Bereavement
becomes the
catalyst for Joy's
emotional
breakdown in this
adaptation of
Janice Galloway's
award winning
novel

commissioned by
Matthew Bookman

company
Radio Times

bill sanderson

Fernleigh
Huntington Road
Houghton
Cambridgeshire
PE17 2AV

t. 01480 461506

title
Board canvasses

medium
Scraper board and
inks

purpose of work
Illustration for
Radio 4 play

brief
The death of a
woman at a
reservoir scarcely
rates a mention in
the local press.
Although her father
is tipped off that
his daughter may
have been
murdered, the
police aren't
interested

commissioned by
Nathan Gale

company
Radio Times

kevin o'keefe

38 Osborne Road
Bristol
BS3 1PW

t. 0117 963 3835
f. 0117 963 3835

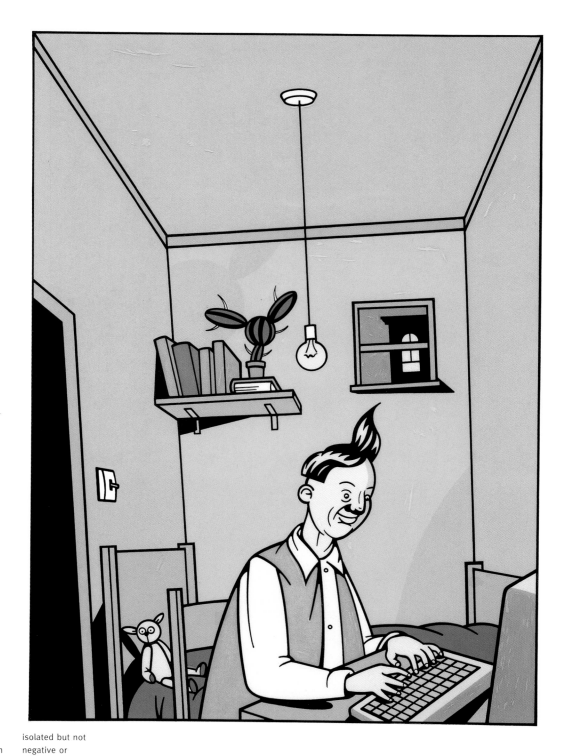

title
Internet Addiction
medium
Ink and acrylic on
acetate
purpose of work
Commissioned
article for a
computer magazine
brief
A small bedroom.
It is night time.
Someone is
working happily on
a computer.
Atmosphere
isolated but not
negative or
depressing
commissioned by
Susie Louis
company
VNU
agent
Black Hat
4 Northington
Street
London WC1N 2JG
t. 0171 430 9146
f. 0171 430 9156

frank love

The Dairy
5-7 Marischal Road
London
SE13 5LE

t. 0181 297 2212
f. 0181 297 2212

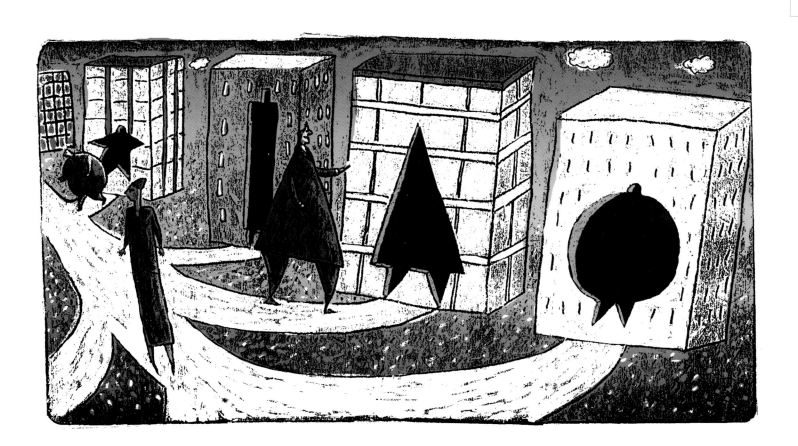

title	commissioned by
Temps	Vera Naughton
medium	**company/client**
Mixed media	Wall Street Journal
purpose of work	**agent**
Illustrate article	Eastwing
brief	98 Columbia Road
Fitting the right	London
temporary staff	E2 7QB
	t. 0171 613 5580

sue climpson

See Agent

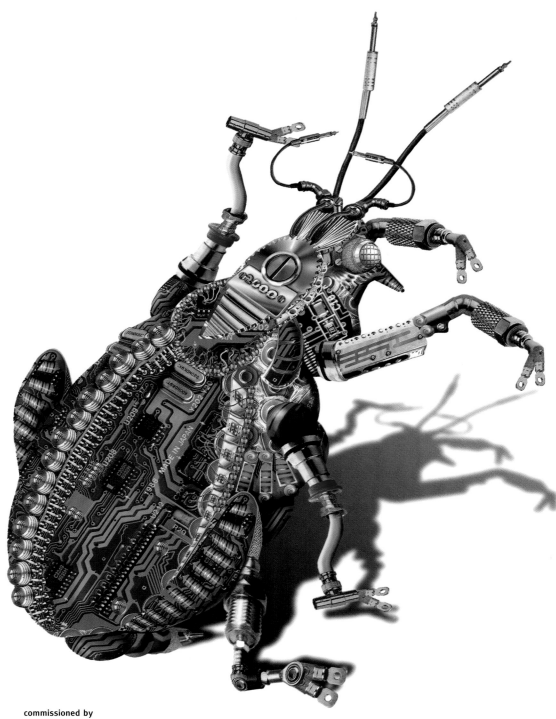

title
Millennium Bug

medium
Digital - Photoshop
and Live Picture

purpose of work
Article about the
possible computer
failure in year 2000

brief
To produce a
picture of the
millennium bug as
a kind of beetle
made of computer-
type hardware

commissioned by
Steve Lewis

company
The Publishing
Team Ltd

client
BUPA

agent
Illustration
1 Vicarage Crescent
Clapham
London SW11 3LP
t. 0171 228 8882

max ellis

See Agent

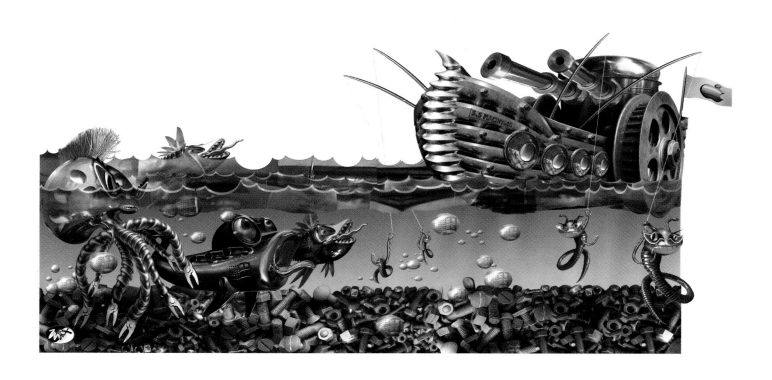

title
Channel Crossing

medium
Digital montage

purpose of work
Magazine feature

brief
Mackintosh are
producing software
to allow pc
programs to be
run. Illustrate this
dangerous new
environment being
entered into

commissioned by
Paul Kurjeja

company/client
Dennis Publishing

agent
Illustration
1 Vicarage Crescent
Clapham
London SW11 3LP
t. 0171 228 8882

stuart briers

186 Ribblesdale
Road
London
SW16 6QY

t. 0181 677 6203
f. 0181 677 6203

★ **winner:** *Daler and Rowney*
- best use of traditional materials

DALER~ROWNEY
TRUSTED by ARTISTS WORLDWIDE

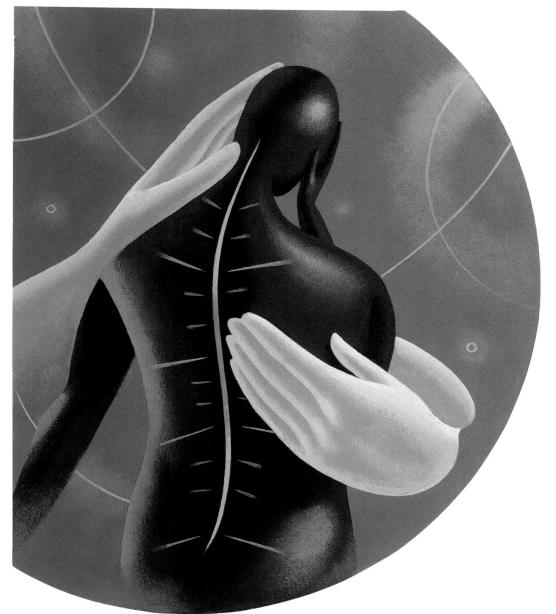

title
Care to fit the bill

medium
Acrylic

purpose of work
Editorial illustration

brief
To accompany
article about care
for the sufferers of
MS which typically
attacks the spinal
cord

commissioned by
Nancy Yuill

company/client
Health Which

title
Judge Not?

medium
Acrylic

purpose of work
Editorial illustration

brief
To accompany an
article which takes
a very critical look
at those who award
literary prizes

commissioned by
Susan Buchanen

company
Buchanen Davey

client
Prospect Magazine

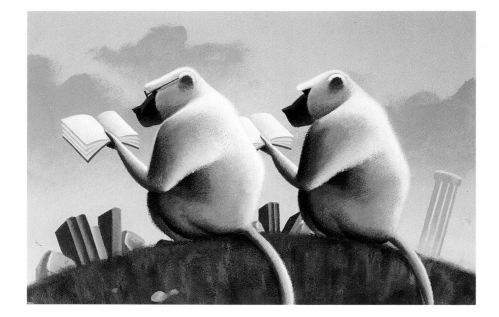

andrew bylo

Clockwork Studios
38b Southwell Road
London
SE5 9PG

t. 0171 274 4116
f. 0171 738 3743
www.aoi.co.uk/bylo

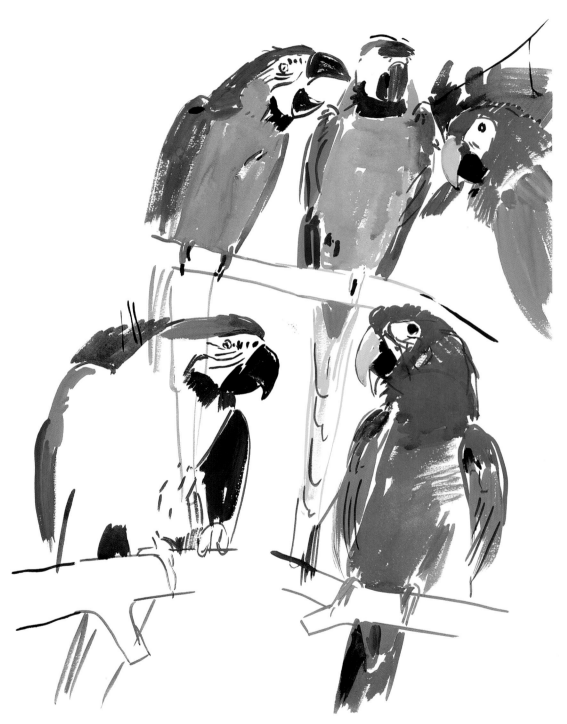

title
Macaws
medium
Watercolour and
gouache
purpose of work
Self promotional
brief
Painted from life in
private aviary

MAGNET
ARTISTS

ali pellatt

63 Nevis Road
London
SW17 7QL

t. 0181 772 0332
f. 0181 772 0332
mobile. 0402 748619

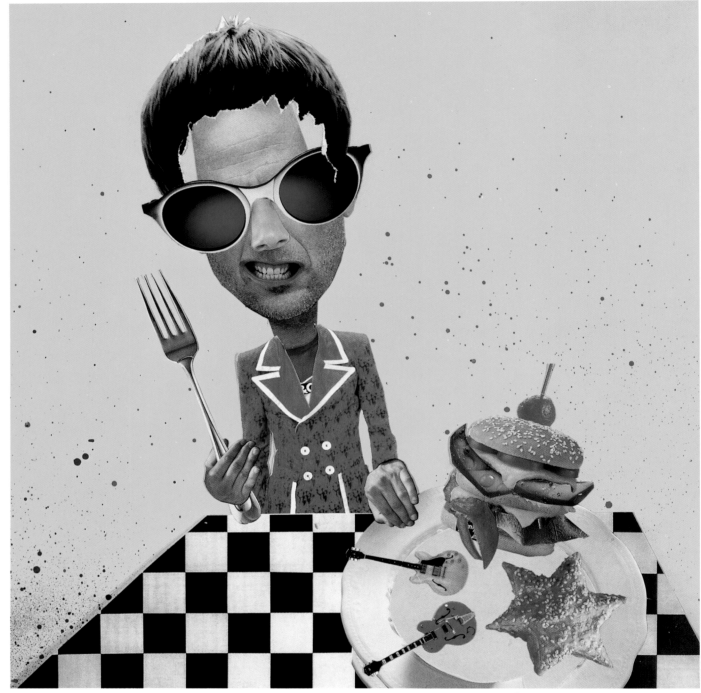

title
Scooby Snacks

medium
Montage,
neopastels and
spray paint

purpose of work
Jacket: Times
Directory

brief
A humorous
portrait of generic
pop star and his
food on tour

commissioned by
David Driver

company
The Times

MAGNET
ARTISTS

anna steinberg

57A Linden Avenue
Kensal Rise
London
NW10 5RG

t. 0181 964 1069
f. 0181 964 1069
pager. 01426 355 030

title
Eating out

medium
Ink and Pastel

purpose of work
In-flight magazine
article

brief
Business lunches
are the health bane
of the modern
executive

commissioned by
Mike Wescombe

company/client
International High
Flyer

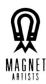

MAGNET
ARTISTS

alan alder

Flat 6
41 Craven Hill Gardens
London
W2 3EA

t. 0171 240 8925 (UK)
t. 0046 21 41 22 00 (Sweden)

title
Tracker Fund

medium
Pencil

purpose of work
To illustrate
Newspaper article

brief
To show how
personal tracker
funds perform at
the same rate as
the 100 top
performing UK
shares : the FTSE
100

commissioned by
David Driver

company
News International

client
The Times

agent
CIA
36 Wellington
Street
London WC2
t. 0171 240 8925

veronica bailey

188 Langham Road
Turnpike Lane
London
N15 3NB

t. 0181 888 0606
f. 0181 374 1891

title
Holographic TV
medium
Collage and
computer
generated
purpose of work
Editorial spread for
New Scientist

brief
Illustrate how
holograms work
with reference to
its use in film
commissioned by
Deborah George
company/client
New Scientist
agent
Debut Art
30 Tottenham
Street
London
W1 9PN
t. 0171 636 1064

zafer & barbara baran

47 Kings Road
Richmond
Surrey
TW10 6EG

t. 0181 948 3050
f. 0181 948 3050

76

GB

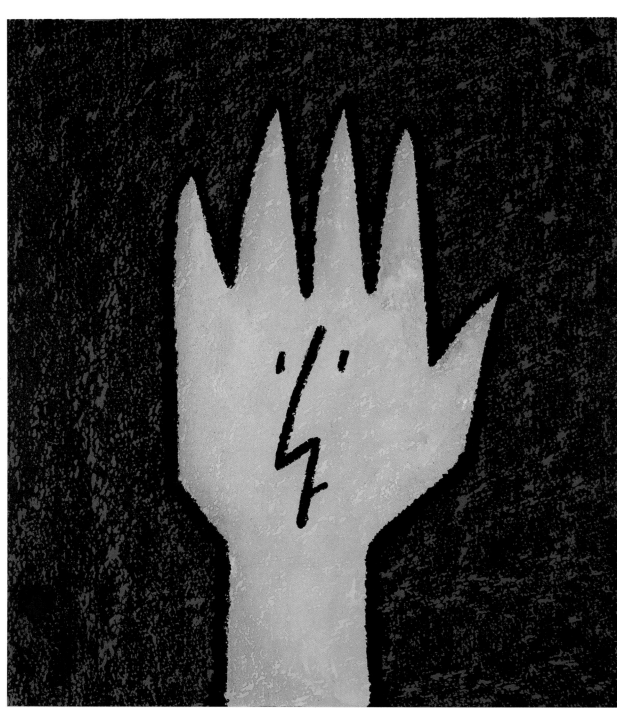

title
Volunteer

medium
Liquid watercolour
and ink

purpose of work
Magazine
illustration

brief
To illustrate article
'Redefining the
voluntary sector',
published in the
Royal Society of
Arts Journal

commissioned by
Mike Dempsey

company
CDT Design

client
Royal Society of
Arts

zafer & barbara baran

47 Kings Road
Richmond
Surrey
TW10 6EG

t. 0181 948 3050
f. 0181 948 3050

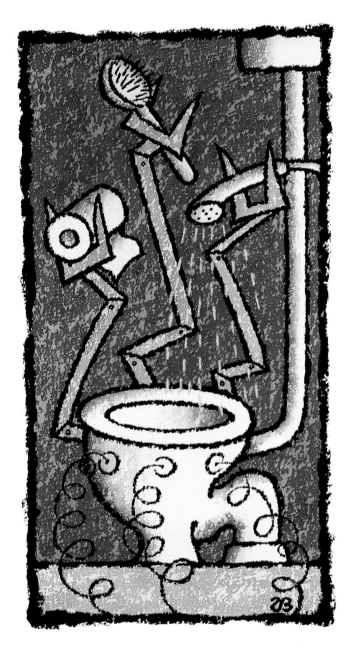

title
Egg Heads

medium
Liquid watercolour
and ink

purpose of work
Illustration for
newspaper
supplement

brief
To illustrate article
on the Disability
Discrimination Act

commissioned by
Mary Jane Bogue

company/client
Daily Telegraph

title
Hi-tech Toilet

medium
Liquid watercolour
and ink

purpose of work
Illustration for
newspaper
supplement

brief
To illustrate article
'Japanese offer the
world hi-tech toilet
training'

commissioned by
David Riley

company/client
Daily Telegraph

bill butcher

Sans Works
1 Sans Walk
London
EC1R 5oLT

t. 0171 336 6642
f. 0171 251 2642

title
Playing with Fire

medium
Acrylic

purpose of work
Lloyds list front
cover

brief
To illustrate the
RISK of natural
disasters focusing
on the dangers of
forest fires

commissioned by
Nick Blaxall

company
Lloyds List

title
Jet Jam

medium
Collage acrylic

purpose of work
Editorial piece for
European

brief
To illustrate build
up of air traffic at
European airports

commissioned by
John Belknap

company
The European

linda combi

17 Albemarle Road
York
YO23 1EW

t. 01904 623036
f. 01904 623036

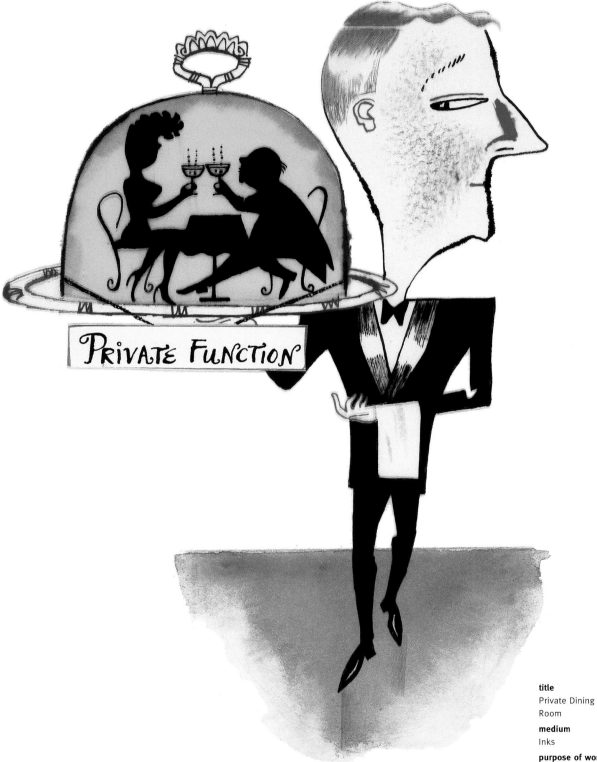

PRIVATE FUNCTION

title
Private Dining
Room

medium
Inks

purpose of work
Illustration for
article on private
dining rooms

brief
To humorously
depict the idea of
private dining
rooms in
restaurants where
discretion would be
assured

commissioned by
Tracey Young

company/client
Tatler Magazine

jill calder

20 Henderson Street
Flat 3F2
Leith
Edinburgh
EH6 6BS

t. 0131 553 2986
f. 0131 553 2986
email: Jill.C@btinternet.com

80
GB

title	**brief**
Mr Director	Open brief
medium	**commissioned by**
Ink collage	Sandra Colamartino
purpose of work	**company**
Illustrates Honor	Scotsman
Fraser's weekly	Publications Ltd
column for	**client**
Scotland on	Spectrum Magazine
Sunday Newspaper	

jill calder

20 Henderson Street
Flat 3F2
Leith
Edinburgh
EH6 6BS

t. 0131 553 2986
f. 0131 553 2986
email: Jill.C@btinternet.com

title
Sitting Room
Habits
medium
Ink
purpose of work
Illustrates Honor
Fraser's weekly
column for
Scotland on
Sunday Newspaper

brief
Open brief
commissioned by
Sandra Colamartino
company
Scotsman
Publications Ltd
client
Spectrum Magazine

title
Fitba' Daft
medium
Ink
purpose of work
Illustrates Honor
Fraser's weekly
column for
Scotland on
Sunday Newspaper

brief
Open brief
commissioned by
Sandra Colamartino
company
Scotsman
Publications Ltd
client
Spectrum Magazine

title
Le Driver
medium
Ink collage
purpose of work
Illustrates Honor
Fraser's weekly
column for
Scotland on
Sunday Newspaper

brief
Open brief
commissioned by
Sandra Colamartino
company
Scotsman
Publications Ltd
client
Spectrum Magazine

cyrus deboo

57 Ormonde Court
Upper Richmond Road
London
SW15 6TP

t. 0181 788 8167
f. 0181 788 8167
mobile. 07050 039 477

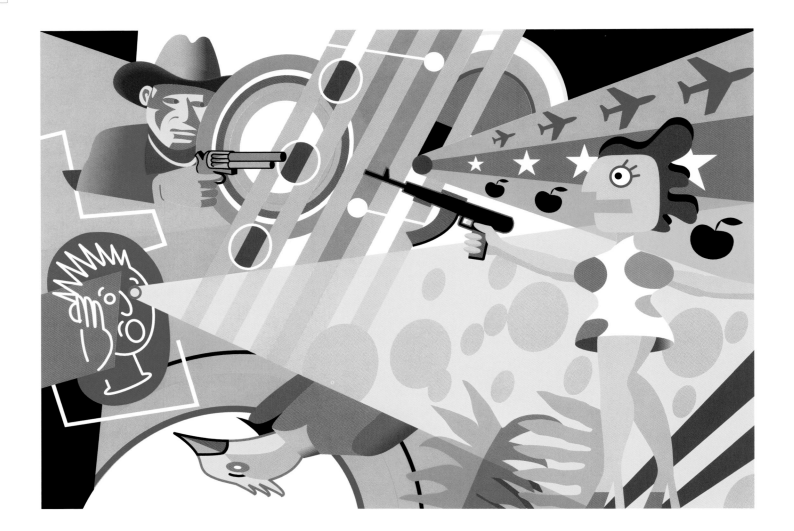

title
Room with a view

medium
Computer
generated -
Illustrator 7

purpose of work
Editorial

brief
To create an
abstract and non
obvious illustration
for a review about
two CD systems
(games and
movies) for home
entertainment

commissioned by
Alex Westthorpe

company
Computer Shopper

title
High Flyer

medium
Computer
generated -
Illustrator 7

purpose of work
Editorial

brief
To create an
illustration about
flight and fatigue.
To get plenty of
sleep - a glass of
wine will help

commissioned by
Gary Lockerby

company
YOU Magazine

philip disley

34 East Wapping
Quay
Liverpool
L3 4BU

t. 0151 709 9126

title
The New Culture
Club

medium
Ink

purpose of work
Editorial illustration

brief
To illustrate an
article on the new
art establishment

commissioned by
Kate Dwyer

company
Frank

jovan djordjevic

9 Fairlop Road
Leytonstone
London
E11 1BL

t. 0181 539 3892
f. 0181 539 3893
e-mail. jovan@jovan.demon.co.uk

title
Why Training Fails

medium
Montage, ink,
photocopy, digital
output

purpose of work
To illustrate
remedial actions
within management

brief
Open interpretation

commissioned by
Peter Drake

company
VNU Business
Publications
Management
Consultancy

jovan djordjevic

9 Fairlop Road
Leytonstone
London
E11 1BL

t. 0181 539 3892
f. 0181 539 3893
e-mail. jovan@jovan.demon.co.uk

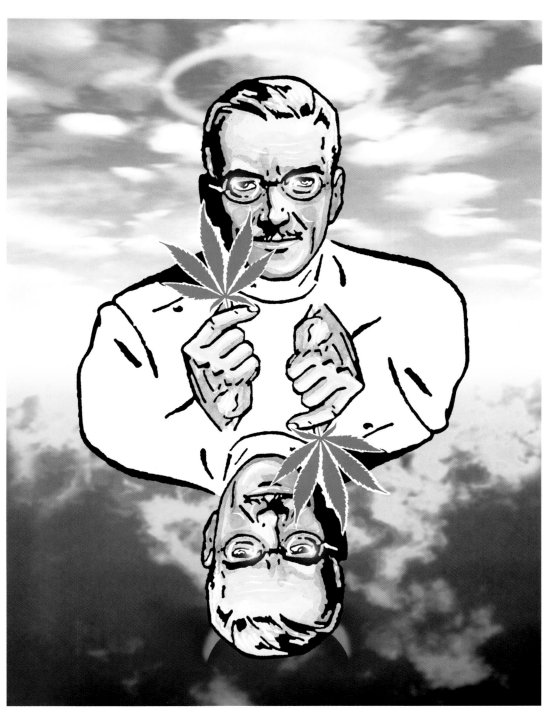

title
Cannabis Crossfire

medium
Montage,
watercolour,
photocopy, digital
output

purpose of work
Positive/negative -
professional/legal
debate over
medical use of
cannabis

brief
Open interpretation

commissioned by
Ned Campbell

company
Wolff Olins Ltd

client
Vision Magazine

jasper goodall

25c Jeffreys Road
Clapham
London
SW4 6QU

t. 0958 306 988
website: www.sonnet.co.uk/madforit/jasper
email: jasper_goodall@hotmail.com

title
Dudley Smith

medium
Digital

purpose of work
To illustrate a
literary character

brief
Visual portrayal of
fictional character
to introduce people
to writers they may
not have heard of

commissioned by
Ash Gibson

company
GQ Magazine

title
Skink

medium
Digital

purpose of work
To illustrate a
literary character

brief
Visual portrayal of
fictional character
to introduce people
to writers they may
not have heard of

commissioned by
Ash Gibson

company
GQ Magazine

adam graff

10 St Columbas
House
16 Prospect Hill
Walthamstow
London
E17 3EZ

t. 0181 521 7182
f. 0181 521 7182

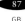

title	commissioned by
Tobacco Emporia	Time Out
medium	**client**
Chinagraph and computer	Time Out Magazine Ltd
purpose of work	**agent**
Editorial	The Organisation
brief	69 Caledonian Road
To head an article on London's specialist tobacco emporia	London N1 9BT t. 0171 833 8268

nick hardcastle

14 Loxley Road
London
SW18 3LJ

t. 0181 871 1748
f. 0181 871 1748

title
Bumper harvest
medium
Pen and ink with
watercolour
purpose of work
Illustration for
Brain Waves
column in Weekend
Guardian

brief
To illustrate the
phrase "bumper
Harvest" in a
humorous fashion
commissioned by
Chris Maslanka
company/client
Weekend Guardian
agent
Illustrators.Co
3 Richborne
Terrace
London
SW8 1AR
t. 0171 793 7000

jo hassall

Represented by
Private View

t. 0181 299 1392

title
Green Trees
medium
Mixed media
purpose of work
For Prudential
in-house magazine

brief
To illustrate
ecologically sound
business practice
leading to growth
commissioned by
Harry McFarland
company
Perception Design
client
Prudential

kevin hauff

7 Pendre Avenue
Prestatyn
Denbighshire
LL19 9SH

t. 01745 888734
f. 01745 888734

title
The Alchemist

medium
Acrylic/collage

purpose of work
Economist special
supplement cover

brief
To illustrate an
economist
supplement cover
entitled The
Alchemist,
depicting a
medieval
Alchemist's shock
at the new
methods of drug
design and
development

commissioned by
Una Corrigan

company
The Economist

frazer hudson

150 Curtain Road
1st Floor Studio,
Back Building
London
EC2A 3AR

t. 0973 616 054
f. 0171 613 4434

title
Barking Mad

medium
Mixed media

purpose of work
Science illustration

brief
To illustrate the
science behind
quarantine
highlighting the
new passport rules
this brings about

commissioned by
Naomi Depeza

company
*The Independent
on Sunday Review*

Flat 2
40 Tisbury Road
Hove
East Sussex
BN3 3BA

t. 01273 771539
f. 01273 771539

title
Decline of British
Literature

medium
India Ink and
watercolour

purpose of work
An editorial spot
illustration

brief
To illustrate an
essay about the
decline of quality
literature in Britain

commissioned by
Susan Buchanan

company
Buchanan-Davey

client
Prospect

agent
Ian Fleming
72-74 Brewer
Street
London
WIR 3PH
t. 0171 734 8701

satoshi kambayashi

Flat 2
40 Tisbury Road
Hove
East Sussex
BN3 3BA

t. 01273 771539
f. 01273 771539

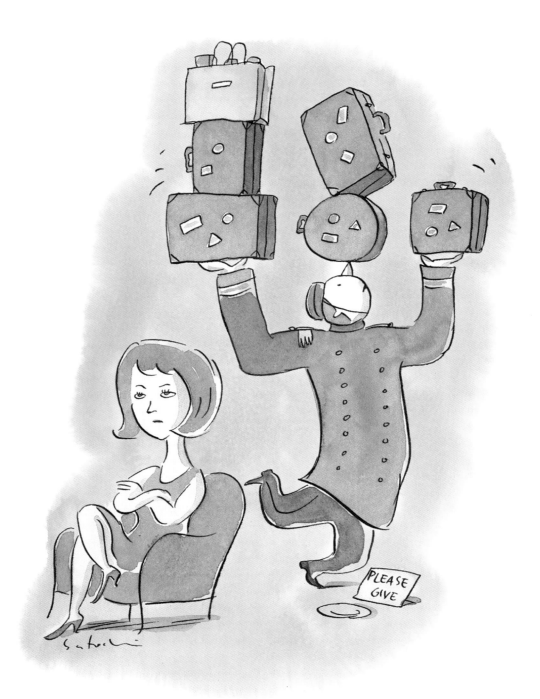

title
Please Give

medium
Ink and
watercolour

purpose of work
An editorial spot
illustration

brief
For an article about
the ever-decreasing
amount of tipping
in hotels

commissioned by
Adrian Hulf

company
Illustrated London
News Group

client
First Class
Magazine

agent
Ian Fleming
72-74 Brewer
Street
London
WIR 3PH
t. 0171 734 8701

peter knock

17 Nelson Drive
Leigh on Sea
Essex
SS9 1DA

t. 01702 476885
f. 01702 476885

EDITORIAL

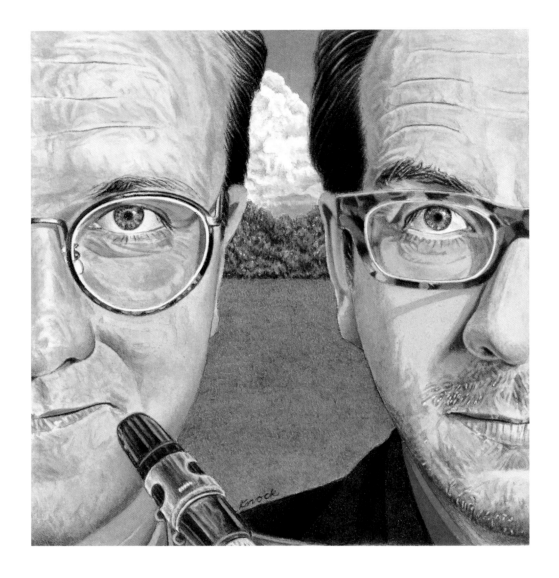

title
Elvis Costello and
John Harle

medium
Watercolour

purpose of work
Magazine
Illustration

brief
Double portrait of
two musicians for a
review of their
collaborated
material

commissioned by
Robert Priest

company
Esquire Magazine
(US)

client
American Esquire

Bristol Craft &
Design Centre
6 Leonard Lane
Bristol
BS1 1EA

t. 0117 9299077
f. 0117 9299077

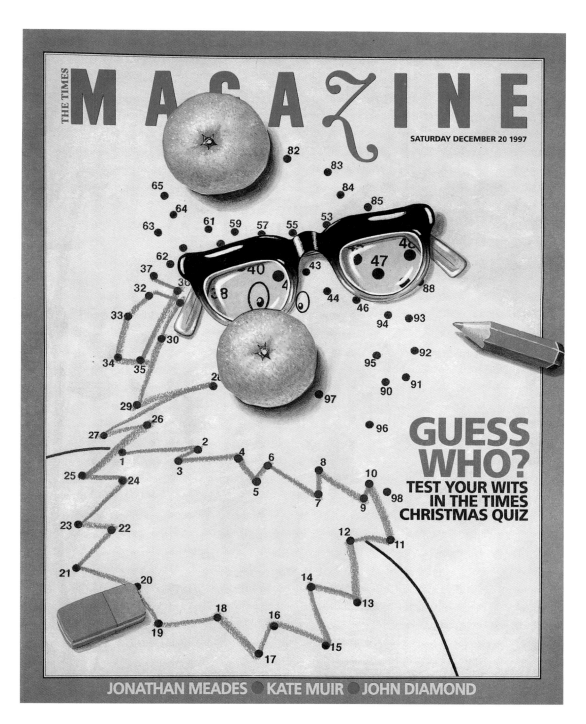

title
Christmas Quiz
medium
Acrylic
purpose of work
Cover Illustration
for the Saturday
Times magazine

brief
To find a striking
image for the
Christmas quiz
cover
commissioned by
D Curless
company
The Times

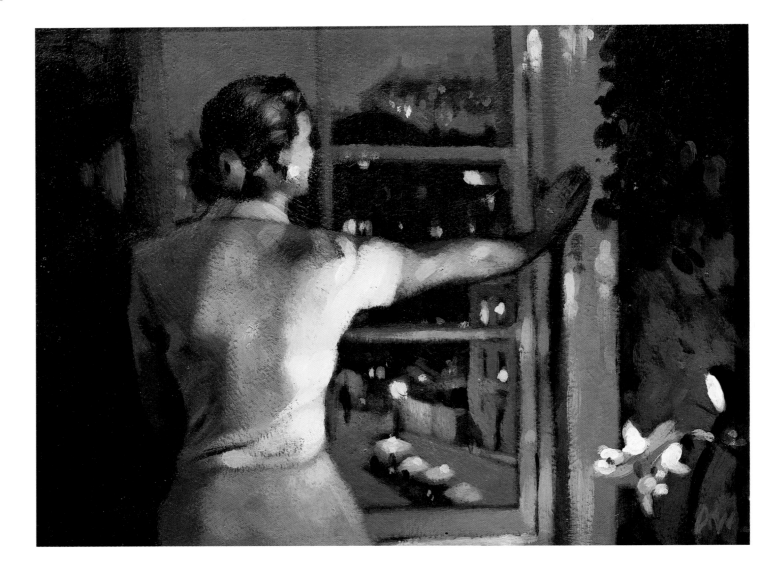

title
Missing You

medium
Acrylic on paper

purpose of work
To illustrate a
fiction piece

brief
To depict the figure
of the woman
central to the story
as she ponders her
failed marriage

commissioned by
Lorraine Older

company
South Bank
Publishing Group

client
Woman and Home
Magazine

agent
The Inkshed
98 Columbia Road
London
E2 7QB
t. 0171 613 2323

james marsh

21 Elms Road
London
SW4 9ER

t. 0171 622 9530
f. 0171 498 6851

97

GB

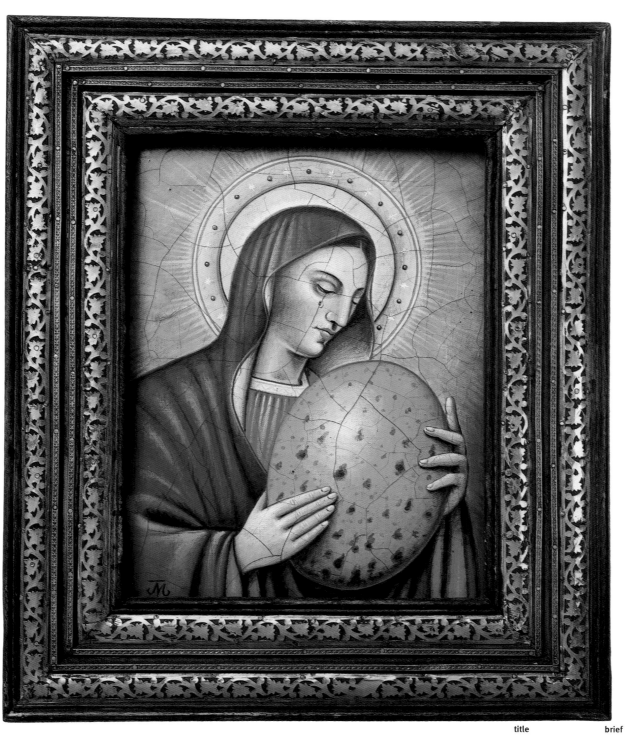

title
Madonna's Child

medium
Acrylic on canvas

purpose of work
To illustrate
fictional story in
magazine

brief
Open brief to
illustrate story
about a girl who
thinks she is the
madonna's child

commissioned by
Susan Buchanan

company
Buchanan Davey

client
Prospect Magazine

glen mcbeth

12, 37 Sandport
Street
Edinburgh
EH6 6EP

t. 0131 555 0576
f. 0131 555 0576

Mr Bun the Baker — Mr Bun Jnr — Mrs Bun the Baker's wife

Brother Bun — Miss Bun Jnr — Mrs Bun Jnr — Ex- Mrs Bun Jnr — Grandson Bun

Grandson Bun — Granddaughter Bun — Cousin Bun — Grandson Bun

Uncle Bun — Cousin Bun — Baby Bun — Aunty Bun — Distant Cousin Bun

Great Cousin Bun — Long Lost Brother Bun — Second Cousin Twice Removed Bun

title
The Buns

medium
Pen ink collage
colour copy

purpose of work
Magazine
illustrations

brief
To produce happy
family cards to
show how
everyone from
close family to
distant relatives
want a part of a
family business

commissioned by
Jane Greig

company
CA Magazine

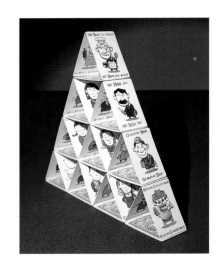

shane mcgowan

23A Parkholme
Road
London
E8 3AG

t. 0171 249 6444
f. 0171 249 6444

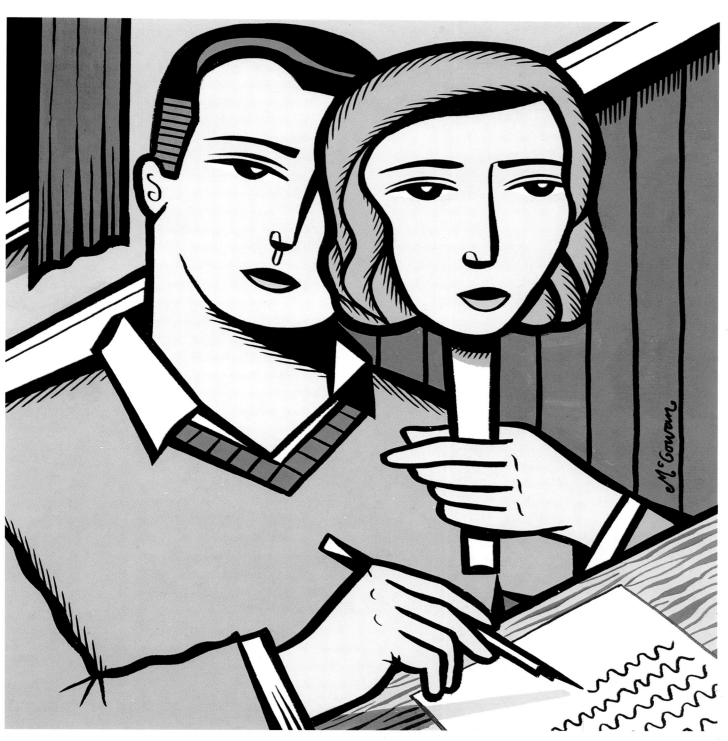

title
First person
feminine

medium
Gouache, ink

purpose of work
To illustrate article
in the 'Real Life'
section

brief
To show how men
narrate novels
through female
heroines

commissioned by
Mark Hayman

company/client
*The Independent
on Sunday*

agent
The Organisation
69 Caledonian
Road
London N1
t. 0171 833 8268

tony mcsweeney

4 Water Lane
Richmond
Surrey
TW9 1TJ

t. 0181 940 2425
f. 0181 940 2425

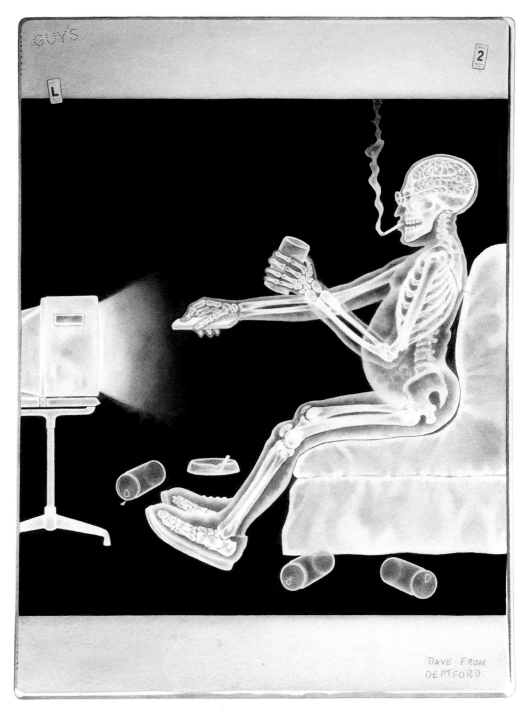

title
Power to the
People

medium
Watercolour
gouache

purpose of work
To illustrate an
article in ES
magazine

brief
To provide a
convincing looking
x-ray of a couch
potato watching TV
during World Cup
'98

commissioned by
Robin Hedges

company
Associated
Newspapers

client
*Evening Standard
Magazine*

kate newington

30 Saltoun Road
London
SW2 1EP

t. 0171 274 1418
f. 0171 274 1418

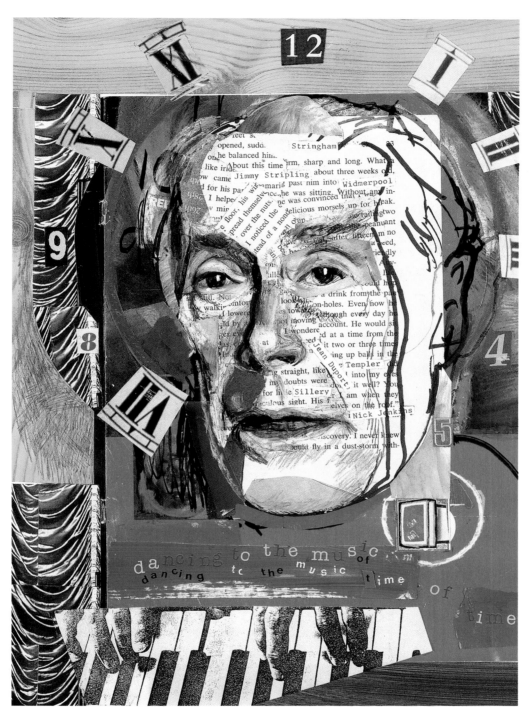

title
Anthony Powell
medium
Mixed media on
paper
purpose of work
Commission for the
Observer
Newspaper

brief
An illustration for a
profile of the writer
Anthony Powell
whose series of
novels 'A Dance to
the Music of Time'
had just been
dramatised for TV
commissioned by
The Observer

chris robson

13 Whatley Road
Clifton, Bristol
BS8 2PS

t. 01179 737694
f. 01179 737694
mobile. 0797 137 9354
e-mail. cbrobson@aol.com

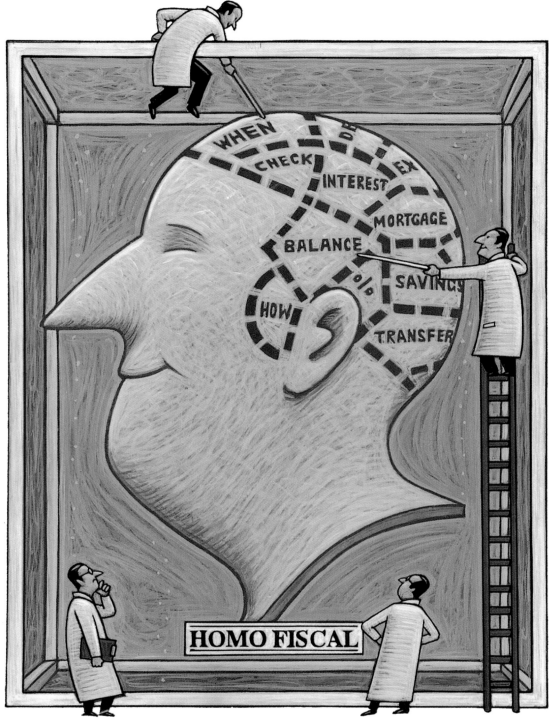

title
Homo Fiscal

medium
Acrylic

purpose of work
Magazine
Illustration

brief
To show how
financiers make
decisions

commissioned by
Jane Ure-Smith

company
TPD Publishing

client
Talking Business
Magazine

andrew selby

9 Perryfield
Matching Green
Essex
CM17 0PY

t. 01279 731452 /
0973 271449
f. 01279 731452

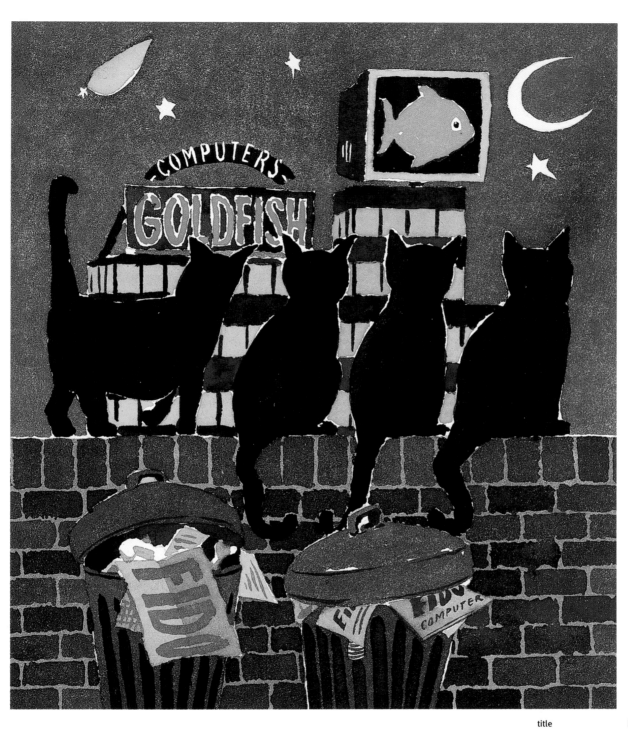

title
All Change

medium
Watercolour

purpose of work
Editorial

brief
Changing your company name can make you more appealing to a wider audience

commissioned by
Karen Falconer

company
Dennis Publishing

penny sobr

Omnibus Centre
Unit 35
39-41 North Road
London
N7 9DP

t. 0171 609 3979
f. 0171 607 4652

title
Ascot Fashion

medium
Gouache

purpose of work
Illustrate
Newspaper article

brief
What to wear this
year at Ascot

commissioned by
John Belknap /
Julian Bovis

company
Sunday Business

peter till

11 Berkeley Road
London
N8 8RU

t. 0181 341 0497
f. 0181 341 0497

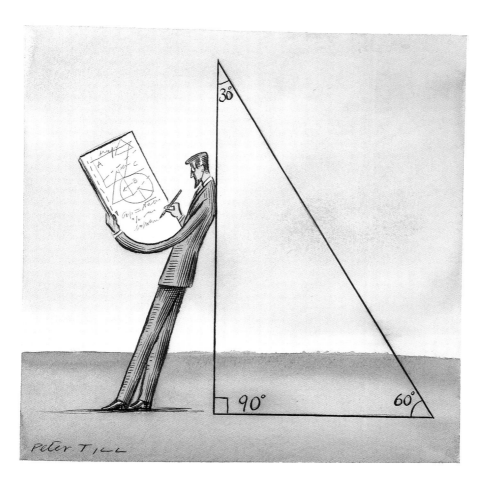

title
Triangle
medium
Pen, ink and
watercolour
purpose of work
For magazine
article
brief
Article about
science being
based on first
principles
commissioned by
Colin Brewster
company
New Scientist

title
Chip Art
medium
Pen, ink and
watercolour
purpose of work
To accompany
article
brief
Given a brief news
item about
computers - here
computer art
commissioned by
Peter Kirwan
company
VNU
client
Computing

judges

Carolyn Gowdy **illustrator**
Peter Cotton **art director** Little Brown Books
Ami Smithson **senior designer** Penguin Books
Bob Hollingsworth **senior designer** Random House
Nick Castle **art director** Orion Publishing

peter gudynas

89 Hazelwell Crescent
Stirchley
Birmingham
B30 2QE

t. 0121 459 0080
f. 0121 459 0080
e-mail. peter@zapart.demon.co.uk

W

★ general books section winner
★ winner: *Waterstone's Booksellers Award*

title
Diaspora

medium
Digital

purpose of work
Book Cover

brief
A novel about post human evolution featuring a future where humanity has drastically reconfigured itself via bio-technological intervention, digital simulation and artificial consciousness

commissioned by
Carl D Galian

company/client
Harper Collins
(USA)

nelly dimitranova

Top Flat
33 Savernake Road
London
NW3 2JU

t. 0171 284 2334

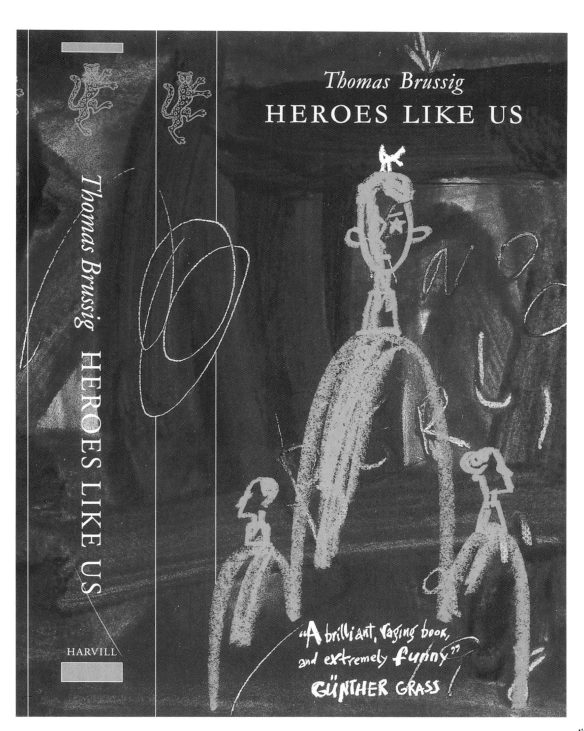

title
Heroes Like Us
medium
Acrylic and crayon
purpose of work
Book Jacket
brief
The book
commissioned by
Harvill Press
client
Christopher
Maclehose

geoff grandfield

30 Allen Road
London
N16 8SA

t. 0171 241 1523
f. 0171 241 1523
e-mail. g.grandfield@mdx.ac.uk

title
Brighton Rock

medium
Chalk pastel

purpose of work
Book Illustration

brief
Read the novel

commissioned by
Joe Whitlock-
Blundell

company/client
The Folio Society

title
A Burnt Out Case

medium
Chalk pastel

purpose of work
Book Illustration

brief
Read the novel

commissioned by
Joe Whitlock-
Blundell

company/client
The Folio Society

geoff grandfield

30 Allen Road
London
N16 8SA

t. 0171 241 1523
f. 0171 241 1523
e-mail. g.grandfield@mdx.ac.uk

title
The Power and the
Glory
medium
Chalk pastel
purpose of work
Book Illustration
brief
Read the novel
commissioned by
Joe Whitlock-
Blundell
company/client
The Folio Society

title
The End of the
Affair
medium
Chalk pastel
purpose of work
Book Illustration
brief
Read the novel
commissioned by
Joe Whitlock-
Blundell
company/client
The Folio Society

lesley hilling

152 Mayall Road
London
SW24 0PH

t. 0171 737 2689
f. 0171 733 1845
e-mail. offbeat@dircon.co.uk

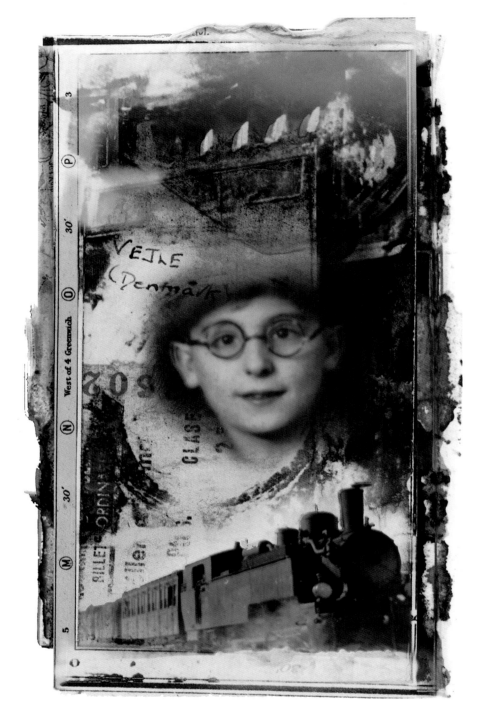

title
The Search

medium
Digital image

purpose of work
Book jacket

brief
To illustrate one
man's search for a
group of 89 boys
who all survived
Birkenau
concentration camp

commissioned by
Serpent's Tail

company
Serpent's Tail
Books

client
Peter Ayrton

harry horse

20 Bruntsfield
Gardens
Edinburgh
EH10 4EA

t. 0131 228 4196
f. 0131 228 4196

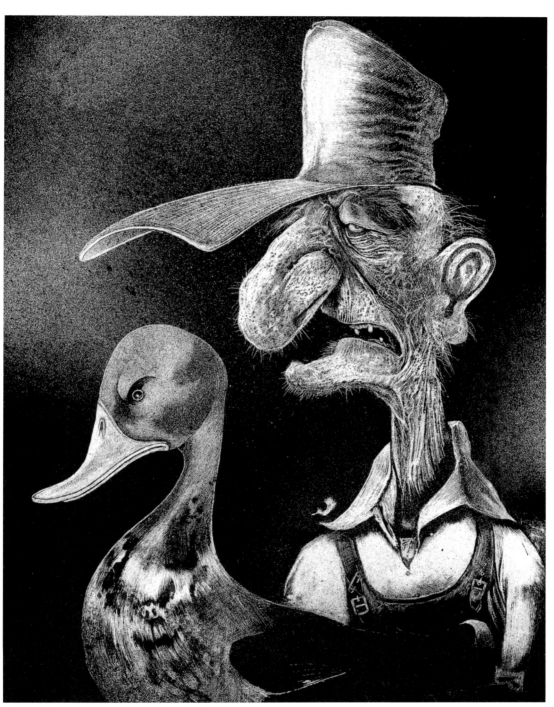

title
Fup

medium
Mixed media,
shelac and ink

purpose of work
Illustrate novel

brief
To illustrate Jim
Dodge's novel
about two hillbillies
and one duck
called Fup

commissioned by
Jamie Byng

company/client
Canongate Books

agency
Caroline Sheldon
Literary Agency
London Farm
Whiteoaks Lane
Shalfleet
PO30 4NU
t. 01983 531826

peter simon jones

72 Forthill Road
Broughty Ferry
Dundee
Scotland
DD5 3DN

t. 01382 738444
e-mail. p.s.jones@dundee.ac.uk

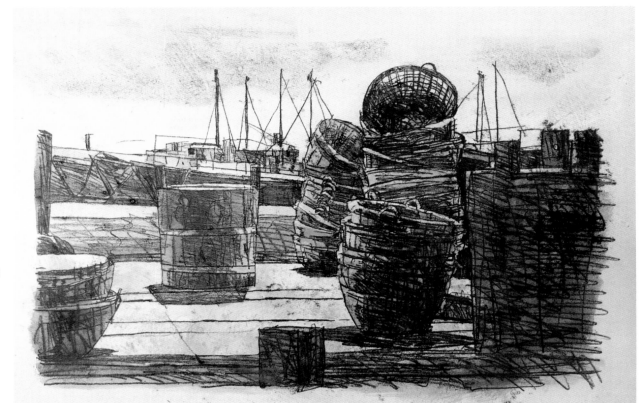

title
Sai Kung, Hong Kong

medium
Monoprint

purpose of work
Illustration for a book entitled Hong Kong Visual diary

brief
Double Page Spread illustrating a way of life in changing Hong Kong

commissioned by
Mandarin Publishers

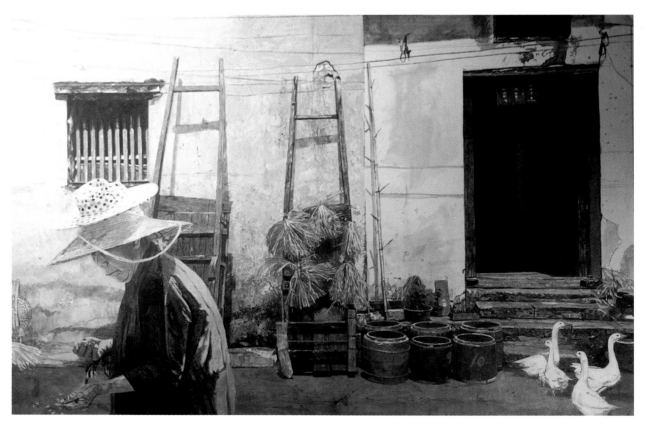

title
Tai Long Village

medium
Acrylic/watercolour on canvas board

purpose of work
One of a series of illustrations depicting various aspects of Hong Kong life and culture

brief
Double Page illustration from the book 'Hong Kong A Diary', depicting rural life in the New Territories, Hong Kong

commissioned by
Mandarin Publishers

anne magill

See Agent

t. 0468 362420

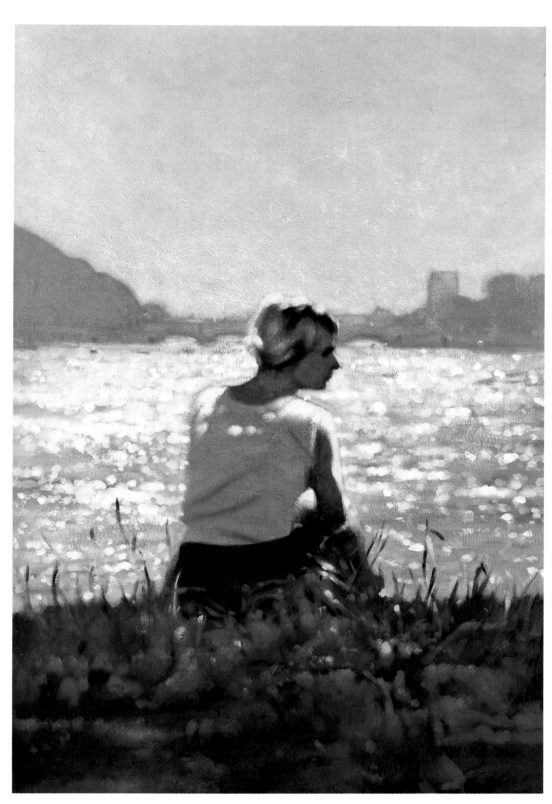

title
Julia Alone

medium
Acrylic on paper

purpose of work
Book jacket - Julia Alone by Ann Stevens

brief
To portray Julia, sitting alone, the Thames and Putney Bridge to be behind her. The portrait was not to be too specific but had to hint at her sadness and loneliness

commissioned by
Sonia Dobie

company/client
Harper Collins

agent
The Inkshed
98 Columbia Road
London
E2 7QB
t. 0171 613 2323

james marsh

21 Elms Road
London
SW4 9ER

t. 0171 622 9530
f. 0171 498 6851

116

GB

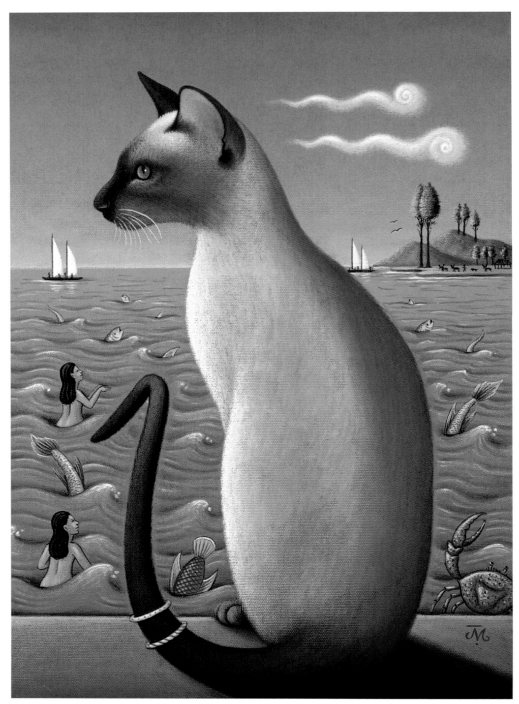

title
A cat's Tail

medium
Acrylic on canvas

purpose of work
Page in Best Ever
Book of Cats

brief
To illustrate Thai
legend: Why the
Siamese cat has a
kink in its tail

commissioned by
Sue Aldworth

company
Kingfisher Books

client
Larousse plc

daren mason

Echo Beach Studio
19 Muspole Street
Norwich
NR3 1DJ

t. 01603 630 500
mobile. 0410 769203
f. 01603 630 500
e.mail. daren.mason@btinternet.com

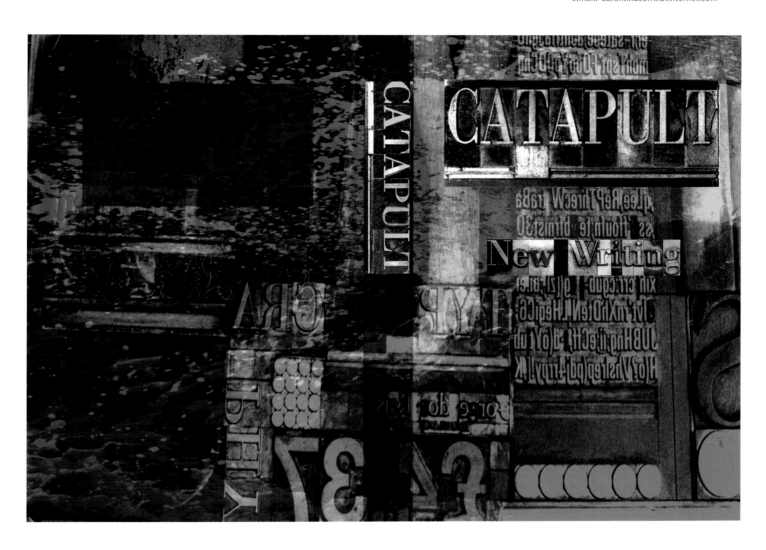

title
Catapult

medium
Photography and
computer

purpose of work
Book jacket

brief
Book jacket for MA
Creative Writing
course UEA

commissioned by
UEA/CCPA
Centre for Creative
& Performing Arts

sarah perkins

37e Guinness Court
Snowfields
London
SE1 3SX

t. 0171 378 1510
f. 0171 357 6442

118
GB

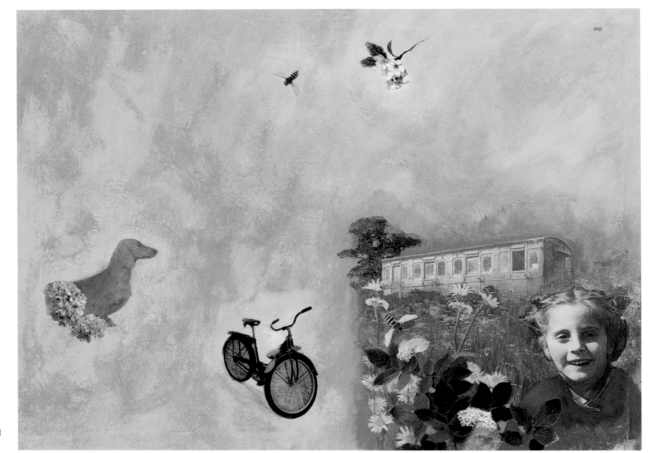

title
Orchard on Fire
medium
Mixed
purpose of work
Book jacket
brief
Read the book
commissioned by
Ami Smithson
company
Reed Consumer
Books
agent
The Inkshed
98 Columbia Road
London E2 7QB

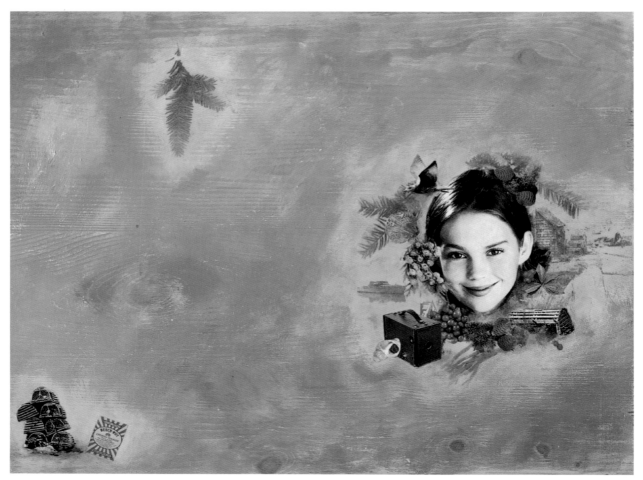

title
A Running Tide
medium
Mixed
purpose of work
Book jacket
brief
Illustrate the book
telling the story of
a girls childhood
memories in Maine,
America
commissioned by
Juliet Rowley
company
Random House
agent
The Inkshed
98 Columbia Road
London E2 7QB

sarah perkins

37e Guinness Court
Snowfields
London
SE1 3SX

t. 0171 378 1510
f. 0171 357 6442

title
A Way of Being
Free - Ben Okri

medium
Mixed

purpose of work
Book jacket

brief
The idea of words
liberating the
person,
transporting a mind
to another place,
freedom

commissioned by
Nick Castle

company
Orion

agent
The Inkshed
98 Columbia Road
London E2 7QB

ian pollock

171 Bond Street
Macclesfield
Cheshire
SK11 6RE

t. 01625 426205
f. 01625 261390

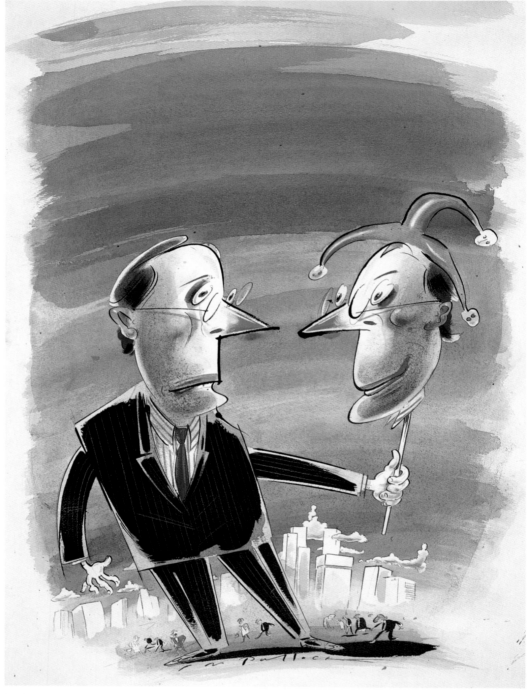

title
The Corporate Fool

medium
Watercolour ink
and gouache

purpose of work
Book jacket

brief
Book jacket for The
Corporate Fool by
David Firth

commissioned by
Capstone
Publishing Limited

agent
The Inkshed
98 Columbia Road
London
E2 7QB
t. 0171 613 2323

nancy tolford

The Coach House
23 Rushmore Road
Clapton
London
E5 oET

t. 0181 985 8377
f. 0181 985 8377

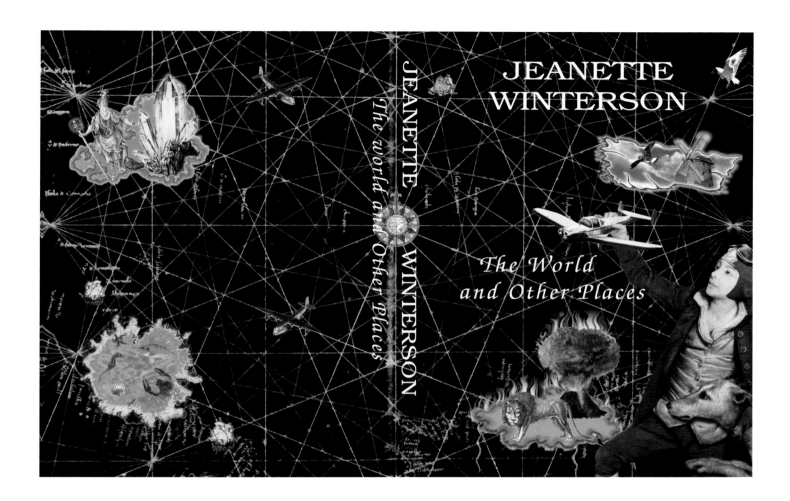

title
The World and
Other Places

medium
Computer
generated

purpose of work
Book jacket

brief
Collection of short
stories, involving
travel to both real
and imaginary
places. By
Jeannette
Winterson

commissioned by
Caz Hildebrand

company
Random House UK

borin van loon

117 Belle Vue Road
Ipswich
Suffolk
IP4 2RD

t. 01473 421529
e-mail. borin@vanloon.keme.co.uk

title
"Oh goodie, it's
the po-mo bit
next!"

medium
Brush and ink with
'paper-print' on
paper

purpose of work
Book illustration

brief
To provide a full-
page facial image
with a post-
modernist twist.

title
Ashis Nandy

medium
Ink, brush and
fingerprint on
paper

purpose of work
Book illustration

brief
Portrait of Nandy,
psychologist and
cultural critic.

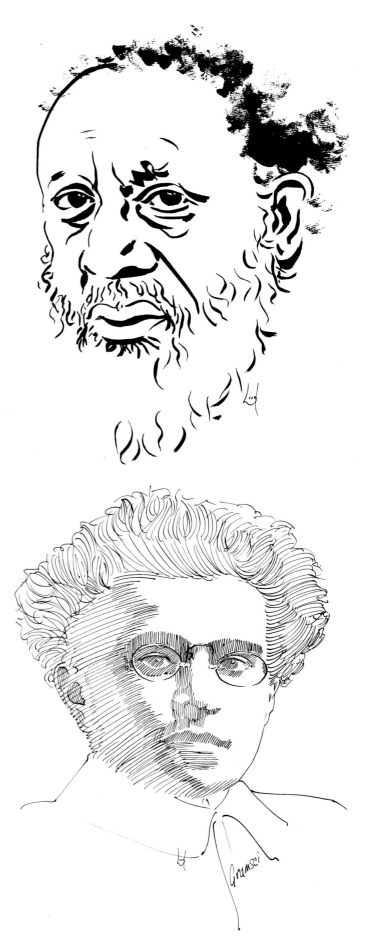

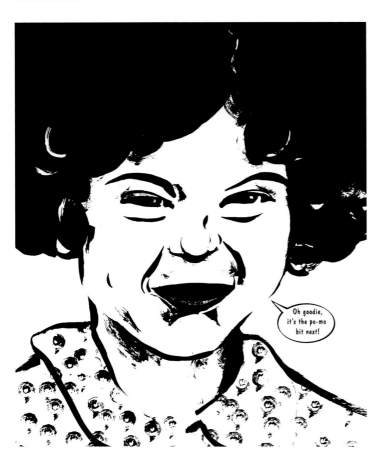

all images from
"Cultural Studies
for Beginners"

commissioned by
Richard
Appignanesi

company/client
Icon Books Ltd

title
Antonio Gramsci

medium
Dip pen on paper

purpose of work
Book illustration

brief
To illustrate the
Marxist thinker
Gramsci who
devised the term
"Subaltern"
studies.

rosemary woods

2 Gosberton Road
London
SW12 8LF

t. + 44 (0) 207 378 1219
f. + 44 (0) 208 673 6700

title
Buhari Steam
medium
Acrylic on paper
purpose of work
Little Indian Cook
Book
brief
To give a flavour of
India and include
some of the
ingredients of
Buhari Gosht
commissioned by
John Murphy
company/client
Appletree Press

title
Coconut Coast
medium
Acrylic on paper
purpose of work
Little Indian Cook
Book
brief
To give a flavour of
India for chilli
coconut sauce
recipe
commissioned by
John Murphy
company/client
Appletree Press

judges

Roger Walton **art director** Duncan Baird
Nick Clark **art director** Readers Digest General Books
Les Hayes **creative executive** London Transport Advertising and Publicity
Colin Wilkin **illustrator**
Bill O'Neill **editor** Guardian On Line

information

angela harland

Haven Cottage
Atlow
Ashbourne
Derbyshire
DE6 1NS

t. 01335 370992

★ information section winner

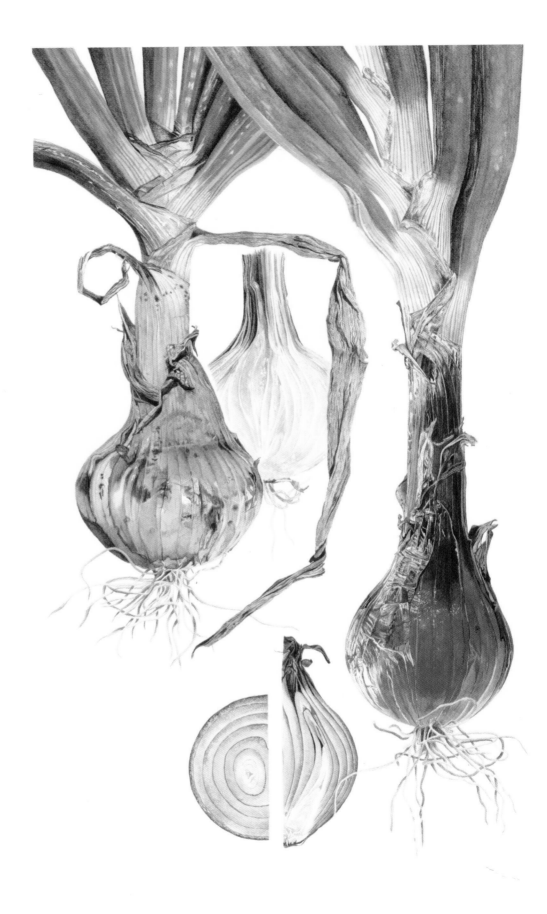

title
Onions

medium
Watercolour

purpose of work
Degree illustration
project work

brief
Botanical

submitted by
Blackpool and The
Fylde College

paul bimrose

43 Lee Moor Road
Stanley
Wakefield
WF3 4EF

t. 01924 826625

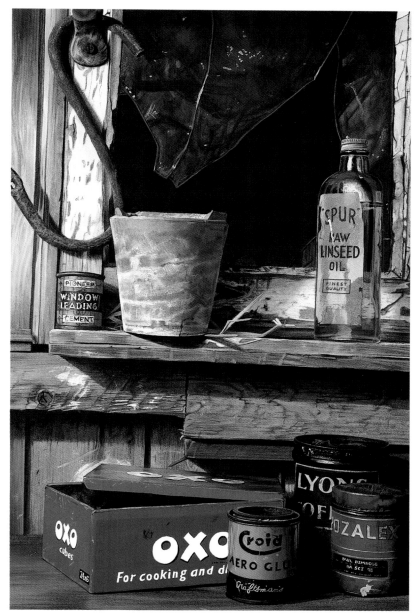

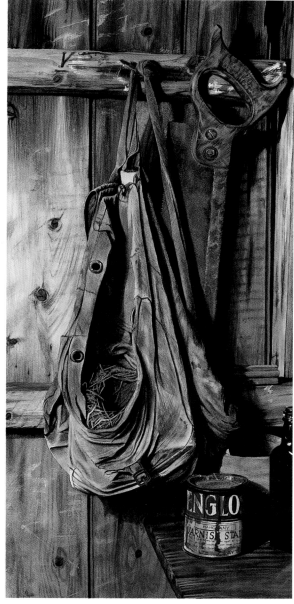

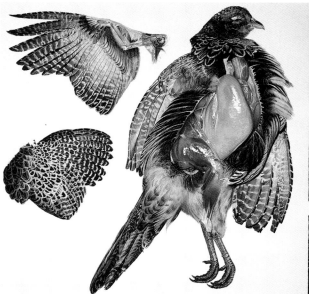

title
Pheasant
Dissection

medium
Watercolour
Gouache

purpose of work
Degree illustration

brief
Professional media
brief, Year 3

submitted by
Blackpool and The
Fylde College

title
Shed

medium
Watercolour
Gouache

purpose of work
Degree illustration
project work

brief
Professional media
brief, Year 3

submitted by
Blackpool and The
Fylde College

mark holmes

7 Holly Dene
Armthorpe
Doncaster
South Yorkshire
DN3 2HJ

t. 01302 834066

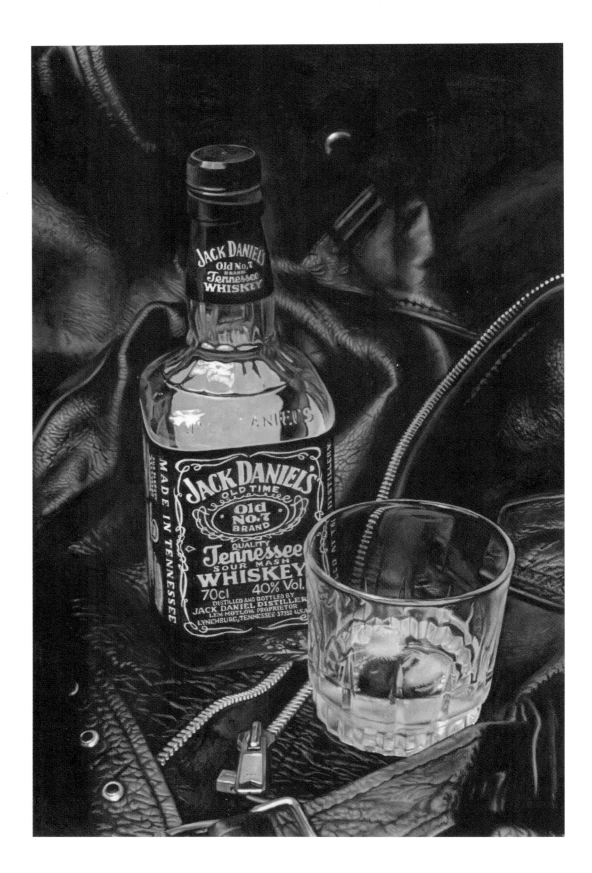

title
Still Life with Jack
Daniels and jacket

medium
Acrylic

purpose of work
Degree project
work

brief
Professional media
brief

submitted by
Blackpool and The
Fylde College

christopher jacks

35 Keswick Drive
Frodsham
Cheshire
WA6 7LT

t. 01928 732067
mobile.
07957 330322

jeremy glover

13 North Drive
High Legh
Knutsford
Cheshire
WA16 6LX

t. 01925 754834

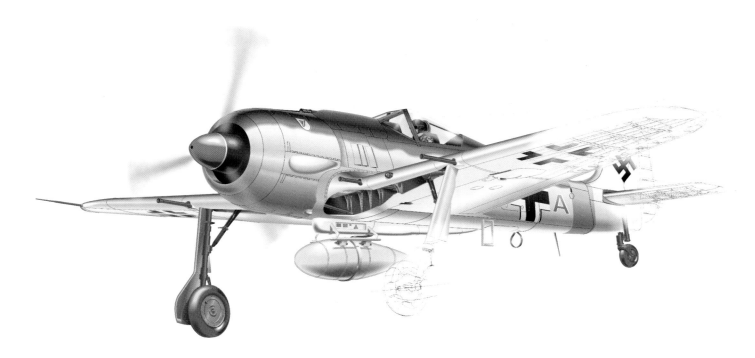

title	**brief**
Focke Wulf 190A8	Team project year
medium	two evolution of
Conventional pencil	technology
stage: rendered in	**submitted by**
Adobe Illustrator	Blackpool and The
purpose of work	Fylde College
Degree project	
work	

anne louise jennings

Domus,
Woodland Avenue
Scarisbrick
Ormskirk
Lancs
L40 9QL

t. 01704 880654
f. 01704 880654

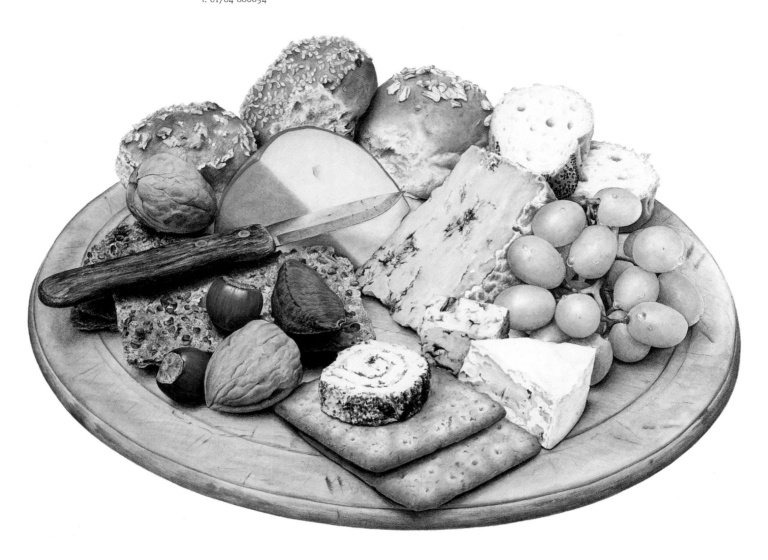

title
Still life with
cheese board

medium
Watercolour

purpose of work
Degree project
work

brief
Professional media
brief

submitted by
Blackpool and The
Fylde College

elaine kenyon

West End Farm
Ingleton
Darlington
County Durham
DL2 3HS

t. 01325 730335

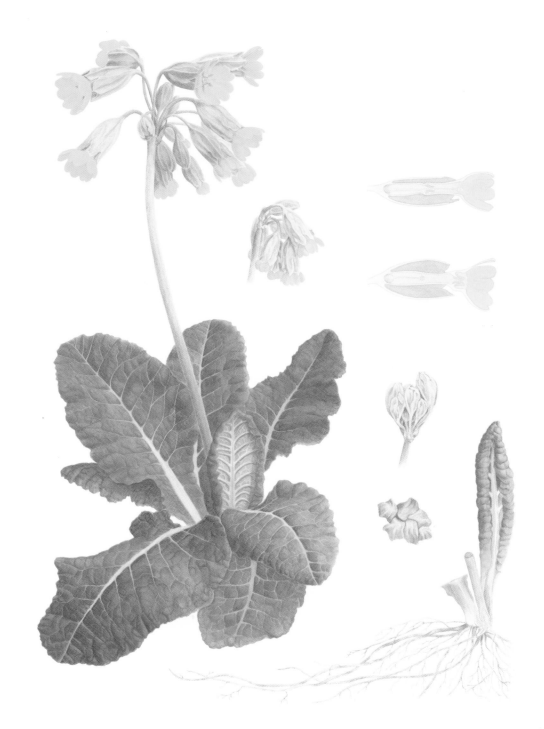

title
Cowslip

medium
Watercolour and
gouache

purpose of work
BA (Hons) Degree
project work

brief
Botanical - exam
project

submitted by
Blackpool and The
Fylde College

jonathan latimer

92 Swinley Road
Wigan
Lancs
WN1 2DL

t. 01942 230502

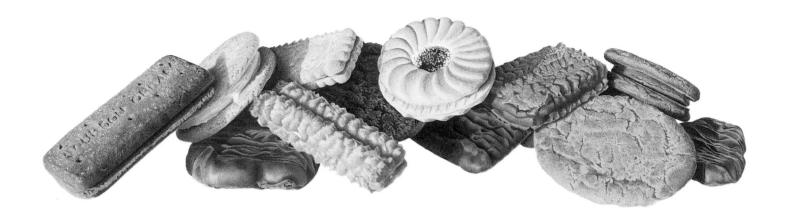

title
Biscuits

medium
Acrylic

purpose of work
Degree project
work

brief
Year three
professional media
brief

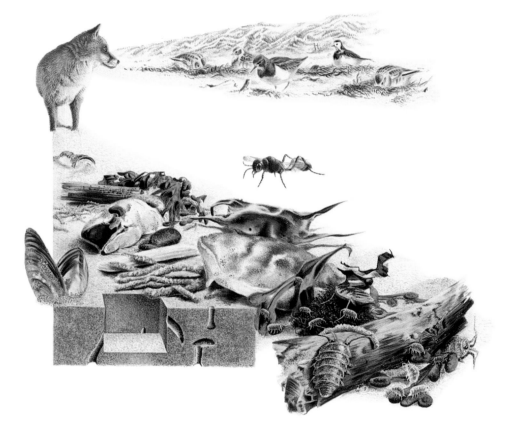

title
Strandline

medium
Acrylic

purpose of work
Degree project
work

brief
Year three final
project; Strandline
ecosystem

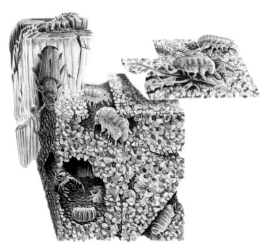

alastair miller

11 Priory Close
Deeping St. James
Peterborough
Lincs
PE6 8PR

t. 01778 342787

title
Cycle Hub

medium
Form Z Auto Des
Sys

purpose of work
Degree project
work

brief
Cut away
promotional
illustration
Winner of "The
Form Z Award of
Distinction 1998" in
the category for
visualisation and
illustration

submitted by
Blackpool and The
Fylde College

stephen palmer

227 Ainsworth
Road
Radcliffe
Manchester
M26 4EE

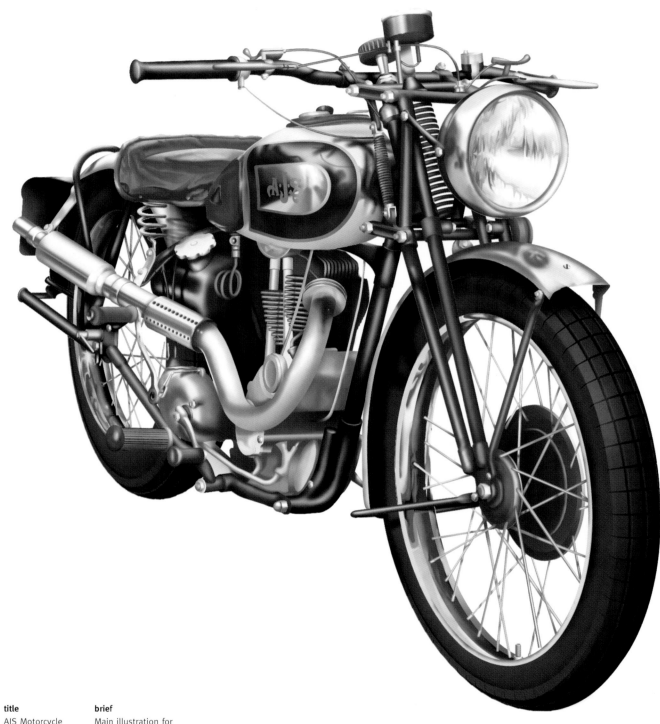

title
AJS Motorcycle

medium
Conventional pencil
stage through to
full digital

purpose of work
Degree Project
work

brief
Main illustration for
motorcycle
museum

submitted by
Blackpool and The
Fylde College

stuart rowbottom

The Grange
Haycroft Lane
Fleet
Nr. Holbeach
Spalding
Lincs
PE12 8LB

t. 01406 424005

title
Shimano Gear
System
medium
Digital: Illustrator
and Photoshop
purpose of work
Degree project
work
brief
Form and function
brief: editorial/
promotional
information
illustration poster
submitted by
Blackpool and The
Fylde College

title
Architectural visual
medium
Auto Des Sys Form
Z Renderzone
purpose of work
Degree project
work
brief
Visualization of
proposed building
evolution of
technology brief
submitted by
Blackpool and The
Fylde College

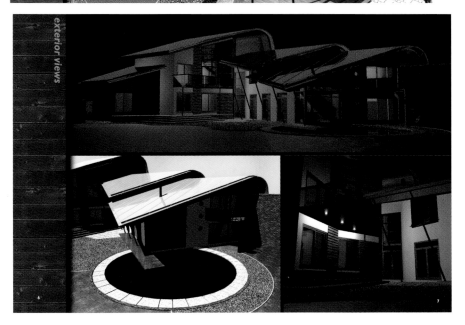

title
Architectural visual
medium
Auto Des Sys Form
Z Renderzone
purpose of work
Degree project
work
brief
Visualization of
proposed building
evolution of
technology brief
submitted by
Blackpool and The
Fylde College

william smith

24 Merton Road
Daventry
Northants
NN11 4RR

t. 01327 705331

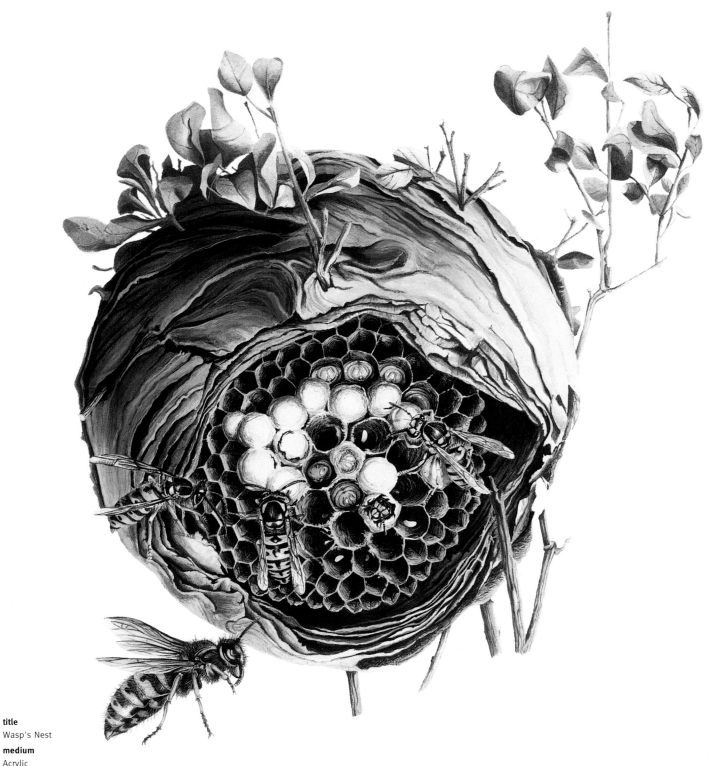

title
Wasp's Nest
medium
Acrylic
purpose of work
Degree project
work
brief
Final project
submitted by
Blackpool and The
Fylde College

brian turner

63 Honeybourne
Belgrave
Tamworth
Staffs
B77 2JG

title
Power Transfer
Gearbox

medium
Auto Des Form Z
Render
Zone/Photoshop

purpose of work
Degree project
work

brief
Promotional
information poster

submitted by
Blackpool and The
Fylde College

martin wilcock

213 Brownhill Drive
Blackburn
Lancashire
BB1 9SB

t. 01254 245742

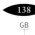

138
GB

title
Hay Meadow

medium
Watercolour

purpose of work
Degree project
work

brief
Live project -
Northern Hay
Meadows

submitted by
Blackpool and The
Fylde College

andrew wood

78 Warwick Road
Alkrington
Middleton
Manchester
M24 1HX

t. 0161 653 3955

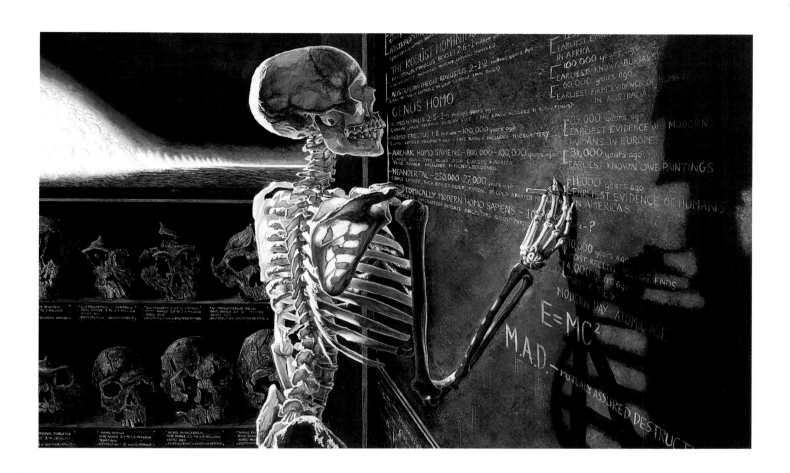

title
Skeleton

medium
Acrylic

purpose of work
Degree project
work

brief
Evolution

submitted by
Blackpool and The
Fylde College

jean hawke

16 St Michael's
Close
Aylsham
Norwich
Norfolk
NR11 6HA

t. 01263 732693
f. 01263 732693

title
Worstead Station

medium
Pen and ink and
watercolour wash

purpose of work
Illustration

brief
To show the quality
of the building in
its environment

title
Buckinghamshire
Arms, Blickling

medium
Pen and ink and
watercolour wash

purpose of work
Illustration

brief
To show the quality
of the building in
its environment

title
Blickling Orangery

medium
Pen and ink and
watercolour wash

purpose of work
Illustration

brief
To show the quality
of the building in
its environment

annabel milne

Grooms Cottage
Elsenham Hall
Hertfordshire
CM22 6DP

t. 01279 814923
f. 01279 814962

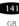

title
31 - 40 weeks

medium
Pencil and
watercolour

purpose of work
To illustrate the
HEA Pregnancy
Book

brief
To show the baby
in the mother's
womb at 31-40
weeks with basic
anatomy

commissioned by
Susan Jilanee

company/client
Health Education
Authority

chris orr & associates

Royal Mail House
11 Portland Street
Southampton
SO14 7EB

t. 01703 333 991
f. 01703 333 995

title
Petrograd Fortress,
St Petersburg
Street by Street

medium
Line and
watercolour wash

purpose of work
3D aerial
illustration for a
travel guide

brief
Accurate detailed
aerial view of given
area to include
listed sites and
walk routes - visit
site, research and
photograph and
produce illustration
in studio

illustrator
Mark Powell, Adam
Finch and Chris Orr

commissioned by
Marisa Renzullo

company
Dorling Kindersley
Adult

client
Eye Witness Travel
Guides

title
The Kremlin,
Moscow Street by
Street

medium
Line and
watercolour wash

purpose of work
3D aerial
illustration for a
travel guide

brief
Accurate detailed
aerial view of given
area to include
listed sites and
walk routes - visit
site, research and
photograph and
produce illustration
in studio

illustrator
Mark Powell and
Chris Orr

commissioned by
Marisa Renzullo

company
Dorling Kindersley
Adult

client
Eye Witness Travel
Guides

title
Beyoğlu, Istanbul
Street by Street

medium
Line and
watercolour wash

purpose of work
3D aerial
illustration for a
travel guide

brief
Accurate detailed
aerial view of given
area to include
listed sites and
walk routes - visit
site, research and
photograph and
produce illustration
in studio

illustrator
Mike Johnson,
Adam Finch and
Chris Orr

commissioned by
Kate Poole

company
Dorling Kindersley
Adult

client
Eye Witness Travel
Guides

judges

Richard Peach **design director** Conran Design Group
Christopher Corr **illustrator**
Stuart Colville **senior designer** The Ian Logan Company
Angela Porter **creative director** Interbrand Newell & Sorrell

print & design

★ **print and design section winner**
★ **winner:** *Kall Kwik Print & Design Award*

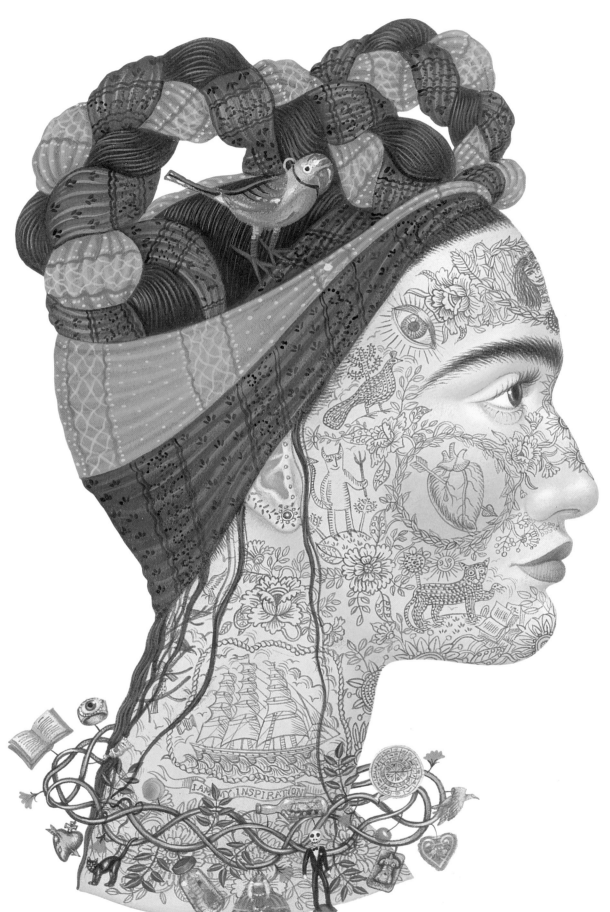

title
I am my Inspiration

medium
Acrylics

purpose of work
Promotion for
Black Book

brief
"I am my
inspiration". A
mailing for the
Black Book Call for
Entries, 1998, USA

commissioned by
Lori McDaniel
company
McDaniel Design
Inc

client
Black Book

agent
Arena
144 Royal College
Street
Camden
London
NW1 0TA
t. 0171 267 9661

ivan allen

The Drawing Room
38 Mount Pleasant
London
WC1X 0AP

t. 0171 713 5489
f. 0171 833 3064

PRINT & DESIGN

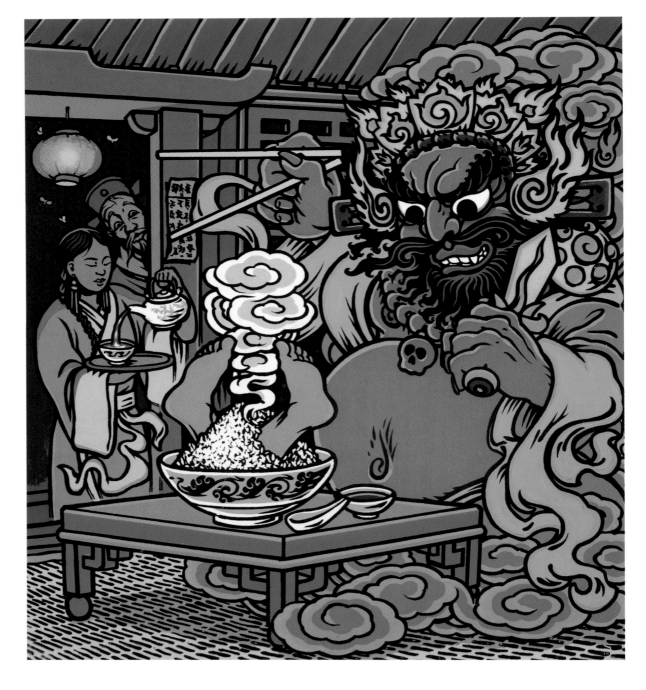

title
Two legged Mutton
medium
Acrylic on acetate
purpose of work
Promotional
calendar

brief
To illustrate fact
that in the Song
dynasty in Ancient
China some
establishments had
human flesh on the
menu, or "Two
legged Mutton"
Commissioned by
Nick Belson
company/client
Origin Design

zafer & barbara baran 47 Kings Road
Richmond
Surrey
TW10 6EG

t. 0181 948 3050
f. 0181 948 3050

title
Christmas Tree
medium
Liquid watercolour
and ink
purpose of work
Christmas-card
illustration

brief
To produce six card
designs with a
humorous twist
commissioned by
Trevor Dunton
company/client
Whistling Fish

stephen bliss

Flat 4
110 Edith Grove
London
SW10 0NH

t. 0171 352 7686
f. 0171 376 8727

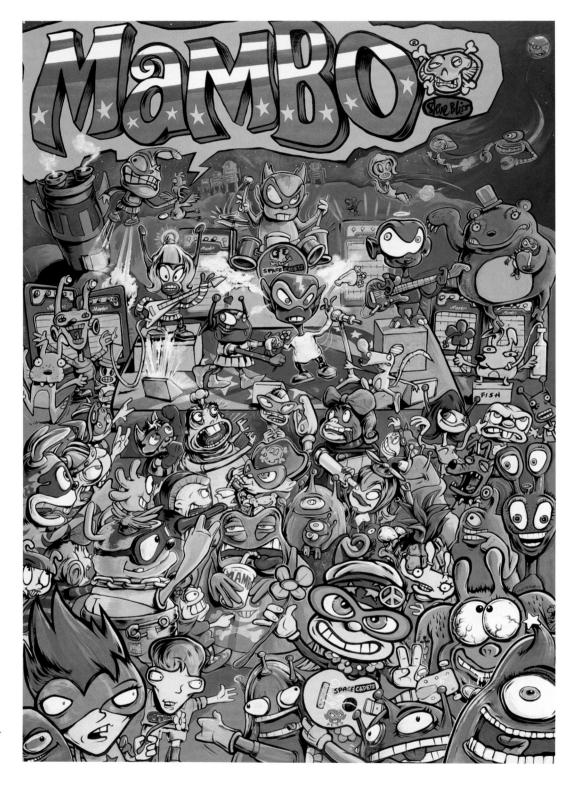

title
Return to the
Planet of the Space
Cadets

medium
Acrylic and ink

purpose of work
Poster for Mambo
fashion label,
children's range

brief
Produce a poster
to entertain and
intrigue kids - a
rock concert in
space

commissioned by
Mark Tydeman

company/client
Mambo UK

kirsten leonora burke

29 Lizban Street
Blackheath
London
SW3 8SS

t. 0181 853 5037
f. 0181 858 6409

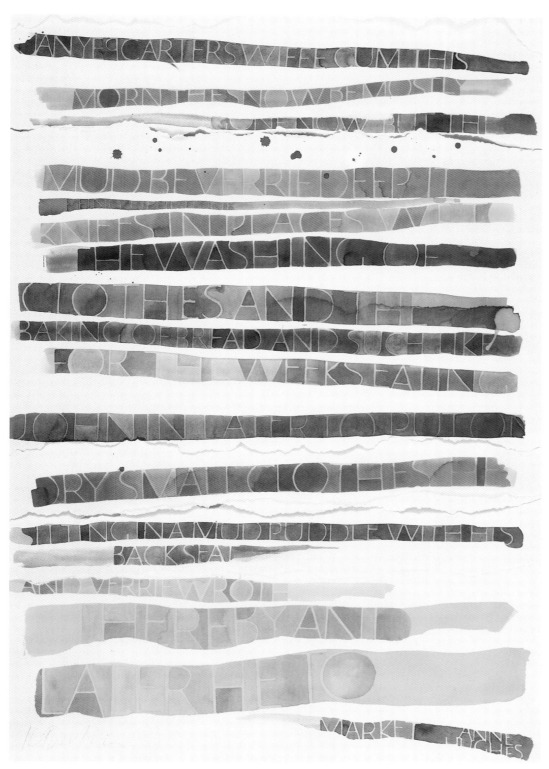

title
Diary of a Farmer's wife

medium
Food colour on printing paper

purpose of work
Enhance image of client and artist

brief
An exhibition of modern calligraphy with the theme "Food and Drink" to tour selected branches of All Bar One

commissioned by
Jeremy Spencer

company/client
All Bar One

jill calder

20 Henderson Street
Flat 3F2
Leith
Edinburgh
EH6 6BS

t. 0131 553 2986
f. 0131 553 2986
email: Jill.C@btinternet.com

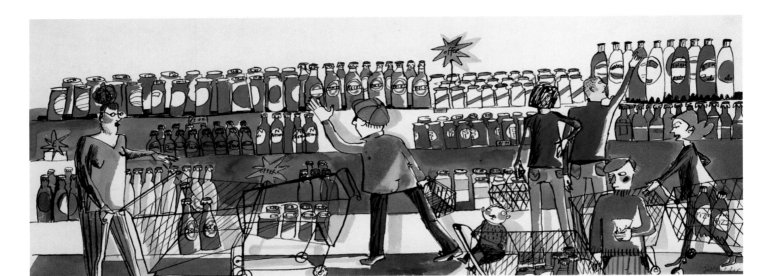

title
Beer Shopping

medium
Ink

purpose of work
How supermarkets
have the upper
hand in the alcohol
retail market

brief
To depict a
supermarket aisle
full of beer

commissioned by
Andrew Lindsay /
Steve Drummond

company
The Union
Advertising Agency

client
Scottish Courage
Brands Limited

title
Cochise

medium
Ink and pastels

purpose of work
Illustration for
menu cover

brief
To produce a
colour drawing of
an American Indian
warrior, and other
drawings/lettering
connected to that
era

commissioned by
Lucy Richards

company
Lucy Richards
Design

client
Cochise Restaurant

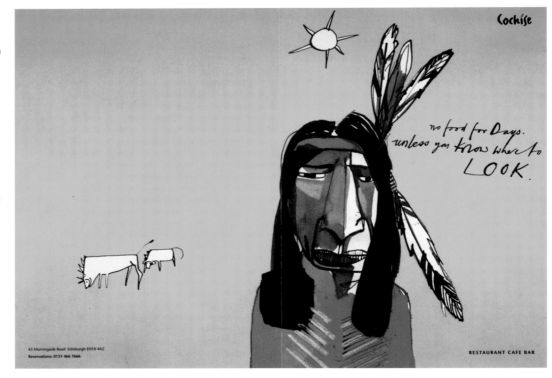

michael clark

60 St John's Grove
London
N19 5RP

t. 0171 272 8943
f. 0171 272 8943

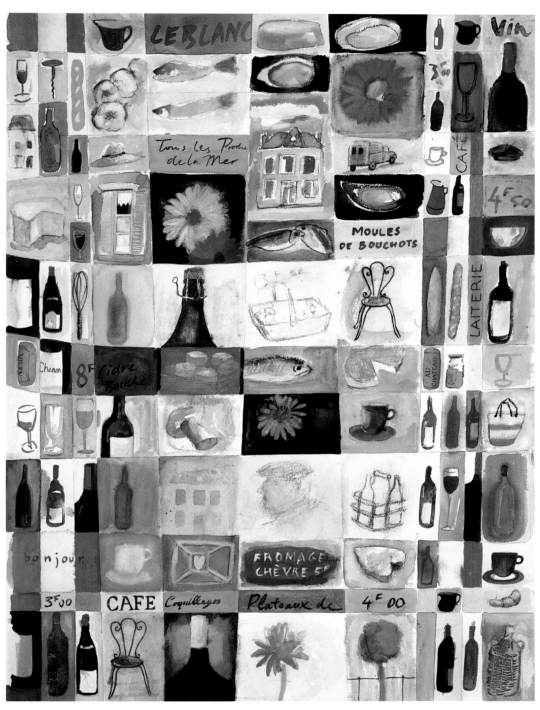

title
A Little Taste of
Normandy
medium
Watercolour on
paper
purpose of work
Birthday card /
wrapping paper

brief
To design a
birthday card and
wrapping paper
commissioned by
Julia
Woodmansterne
company/client
Woodmansterne
Publications Ltd

sarah coleman

71 Rose Cottages
Factory Road
Hinckley
Leicestershire
LE10 0DW

t. 01455 632819
f. 01455 632819
www.AOI.co.uk

GB

title
The Twelve Days of
Christmas

medium
3D / Mixed

purpose of work
Illustration for
cover of company
Christmas card

brief
A colourful but
elegant image to
reference the starry
nature of the
clients on Billy
Marsh's books,
without resorting
to tired Christmas
or theatrical
imagery

commissioned by
Jan Kennedy

company
Billy Marsh
Associates
Theatrical Agency

linda combi

17 Albemarle Road
York
YO23 1EW

t. 01904 623036
f. 01904 623036

title
Lion Splash

medium
Bromide of Splash,
pen and ink, then
silkscreen

purpose of work
Part of a paper
samples booklet

brief
The theme of the
booklet was
"anything you want
it to be".
Illustrators were
asked to interpret
and draw into an
ink splash

commissioned by
Peter Silk

company
Silk/Pearce

client
Arjo Wiggins

nelly dimitranova

Top Flat
33 Savernake Road
London
NW3 2JU

t. 0171 284 2334

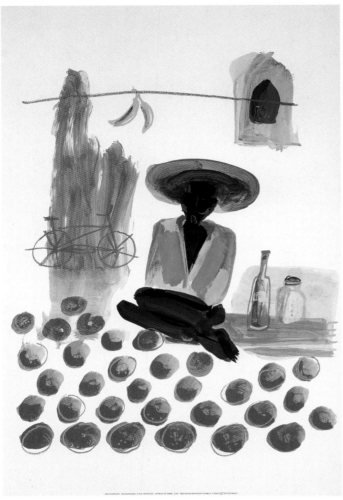

title
The Orange Seller
medium
Acrylic and crayon
purpose of work
Poster

brief
To capture the
atmosphere of
Zanzibar market.
Drawing from a
recent trip to Africa
commissioned by
Licenced by Art
Angels

company
Published by
Graphique de
France
client
Christopher
Cordingley

title
Zanzibary Fruit
medium
Acrylic
purpose of work
Poster

brief
Zanzibary fruit
inspired from a
recent trip to
Zanzibar
commissioned by
Licenced by Art
Angels

company
Published by
Graphique de
France
client
Christopher
Cordingley

title
Spring into 98
medium
Acrylic and crayon
purpose of work
Illustration for the
magazine's spring
mailing
brief
Spring 98 for the
English Heritage
commissioned by
Yuriko Kishida
company
Heritage Today

elena gomez

Stonelands
Portsmouth Road
Milford
Surrey
GN8 5DR

t. 01483 423 876
f. 01483 423 935

title
Tulip March

medium
Acrylic

purpose of work
Card design

brief
Floral card design

commissioned by
Janie Markham

company/client
The Art Group

christopher gunson

63 Sudbury Court
Allen Edwards
Drive
London
SW8 2NT

t. 0171 622 7559

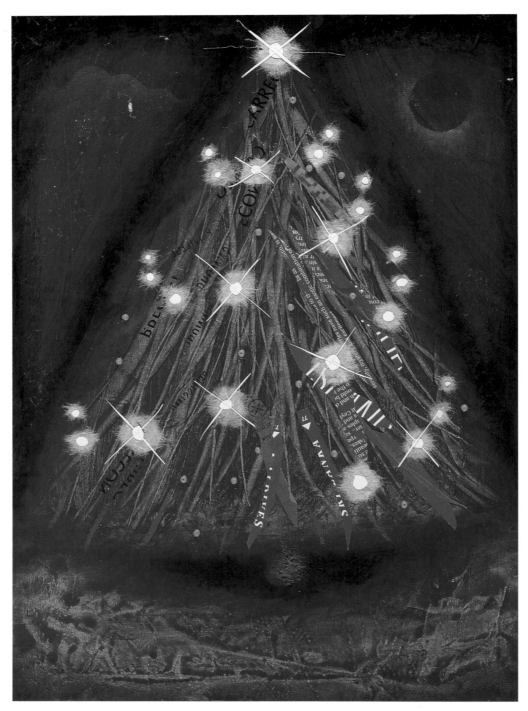

title
Christmas Tree

medium
Mixed media

purpose of work
Christmas card

brief
Open brief to produce a card design suitable for Amnestys (British section) Christmas catalogue

commissioned by
Amnesty International

jon d hamilton

No 1 Bickley Road
London
E10 7AQ

t. 0181 556 3757
f. 0181 926 3029
pager. 01523 446 401

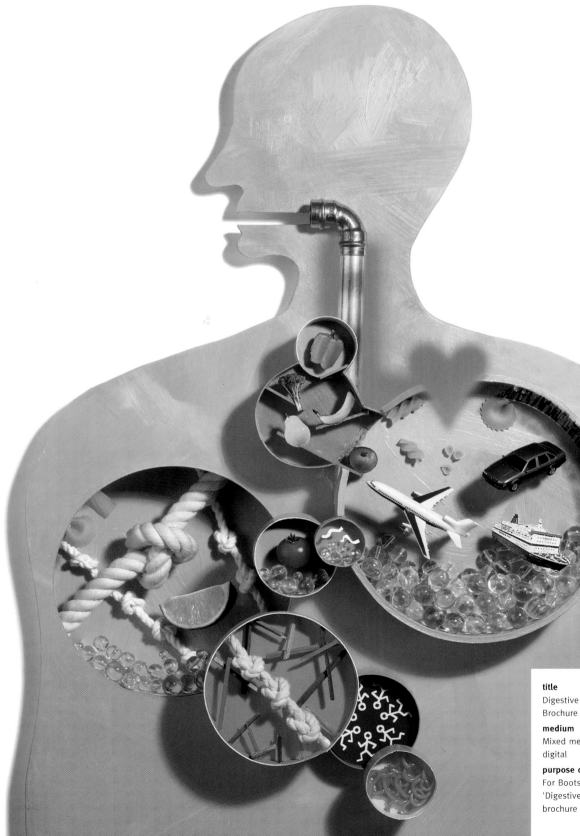

title
Digestive Care
Brochure Cover

medium
Mixed media /
digital

purpose of work
For Boots
'Digestive Care'
brochure

brief
To illustrate front
cover of Boots
'Digestive Care'
brochure showing a
wide range of
situations - travel
sickness, wind,
constipation etc in
a friendly and fun
way, yet
informative

commissioned by
Boots Design
Services

company
Boots

client
Tracey Moult

sara hayward

160
GB

Four Seasons
74 Battenhall
Avenue
Worcester
WR5 2HW

t. 01905 357563
f. 01905 357563

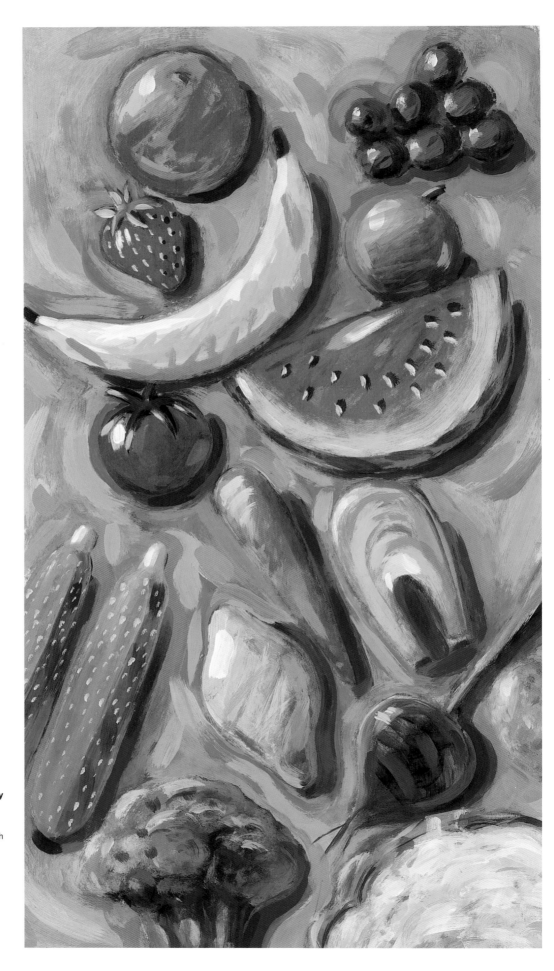

title
Diet and Arthritis

medium
Acrylic

purpose of work
Booklet

brief
'Produce an illustration for a booklet on diet and arthritis

commissioned by
Keir Windsor

company/client
Arthritis Research Campaign

ciaran hughes

33 Reservoir Road
London
SE4 2NU

t. 0171 771 0615
f. 0171 771 0615
e-mail. thebhoys@dircon.co.uk

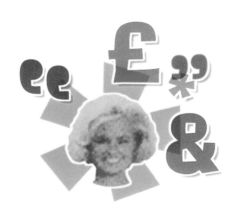

title
Surfing the Net
medium
Digital
purpose of work
Accompany an
in-house guide on
the Internet

brief
Series of
illustrations on
Internet use:
Clockwise from top
left - Getting
Started, Deadlines,
Q&A, Passwords,
Creating your own
Page, Training
Temps
commissioned by
Iva Schroeder
company
Schroeder
Communications
client
Abbey National

curtis jobling

25 Thetford Road
Great Sankey
Warrington
WA5 3EQ

t. 01925 722591
f. 01925 728468

162
GB

title
Fishbone

medium
Acrylic

purpose of work
Animation and
Greetings Card
concept

brief
Concept design for
puppet animated
series and range of
greeting cards

satoshi kambayashi

Flat 2
40 Tisbury Road
Hove
East Sussex
BN3 3BA

t. 01273 771539
f. 01273 771539

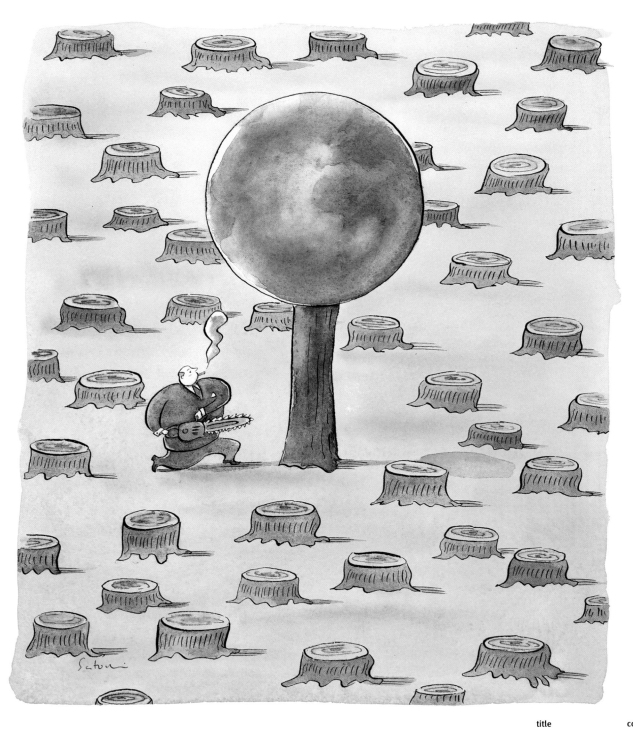

title
The Last Tree

medium
India Ink and
watercolour

purpose of work
A full page
illustration for RSA
Journal

brief
Corporate sector
does have to think
about the
environment now -
green tax may be
the answer

commissioned by
Mike Dempsey

company
CDT

client
RSA

agent
Ian Fleming
72-74 Brewer
Street
London
WIR 3PH
t. 0171 734 8701

20 Tenison Road
Cambridge
CB1 2DW

t. 01223 356645

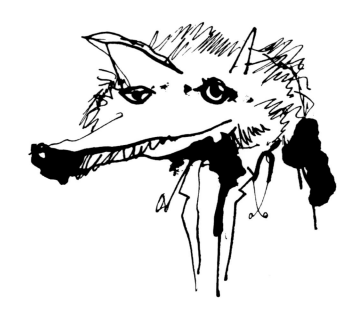

title
Four Doctor Types
medium
Indian Ink
purpose of work
Illustration to article
in the Atticus File

brief
A market research
project that
showed how
doctors can be
classified as four
types
commissioned by
David Freeman
company
Enterprise / IG
client
WPP Group plc

title
Find the Animals

medium
Wood Engraving

purpose of work
Illustration in a
paper swatch book

brief
Show that by
looking more
closely, one will
find the illustration,
like the paper it's
printed on, offers
more than meets
the eye

commissioned by
James Hewitt /
David Freeman

company
Enterprise / IG

client
Sappi Europe

Account Director
Anita Macdonald

agent
The Artworks
70 Rosaline Road
London
SW6 7QT
t. 0171 610 1801

clare mackie

21a Ursula Street
London
SW11 3DW

t. 0171 223 8649
f. 0171 223 4119

title
Happy Christmas

medium
Watercolour and
ink

purpose of work
Christmas card for
clients

brief
To produce a
Christmas card
suitable for
Matches clients

commissioned by
Ruth Chaplin

company/client
Matches

agent
Eileen McMahon
& Co
PO Box 1062
Bayonne
NY 07002 USA
t.001 201 436 4362

title
The Journal

medium
Acrylic on paper

purpose of work
For inclusion on
brochure for
Waterstones / Black
Swan Illustration
Competition

brief
To produce a
painting which
incorporates the
letter 'W'

commissioned by
Claire Ward

company
Transworld

agent
The Inkshed
98 Columbia Road
London
E2 7QB
t. 0171 613 2323

james marsh

21 Elms Road
London
SW4 9ER

t. 0171 622 9530
f. 0171 498 6851

title
Strategic Alliances

medium
Acrylic on canvas

purpose of work
Cover of brochure

brief
Open brief for subject about banks looking for ways to expand their capabilities by finding the right partners

commissioned by
John Robertson

company
Robertson Design Inc

client
Bank Director

title
Philosophy is Clarity

medium
Acrylic on canvas

purpose of work
Promotional - brochure

brief
To illustrate the title for a management brochure promotion

commissioned by
Bhandari Design, Canada

company/client
The Pinnacle Group

maggy milner

Home Farm Cottage
Westhorpe
Southwell
NG25 0NG

t. 01636 814987 / 041 051 5699
f. 01636 814987

title
Infertility
medium
Photographic
multi-image to
transparency
purpose of work
Front cover/book
jacket for the
Infertility
Companion

brief
One in six women
are infertile - use
clinical colours and
props with eggs
and flower, one
egg broken
commissioned by
Amanda McKlevie
company
Harper Collins

aileen mitchell

30H Rowley Way
London
NW8 0SQ

t. 0171 328 8671
f. 0171 328 8180

170

GB

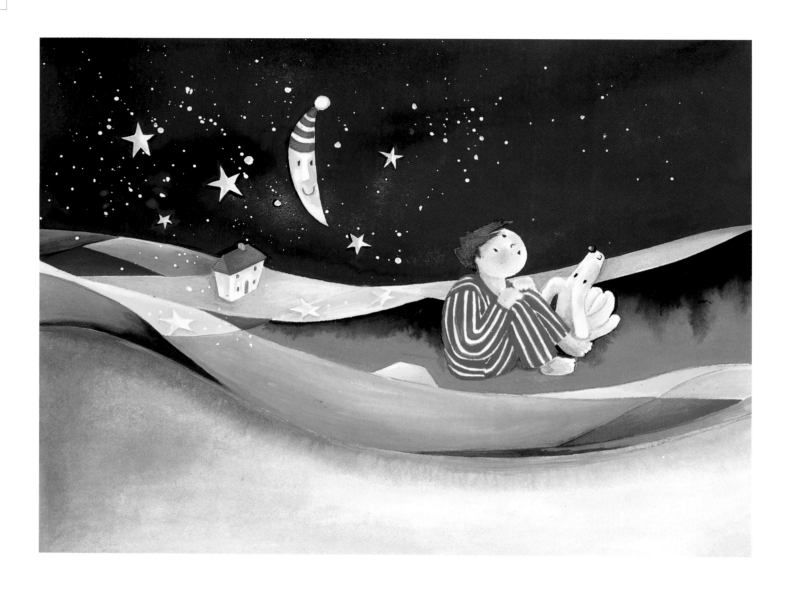

title
Dream Garden II
medium
Watercolour and
gouache
purpose of work
One of six posters
for children's
rooms

brief
Adapt book idea of
boy dreaming from
bed to landscape -
via bedspread.
Make six images
which work
separately and
together
commissioned by
Hans Kunz
company/client
Wizard & Genius

10 Essex Avenue
Dibsbury
Manchester
M20 6AN

t. 0161 448 0260
f. 0161 448 8504

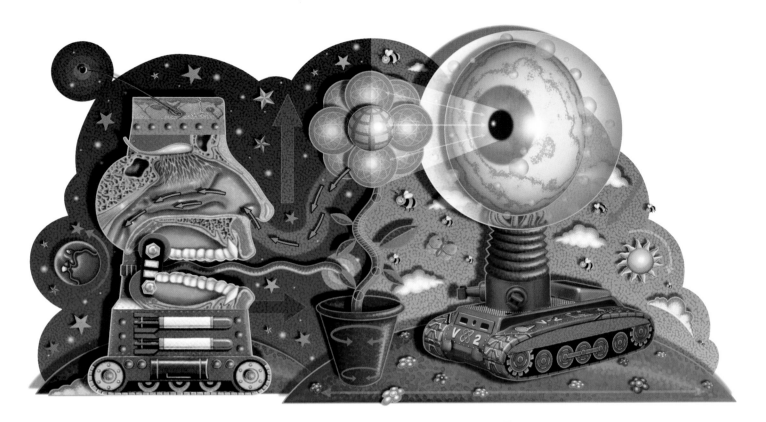

title
Sight and Smell

medium
Computer generated

purpose of work
Illustrations for software consultancy brochure

brief
Illustrate the way in which the use of business software will encourage the growth of a new business

commissioned by
Blue Bark

client
Axiom

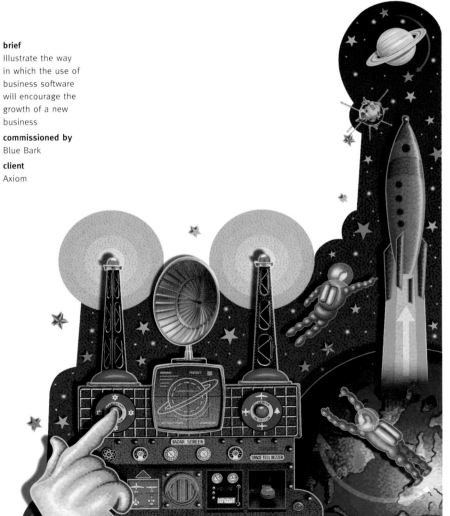

title
Future Shock

medium
Computer generated

purpose of work
Illustrations for software consultancy brochure

brief
Illustrate how business software can help the client predict business trends in the future

commissioned by
Blue Bark

client
Axiom

sarah perkins

37e Guinness Court
Snowfields
London
SE1 3SX

t. 0171 378 1510
f. 0171 357 6442

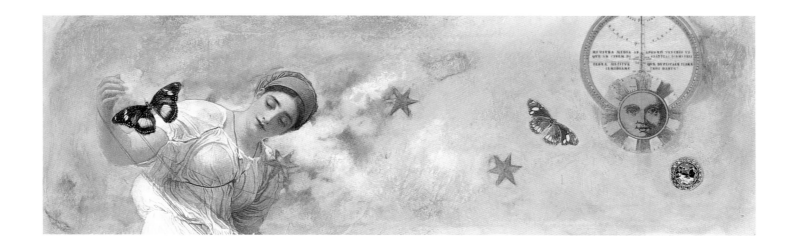

title
White Wine

medium
Mixed

purpose of work
Wine label

brief
Free - but feeling of
lightness, delicacy,
pale

commissioned by
Ernesto Aparicio

company
E. Aparicio Design

client
Domaine Saint-
Amant

agent
The Inkshed
98 Columbia Road
London E2 7QB

ingram pinn

33 Alexandra Road
London
W4 1AX

t. 0181 994 5311
f. 0181 747 8200

173
GB

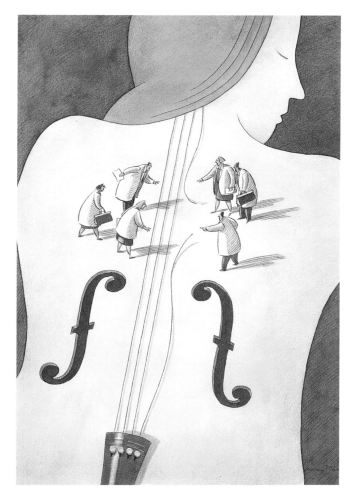

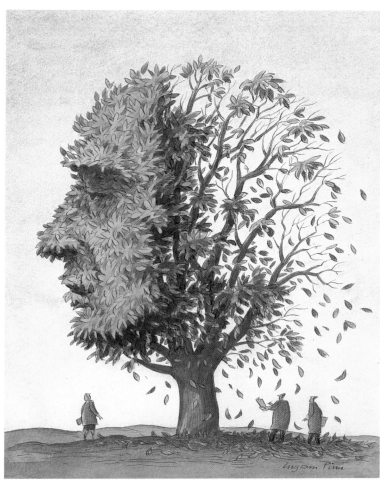

title	**brief**
Spinal Cord Injuries	To illustrate a
medium	poster promoting a
Ink, watercolour	conference on
and crayon	spinal cord injuries
purpose of work	**commissioned by**
Poster	Gabriel Maillard
	company
	IRME, Paris

title	**brief**
Alzheimer's	To illustrate a
medium	poster offering a
Ink, watercolour	grant for research
and crayon	into Alzheimer's
purpose of work	disease
Poster	**commissioned by**
	Jacqueline
	Mervaillie
	company
	Fondation Ipsen,
	Paris

ian pollock

171 Bond Street
Macclesfield
Cheshire
SK11 6RE

t. 01625 426205
f. 01625 261390

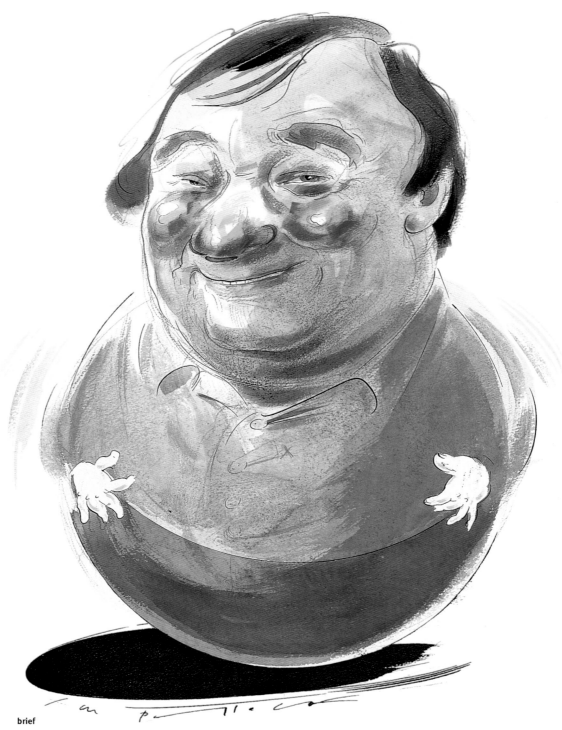

title
Bernard Manning

medium
Watercolour ink
and gouache

purpose of work
Part of title
sequence for BBC
North's "The Big
Question"

brief
Portrait of Bernard
Manning

commissioned by
BBC North

company/client
BBC North

agent
The Inkshed
98 Columbia Road
London
E2 7QB
t. 0171 613 2323

paul powis

Four Seasons
74 Battenhall
Avenue
Worcester
WR5 2HW

t. 01905 357563
f. 01905 357563

title
Golden Valley
medium
Acrylic
purpose of work
Poster print

brief
To produce a lively
painterly landscape
commissioned by
Dominic Seckleer
company
Nouvelle Images

michael sheehy

115 Crystal Palace
Road
East Dulwich
London
SE22 9ES

t. 0181 693 4315
f. 0181 693 4315

176

GB

title	**brief**
Plain Chocolate Espresso Beans	Create a character for a flavoured coffee bean to appear on packaging
medium	
Watercolour	
purpose of work	**commissioned by**
Coffee Bean Packaging	Lindsey Turnham
	company
	Ian Logan Design
	client
	Whittards of Chelsea

title	**brief**
Double Chocolate Truffle	Create a character for a flavoured coffee bean to appear on packaging
medium	
Watercolour	
purpose of work	**commissioned by**
Coffee Bean Packaging	Lindsey Turnham
	company
	Ian Logan Design
	client
	Whittards of Chelsea

michael terry

12 Bartholomew Street
Hythe
Kent
CT21 5BS

t. 01303 269456
f. 01303 269456
http. www.illustrator.org.uk/big/ilstrtrs/terry

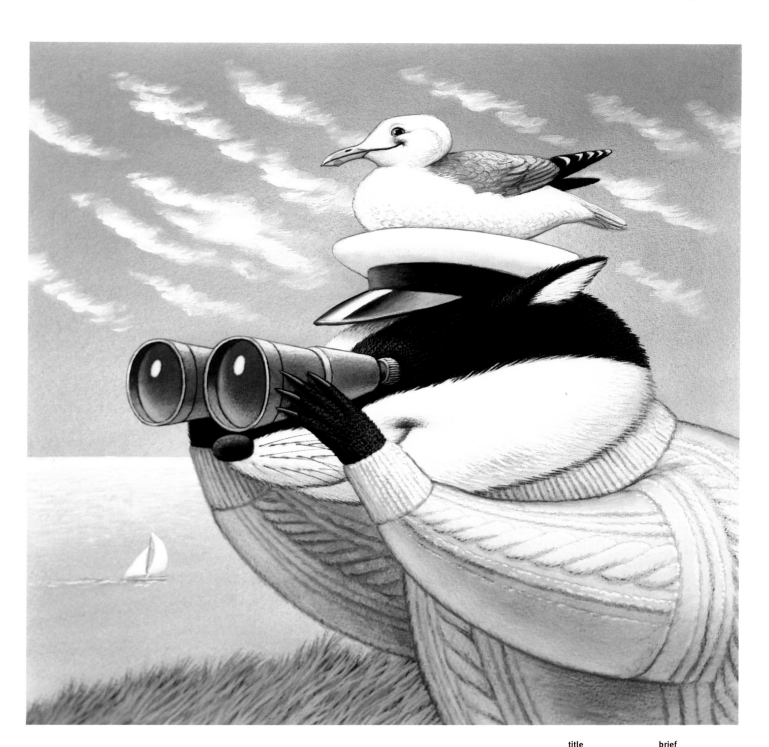

title
Badger's Watch

medium
Gouache and
coloured pencil

purpose of work
Inn Sign for
Vintage Inns

brief
To humorously
illustrate the name
"Badger's Watch"

commissioned by
Mike Tisdale

company
Sign Specialists Ltd

client
Vintage Inns

peter till

11 Berkeley Road
London
N8 8RU

t. 0181 341 0497
f. 0181 341 0497

178

GB

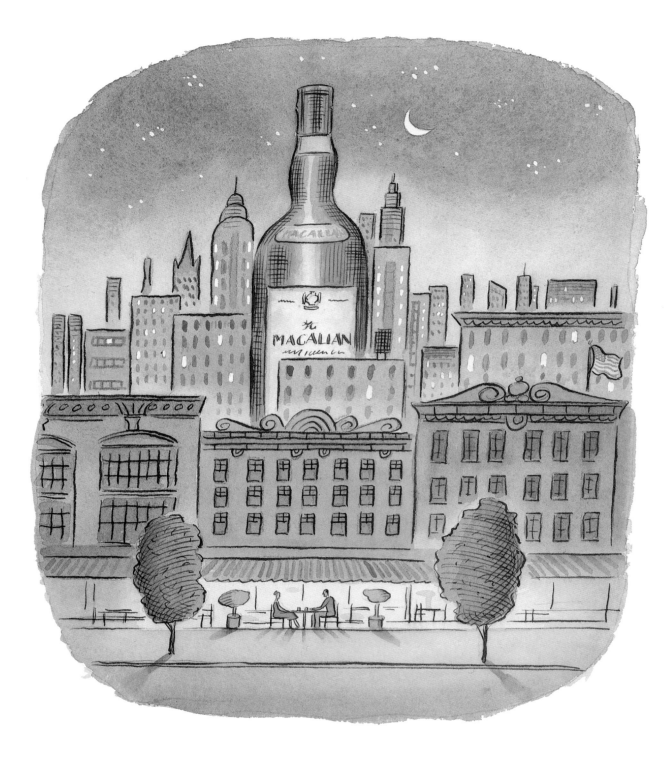

title
New York Bottle

medium
Pen, ink and
watercolour

purpose of work
Brochure
illustration

brief
Image of Macallan
in New York

commissioned by
Andrew Wolffe

company
Tayburn McIlroy
Coates

client
Macallan

russell walker

9 Sussex Road
Colchester
Essex
CO3 3QH

t. 01206 577766

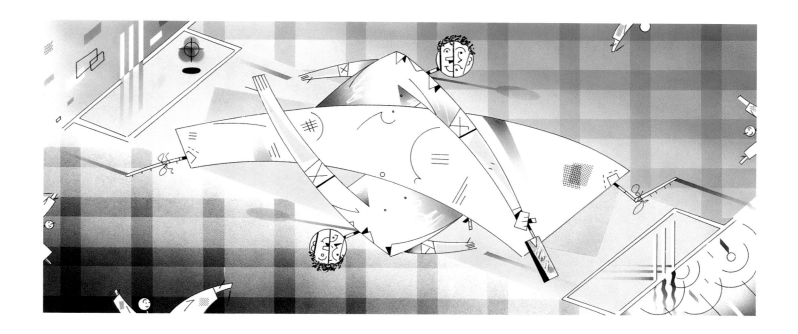

title
Run Em Up,
Run Im Out

medium
Ink

purpose of work
Contribution to
1998 Calendar

brief
To produce an
image that reflects
time of year, and
introduces the
theme of Paper
and Print

commissioned by
Douglas McArthur

client
Caledonian Paper

judges

Paul Slater **illustrator**
John Hughes **agent** London Art Collection
Dominic Finnigan **senior designer** Spy Design
Michael Mascaro **designer** Random House
Philip Davies **partner** Creative Partnership Marketing

student

stephen waterhouse

2a Norwood Grove
Birkenshaw
Bradford
West Yorkshire
BD11 2NP

t. 01274 877111
f. 01274 877111

★ **student section winner**
★ **winner:** *Hawkins Innovation Network Award*

title
The Bird Market

medium
Acrylic

purpose of work
Book written and illustrated for the Macmillan Children's book prize

brief
To create illustrations with an emphasis on the appeal of the work to children, strong colour, good composition skills and an ability to match pictures with text

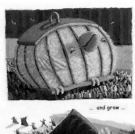

... and grow ...

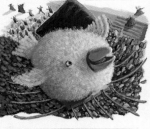

until the cage could not hold him any longer.

Grasping his chance for freedom, he made a joyful sound and flapped his wings towards the other birds.

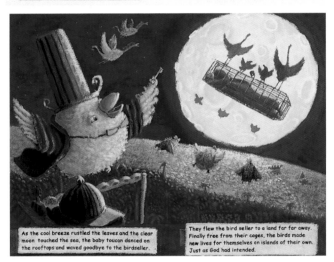

As the cool breeze rustled the leaves and the clear moon touched the sea, the baby toucan danced on the rooftops and waved goodbye to the birdseller.

They flew the bird seller to a land far far away. Finally free from their cages, the birds made new lives for themselves on islands of their own. Just as God had intended.

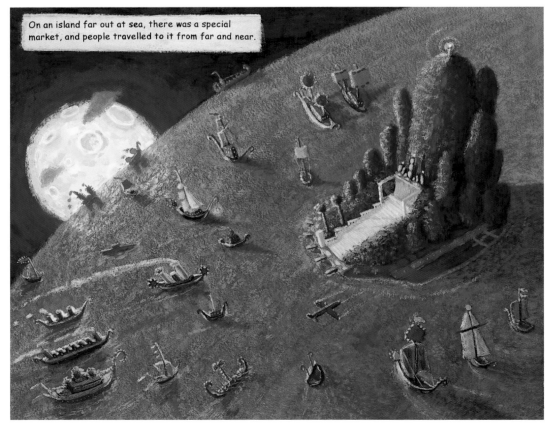

On an island far out at sea, there was a special market, and people travelled to it from far and near.

stephen waterhouse

2a Norwood Grove
Birkenshaw
Bradford
West Yorkshire
BD11 2NP

t. 01274 877111
f. 01274 877111

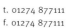

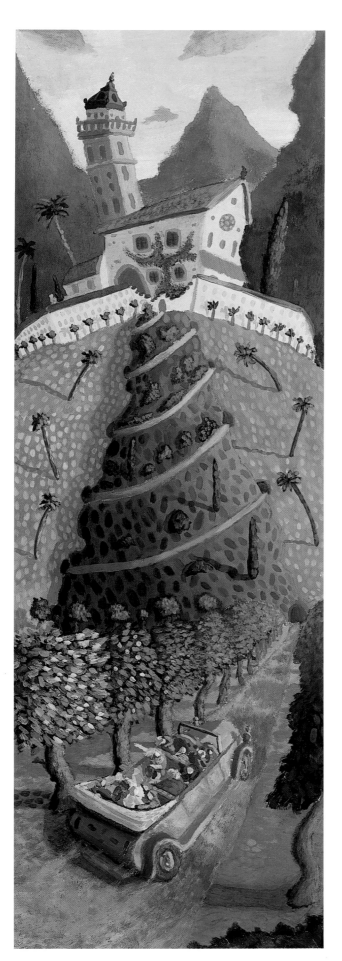

title
The High, Winding Road to Valldemossa in Majorca

medium
Acrylic

purpose of work
Advertising

brief
To create an image with warm vibrant colours and a diverse composition, for use upon a travel brochure, advertising trips around the Balearic islands

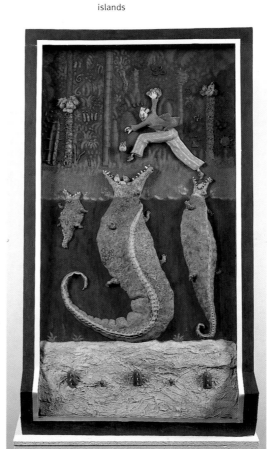

title
A Willingness to Play is a Pre-condition to Creativity

medium
Mixed Media

purpose of work
Self promotional - Development from Editorial

brief
To explore the transformation from two dimensional imagery to low relief, with an emphasis on form, texture and design

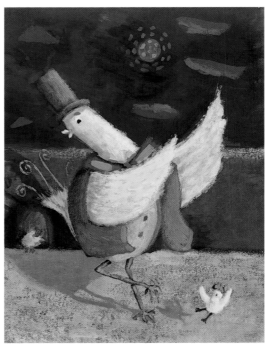

title
Learning to Dance

medium
Acrylic

purpose of work
A series of illustrations for a children's book

brief
To produce a number of spot illustrations for a book about the relationships between mothers and their children

stephen waterhouse

2a Norwood Grove
Birkenshaw
Bradford
West Yorkshire
BD11 2NP

t. 01274 877111
f. 01274 877111

184
GB

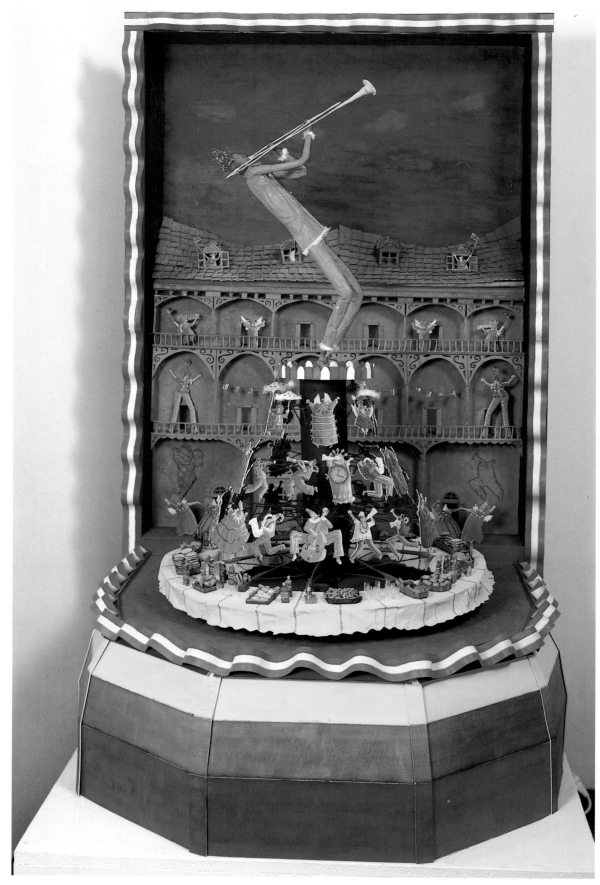

title
The Mardi Gras Jazz
Festival

medium
Mixed Media

purpose of work
Advertising

brief
To produce a three
dimensional
moving model, to
advertise this
prestigious event,
using a diversity of
shape, size, form
and media.

richard calvert

Cheltenham and Gloucester
College of Higher Education

Little Beech Oast
Penhurst
Nr Battle
East Sussex
TN33 9QS

t. 01424 772883
f. 01424 775156

185
GB

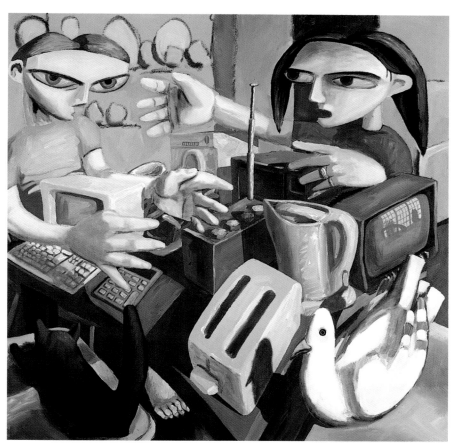

title
Kitchen Table
Discussion
medium
Acrylic and paint
stik on canvas
purpose of work
Personal
promotional work

brief
To portray a
relationship,
perhaps
relationships in
general

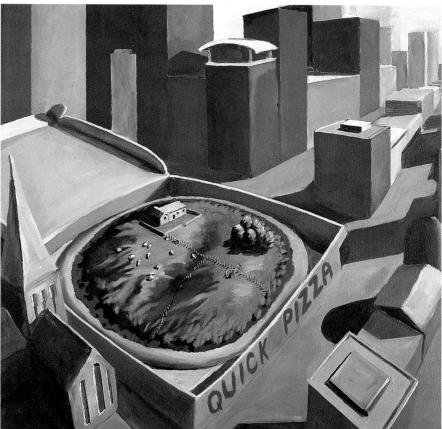

title
The Day the Earth
Stood Still
medium
Acrylic and paint
stik on canvas
purpose of work
Personal
promotional work

brief
To illustrate how
callously we treat
our precious
natural resources

jonathan cusick

10 Wynyates
Sageside,
Tamworth
Staffordshire
B79 7UP

t. 01827 50003
f. 01827 50003

title
The Three Wise
Men
medium
Acrylics
purpose of work
Christmas card

brief
To produce a
seasonal card while
suggesting
directions available
in art education at
Birmingham
Institute of Art and
Design
tutors
Andrew Kulman &
Patrick Mortemore
University of
Central England in
Birmingham

title
Old Tractors and
the Men who Love
them
medium
Acrylics & ink
purpose of work
Book jacket

brief
To produce a cover
for a book titled
"Old Tractors and
the Men who Love
them"
tutors
Andrew Kulman &
Patrick Mortemore
University of
Central England in
Birmingham

title
Ouch !
medium
Acrylics
purpose of work
Hasbro advertising
('Operation')

brief
To create
emotional exciting
images of multi-
cultural consumers
using Hasbro toy
products. The
images should
reflect the Hasbro
strapline "We make
fun for everyone"
tutors
Andrew Kulman &
Patrick Mortemore
University of
Central England in
Birmingham

jonathan cusick

10 Wynyates
Sageside,
Tamworth
Staffordshire
B79 7UP

t. 01827 50003
f. 01827 50003

title
Once there were
Two
medium
Acrylics
purpose of work
Self promotional

brief
Illustrate an article
about the lone twin
network
tutors
Andrew Kulman
University of
Central England in
Birmingham

jonathan cusick

10 Wynyates
Sageside,
Tamworth
Staffordshire
B79 7UP

t. 01827 50003
f. 01827 50003

188
GB

title
The King's
Instrument

medium
Acrylics

purpose of work
Self promotional

brief
To represent Elvis
Presley in an
inventive and
original way

tutors
Andrew Kulman
University of
Central England in
Birmingham

tim etheridge

Brookside
Plaistow Road
Kirdford
West Sussex
RH14 0NG

t. 01403 820458
pager. 0839 035211
e-mail. T_ETHERIDGE@hotmail.com

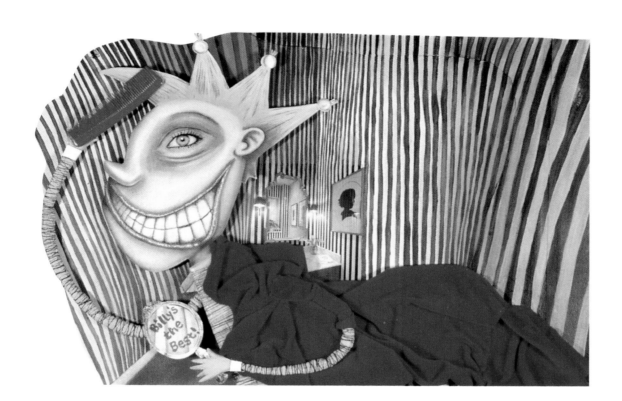

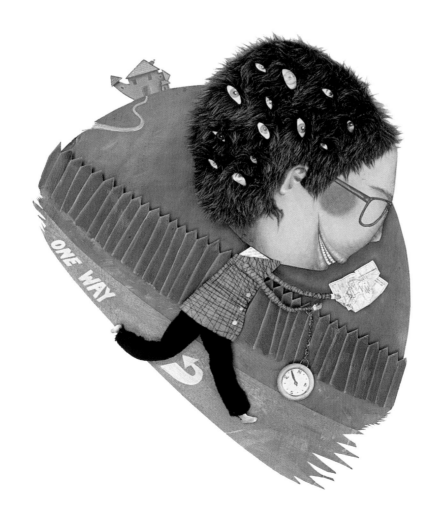

title
Ned with eyes in
the back of his
head
medium
Acrylic and collage
purpose of work
Student work
brief
To accompany a
poetry piece

title
Billy the King
medium
Acrylic and collage
purpose of work
MacMillan Prize
brief
To illustrate a 32
page children's
book

warwick fraser-coombe

16 Edensor Gardens
Chiswick
London
W4 2QY

t. 07970 179188 /
0181 580 1783

title
Quicksands:
Hunter Head

medium
Mixed media on
canvas

purpose of work
Book jacket /
poster

brief
Book jacket for
graphic novel

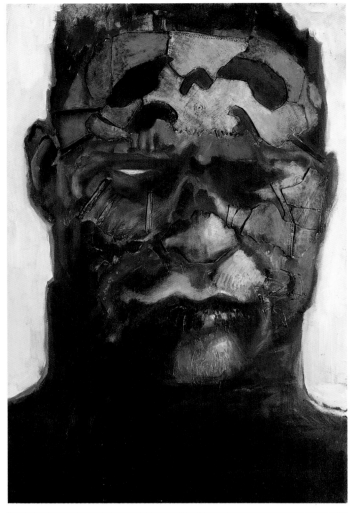

title
Executioner

medium
Mixed media on
card

purpose of work
Book jacket

brief
Book jacket for
"Death in the
Falklands"

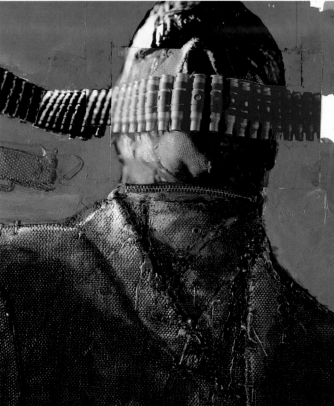

samuel hearn

6 Popham Gardens
Lower Richmond Road
Richmond
Surrey
TW9 4LJ

t. 0181 878 7453
mobile. 0958 966 218

title
A staple diet for
the overweight
medium
Drawing on acetate
purpose of work
Project at
University
brief
Article on stapling
stomachs
agent
Eastwing
98 Columbia Road
London
E2 7QB
t. 0171 613 5580

title
Joint Custody
medium
Drawing on acetate
purpose of work
Project at
University
brief
Article on life as a
butcher's son
agent
Eastwing
98 Columbia Road
London
E2 7QB
t. 0171 613 5580

richard johnson

30 Glen Way
Oadby
Leicester
LE2 5YE

t. 0116 271 3891

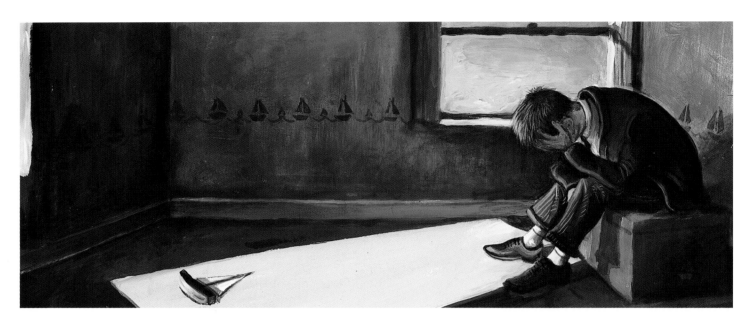

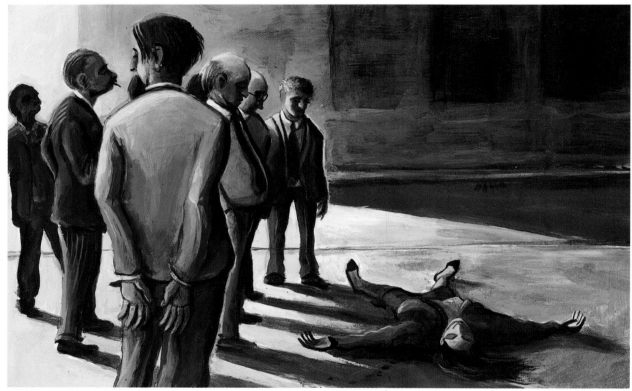

title
Murder

medium
Acrylic

purpose of work
College Project

brief
Taking life room
work into a studio
based project

title
Death in the Family

medium
Acrylic

purpose of work
College Project

brief
Studio project -
editorial

sarah lockwood

16 Christine Close
Bexhill-on-Sea
East Sussex
TN40 2RJ

t. 01424 222666

title
Scrooge and Marley
medium
Coloured pencil,
white acrylic paint
purpose of work
Interior illustrations
for Charles Dickens'
'A Christmas Carol'

brief
To produce a series
of images for 'A
Christmas Carol'
which capture the
mood and setting
of the story

saeko matsushita

c/o Furukata
13 rue Ernest Cresson
Paris 75014
France

t. 0033 1 45 43 38 17
e-mail. raizo_n@yahoo.com

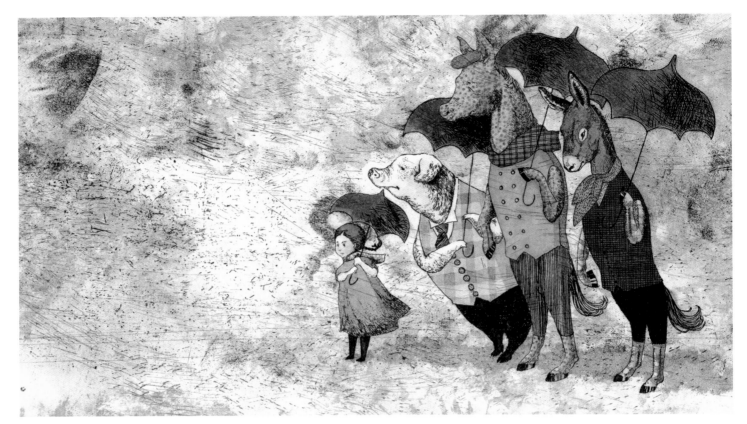

title
The Sound of the
wind blowing,
howling and
wuthering

medium
Etching and
aquatint,
watercolour

purpose of work
College work for
final assessment

brief
From the series of
imaginary drawings
based on my own
fairy tales

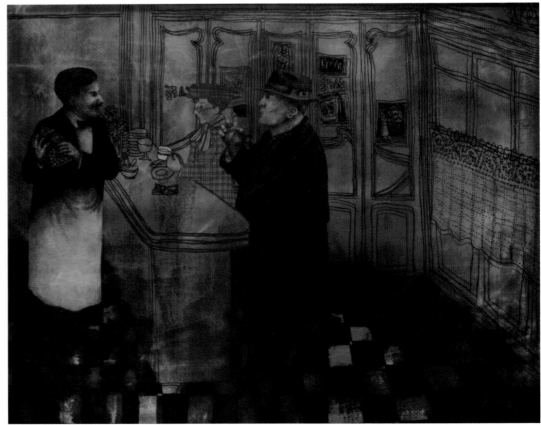

title
In the Cafè - Can I
have sugar cubes?

medium
Computer
generated

purpose of work
College work for
final assessment

brief
From the series of
imaginary drawings
based on my own
dreams

eva tatcheva

80 Waverley Road
Harrow
Middlesex
HA2 9RD

t. 0181 866 3586
f. 0181 866 3586

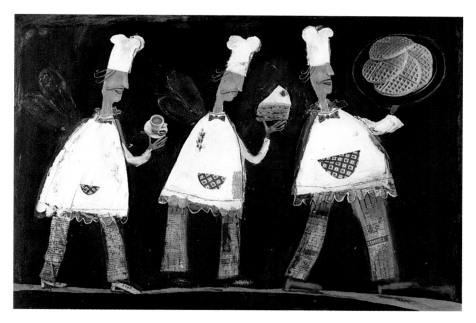

title
Piece of Cake
medium
Mixed media
purpose of work
Illustration for
article about the
diversity of young
European chefs

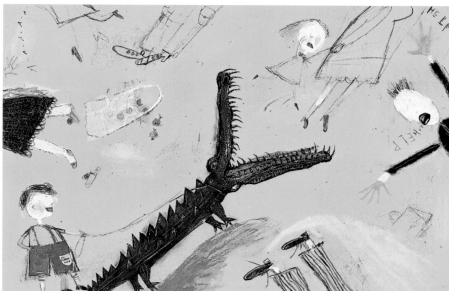

title
If I had a real
crocodile, I would
scare everybody
medium
Mixed media
purpose of work
Children's Book:
'Crocodile Friend'

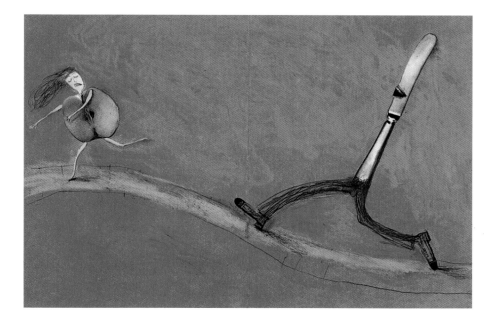

title
Forbidden Fruit
medium
Mixed media
purpose of work
Illustration for an
article on food and
sex

chitra uthaiah

41 Pearl Street
Bedminster
Bristol
BS3 3DZ

t. 0117 902 9460
e-mail. chitra_66@hotmail.com

title
Luxuriant hair is
necessary for
breeding many
children

medium
Pen and ink and
watercolour

purpose of work
Self promotional
study for end of
year show

brief
Examining the role
of Hindu women in
Indian society

title
Pâte de Fois Gras

medium
Pen and ink and
watercolour

purpose of work
Self promotional
study for end of
year show

brief
Examining the role
of Hindu women in
Indian society

title
Tilts

medium
Pen and ink and
watercolour

purpose of work
Self promotional
study for end of
year show

brief
To produce a
children's book

neil wainwright

6B The Drive
Walthamstow
London
E17 3BW

t. 0181 520 9617
f. 0181 520 9617

title
Metropolis

medium
Graphite stick and
pencil

purpose of work
Editorial

brief
The City is a
hyperbole of
industry and wealth
but poverty is still
widespread

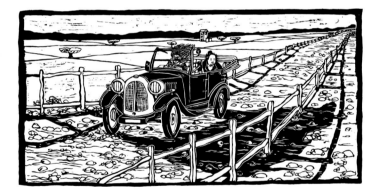

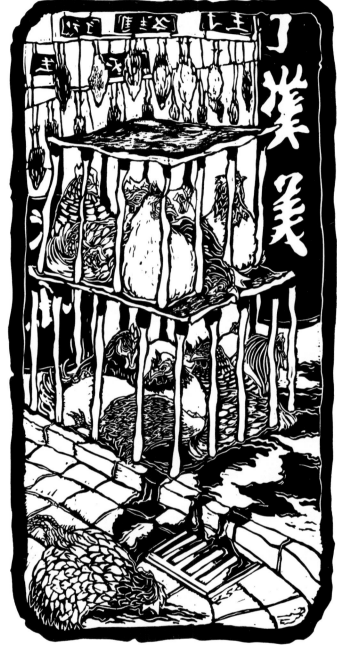

title
The Drive with Milz
Millie

medium
Lino cut

purpose of work
Publishing - book
illustration

brief
To produce
illustrations for
"The Colour
Purple" by Alice
Walker

title
Chicken Flu

medium
Lino cut

purpose of work
Editorial

brief
To accompany an
article discussing
the rise of chicken
flu in Hong Kong

mark ward

8 Clements Court
Green Lane
Hounslow
Middlesex
TW4 6EB

t. 0181 577 0308

title
Books
medium
Watercolour
purpose of work
Self promotional
brief
Self initiated
project - one of a
series of headings
for a listings
magazine

title
Music
medium
Watercolour
purpose of work
Self promotional
brief
Self initiated
project - one of a
series of headings
for a listings
magazine

annette west

c/o 6 Newham Close
Rothwell
Northamptonshire
NN14 6TT

t. 01536 710516
pager. 01523 770446

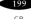
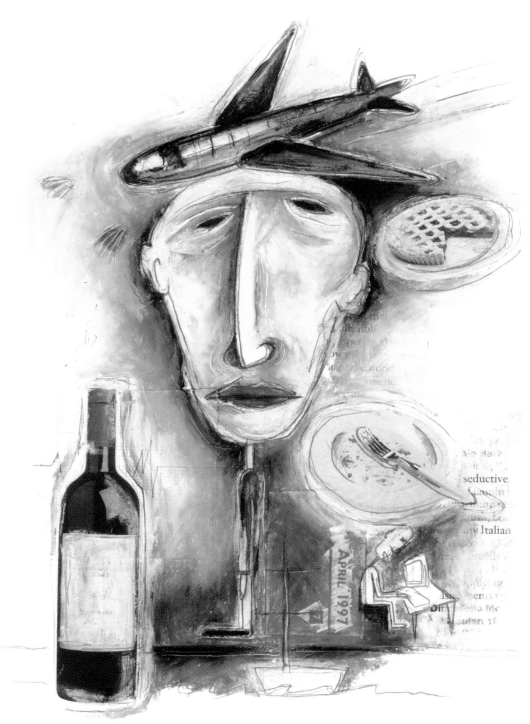

title
Fool to be Lost in
Thought
medium
Oil pastel, pencil,
collage
purpose of work
MA Project

brief
An illustration
created in response
to the following
urban haiku poem
by Nigel Young:
Fool to be lost in
thought the military
plane swoops low
and scalps me

olivia williams

12 Clarke Street
Market
Harbourough
Leicestershire
LE16 9AD

t. 01858 446218

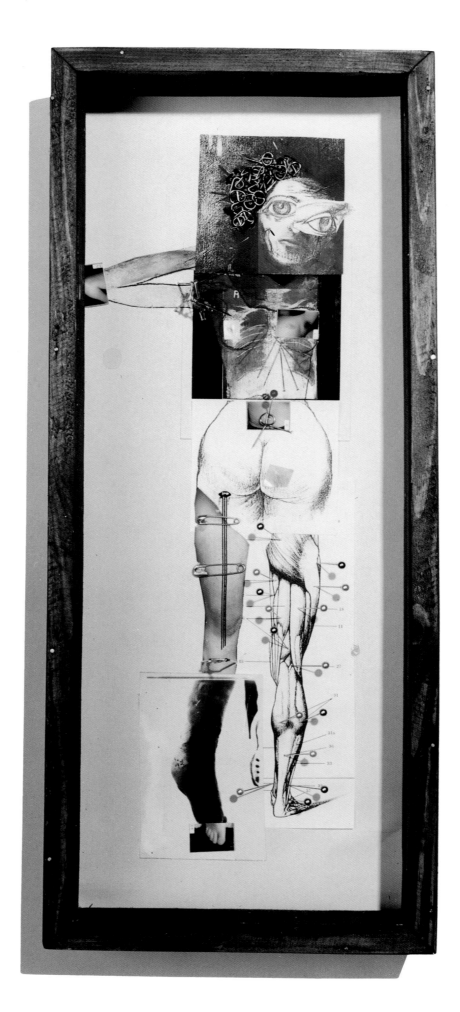

title
Enetophobia
medium
Mixed media
(photocopies/photo
graphs)
purpose of work
Final year projects

brief
To illustrate the
phobia of pins

sam wilson

Cranford
St Nicolas Avenue
Cranleigh
Surrey
GU6 7AQ

t. 01483 274602
f. 01483 274602

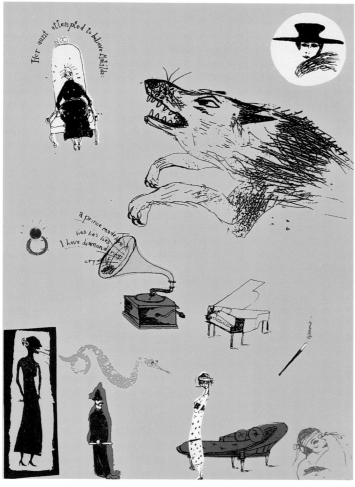

title
Matilda who told lies

medium
Screen print and collage

purpose of work
Self promotional

brief
To introduce the character, Matilda, for a short story book by Hillaire Belloc

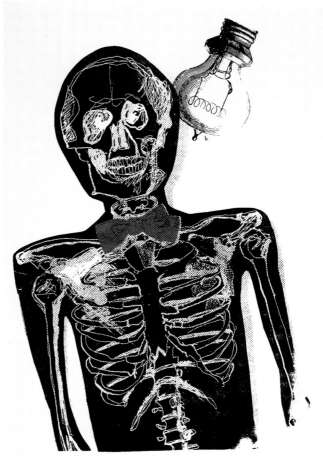

Lord Finchley tried to mend the Electric Light Himself. It struck him dead: And serve him right! It is the business of the wealthy man To give employment to the artisan.

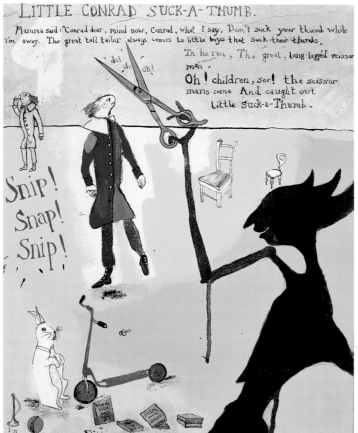

title
Little Suck-a-thumb

medium
Mixed media

purpose of work
Self promotional

brief
To illustrate the moral tale of Little Suck a Thumb by Dr Heinrich Hoffman

title
Lord Finchley

medium
Screen print and collage

purpose of work
Self promotional

brief
To illustrate the moral tale of Lord Finchley by Hillaire Belloc

paula wyatt

Stockers Farm
Stockers Farm Road
Richmansworth
Hertfordshire
WD3 1NZ

t. 01923 773763
f. 01923 773763

title
"And 3 cats
appeared"

medium
Monoprint

purpose of work
Macmillan's
Children's Book
competition

brief
Joe bangs on a tin
with a fork and
three cats
appeared

title
"Breakfast"

medium
Monoprint

purpose of work
Macmillan's
Children's Book
competition

brief
Thomas is not
impressed when
the pigs talk with
their mouths full

stuart rowbottom

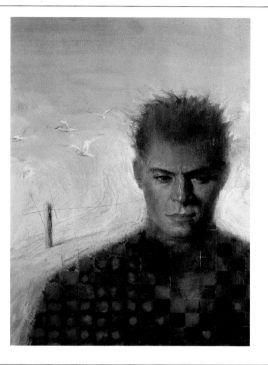

The Grange
Haycroft Lane
Fleet
Nr. Holbeach
Spalding
Lincs
PE12 8LB

t. 01406 424005

title
Ford Puma
medium
Digital: Illustrator
and Photoshop
purpose of work
Degree project
work
brief
Promotional
poster:
professional brief
submitted by
Blackpool and The
Fylde College

colin dunbar

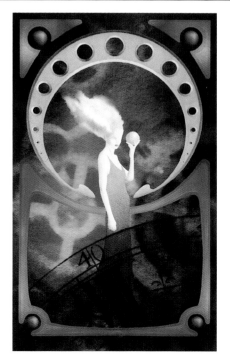

Flat 3f1
34 Barony Street
Edinburgh
EH3 6NY

t. 0131 558 1775

title
Landing Point:
Earth Beach
medium
Oil
purpose of work
Self promotional
brief
To illustrate and
write a story about
an alien's
perceptions of
earth

david mair

See Agent

title
Girl Holding a Ball
medium
Inks, watercolour
and digital
purpose of work
Learning to use
Photoshop
brief
Self promotional
agent
Sylvie Poggio
31 Crouch Hall
Road
London
N8 8HH
t. 0181 341 2722
f. 0181 374 4753

richard myers

GB

13 Cavendish
Avenue
Harrogate
North Yorkshire
HG2 8HX

t. 01423 504172

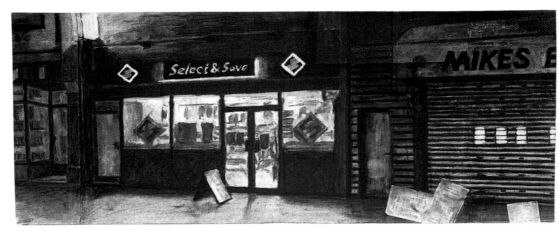

title
Select and Save by
Night
medium
Charcoal, paint,
collage
purpose of work
Self Promotional
brief
Illustrating on the
theme of
Cambridge at night

graham samuels

52 Abbey Road
Hullbridge
Hockley
Essex
SS5 6DJ

t. 01702 230296

title
Groupie
medium
Acrylic on board
purpose of work
Self promotional
brief
An illustration for
the front cover of
Groupie, a novel by
Jenny Fabian and
Johnny Byrne

nikki tadd

53 Home Ground
Westbury on Trym
Bristol
BS9 4UD

t. 0117 983 3982
pager.
04325 721281

title
Maudlin
medium
Oil paint, thread,
muslin
purpose of work
To illustrate the
poem 'Maudlin' by
Sylvia Plath
brief
Part of a series of
nine illustrations to
accompany poems
by Sylvia Plath in
the form of a book,
where importance is
placed on conveying
the emotions and
thoughts of the
poetry through the
use of colour and
space

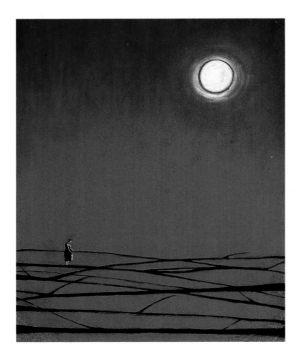

nicola taylor

26 Riffams Drive
Basildon
Essex
SS13 1BG

t. 01268 470531
mobile.
07775 668988

title
Feeding Time
medium
Colour pencil
purpose of work
Image for Oxfam
(Not commissioned)
brief
To illustrate an
Oxfam update
article, helping
people to help
themselves

laura madeleine thomas

Flat 4
106 Fore Street
Heavitree
Exeter, Devon
EX1 2RS

t. 01392 253214

title
Jack in the Box
medium
Lino-cut
purpose of work
BA Hons Degree
brief
Illustrations to
accompany
selected short
stories by Ray
Bradbury

oyvind torseter

224 Vestbugdveien
2312 Ottestad
Norway

t. + 47 918 08095

title
Me. In my room
medium
Computer
generated
purpose of work
College work for
final assessment
brief
A drawing of
imaginary space
exploration of inner
landscape

rupert van wyk

130 Bethnal Green
Road
London
E2 6DG

t. 0171 613 3149

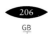

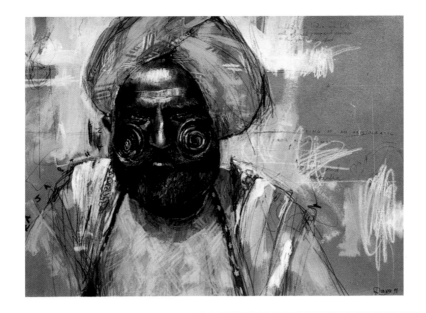

title
Colours of India
medium
Pencil, acrylics,
pastels, water
colour
purpose of work
Self promotional
brief
To show some of
the vibrancy and
colour found in
India

sarah willshaw

Knowle Top
Reapsmoor
Nr Longnor
Buxton
Derbyshire
SK17 0LL

t. 01298 84659

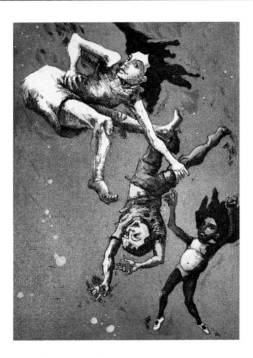

title
The Fall of
Patriarchy
medium
Etching and
aquatint print
purpose of work
A cover image for a
book of
contemporary
feminist fairy tales
brief
To produce an
image which
reflects the
changing social
position of women
in a previously
masculine
dominated society

helen wiseman

Pinkneys Manor
Wimbish
Saffron Walden
Essex
CB10 2XD

t. 01799 599788
f. 01799 599788

title
Padstow Harbour
medium
Water colour and
pen
purpose of work
Editorial /
publishing
brief
Reportage project:
illustrate the camel
trail in Cornwall

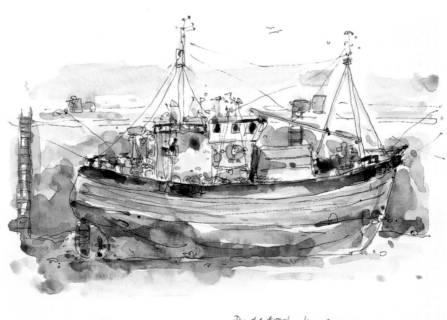

judges

Ann Howeson **illustrator**

Janet Slingsby **director** Tucker Slingsby

Sheri Safran **director** Tango Books

David Eldridge **director** The Senate

Brian Love **course leader, illustration** Kingston University

jill calder

20 Henderson Street
Flat 3F2
Leith
Edinburgh
EH6 6BS

t. 0131 553 2986
f. 0131 553 2986
email: Jill.C@btinternet.com

★ **unpublished section winner**

210
GB

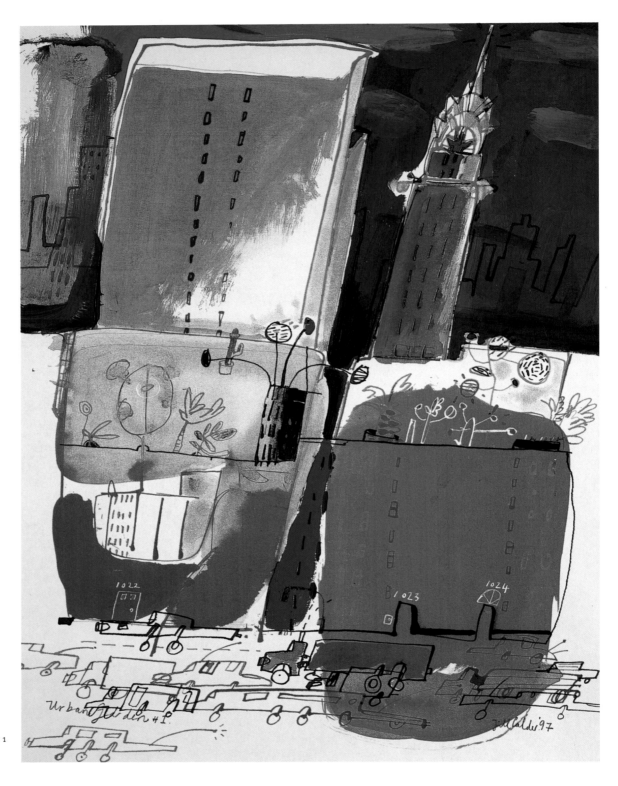

title
Urban Garden No 1
medium
Ink, Acrylic
purpose of work
Personal work
inspired by a trip
to New York City

jill calder

20 Henderson Street
Flat 3F2
Leith
Edinburgh
EH6 6BS

t. 0131 553 2986
f. 0131 553 2986
email: Jill.C@btinternet.com

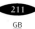

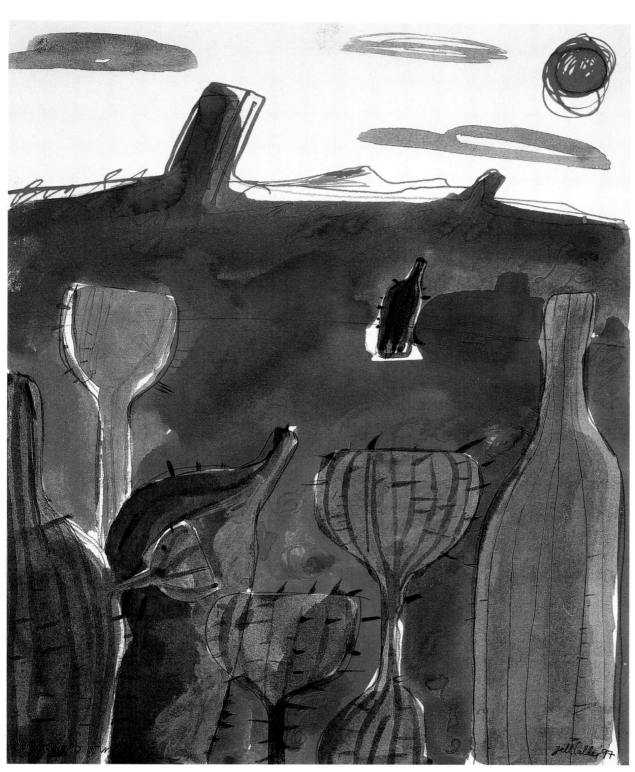

title
Saguaro Wine

medium
Ink

purpose of work
Self promotional -
experimental

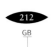

sarah black

11 Poplar Avenue
Gorleston
Gt. Yarmouth
Norfolk
NR31 7PW

t. 0966 392040 /
01493 442521
f. 01493 602854

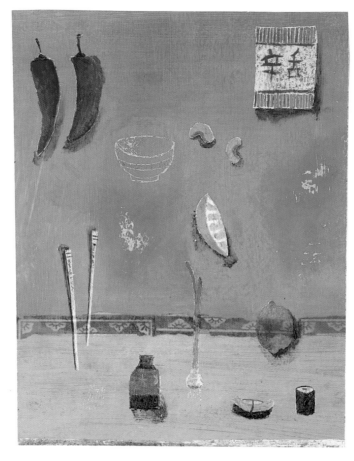

title
Japanese Cookery

medium
Oil bar, gouache,
acrylic, collage

purpose of work
Idea for cookery
book cover based
on types of
cooking

brief
Self promotional
project

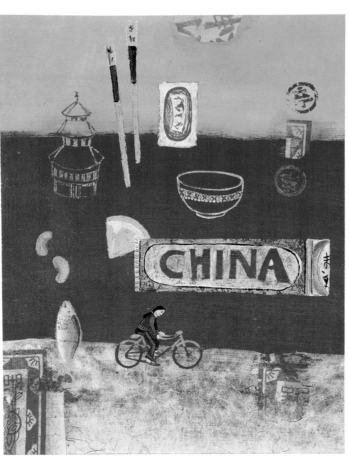

title
China

medium
Oil bar, gouache,
acrylic, collage

purpose of work
Ideas for travel or
language guides

brief
Self promotional
project

stephen bliss

Flat 4
110 Edith Grove
London
SW10 oNH

t. 0171 352 7686
f. 0171 376 8727

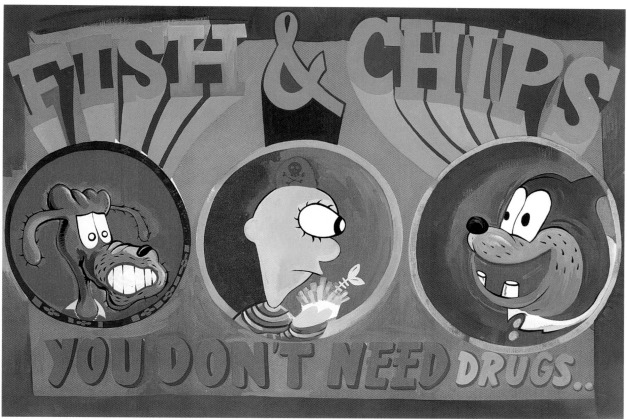

title
Fish and Chips -
You Don't Need
Drugs
medium
Acrylic on canvas
purpose of work
Self promotional -
experimental
brief
To loosen up, get
away from my
detailed paintings,
have fun

title
Kids are OK
medium
Biro, collage,
Illustrator 6 on
MAC
purpose of work
Self promotional -
experimental
brief
To try a new style
for new portfolio of
computer
generated work

nicholas borden

c/o Lower Bowbier Farm
Bampton
Tiverton
Devon EX16 9EE

t. 01398 331587
mobile. 0958 640 9360
Pager. 01523 148966

214
GB

title
Public Library
Reading

medium
Mixed media

purpose of work
Self promotional

brief
To produce an
unconventional
light-hearted image
to a subject
traditionally
thought of as
rather ordinary

title
Revenge of
Domestic
Technology

medium
Mixed media

purpose of work
Self promotional

brief
To produce an
unconventional
humorous image of
something
generally
considered ordinary

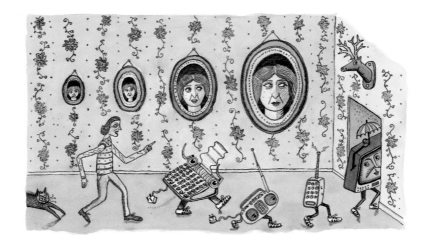

title
Pets who look like
their owners

medium
Mixed media

purpose of work
Self promotional

brief
To consider the
resemblance
between pets and
their owners

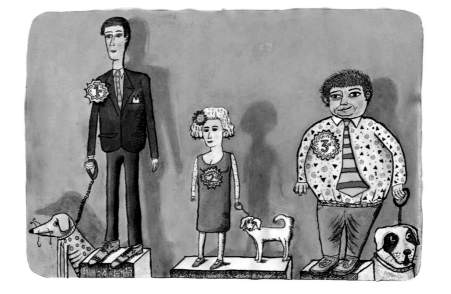

michael bramman

104 Dudley Court
Upper Berkeley
Street
London
W1H 7PJ

t. 0171 723 3564
f. 0171 723 3564

215

GB

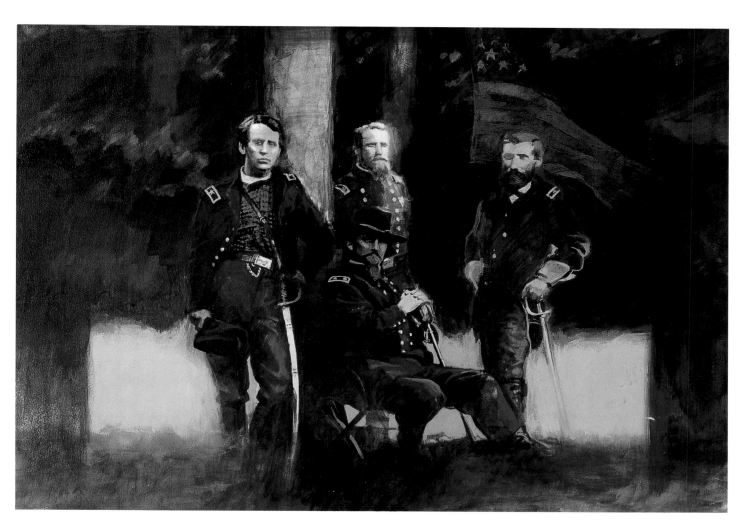

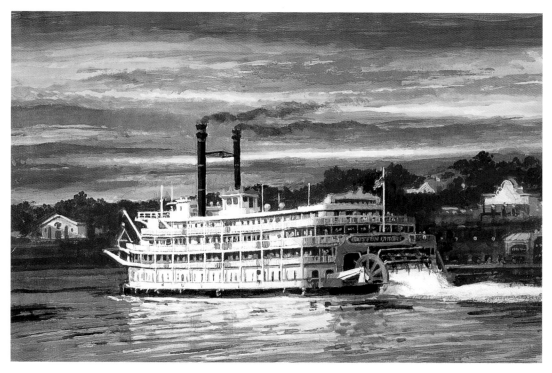

title
Blue on Green
medium
Acrylic
purpose of work
Self promotional
brief
Interpretation of
historical
photograph

title
River Boat
medium
Acrylic
purpose of work
Commissioned
sample for hotel
project
brief
Paint river boat -
summer evening

UNPUBLISHED

neil breeden

28 Vere Road
Brighton
East Sussex
BN1 4NR

t. 01273 700857
f. 01273 700857

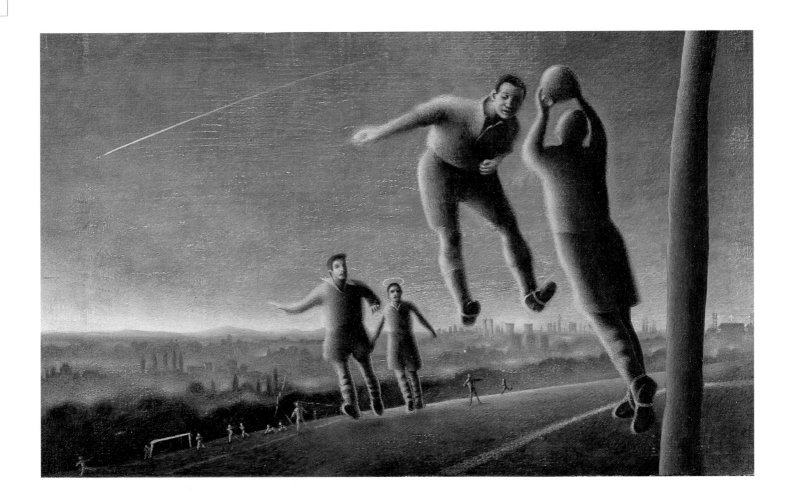

title
I Dream of Football

medium
Acrylic on wood

purpose of work
Self promotional

brief
The illustrator
sought to recreate
an image of his
lost youth spent on
the playing fields
of Birmingham

hazel natasha brook

9 Mount Pleasant
Crescent
Hastings
East Sussex
TN34 3SG

t. 01424 443541
f. 01424 447770

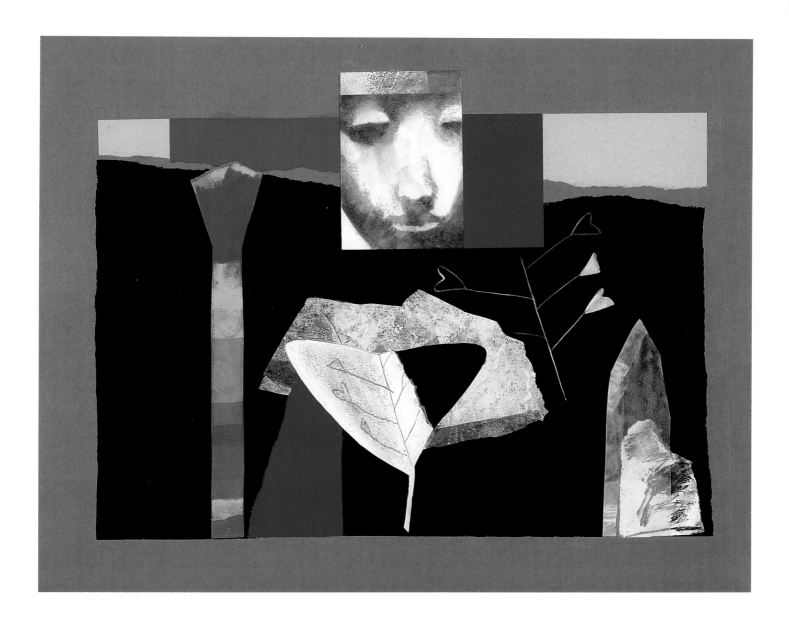

title
The Shepherd's
Purse

medium
Mixed media

purpose of work
To illustrate a
poem by Elizabeth
Smart

brief
Part of a personal
project to produce
a series of
illustrations to
environmental
poems of the 20th
Century, for a
second book
project

harriet buckley

3F2
4 Buccleuch
Terrace
Edinburgh
EH8 9ND

t. 0131 668 1511
e-mail. harriart@aol.com

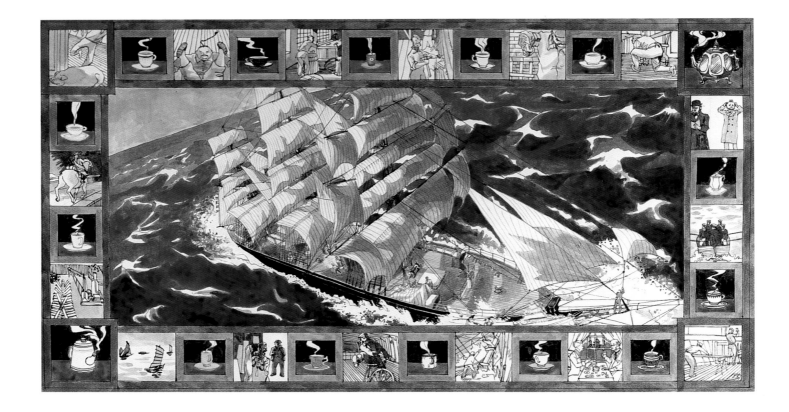

title
How they built the Cutty Sark - Endpapers
medium
Coloured inks
purpose of work
Self promotional (self-initiated picture book)

brief
Endpapers for 32-page book written and illustrated by myself, which follows each stage of building the ship Cutty Sark (keel, ribs, hull, masts, sails)

karen burke

Basement Flat
85 St Margarets Road
Twickenham
London TW1 2LJ

pager. 07666 789 435
e-mail. the2burkes@compuserve.com

219

GB

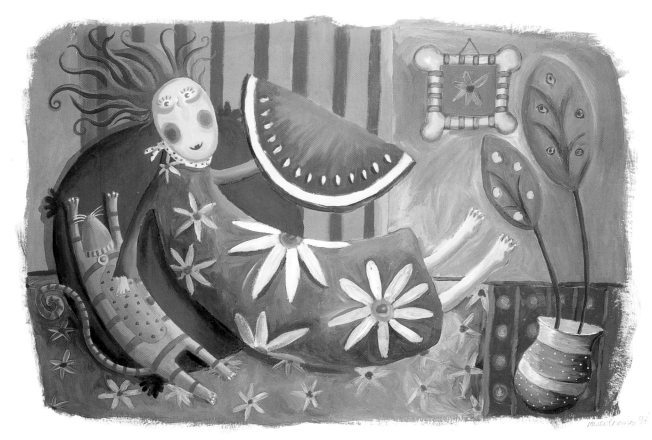

title
Melon Heaven
medium
Acrylic
purpose of work
Self promotional
brief
To produce an
image that could
be used as a
greetings card

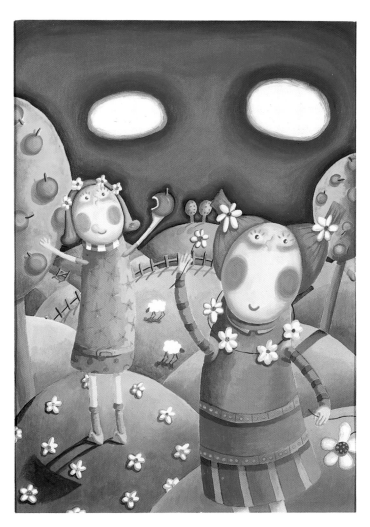

title
Daisy Chain
medium
Acrylic
purpose of work
Self promotional
brief
To produce an
image that could
be used as a
greetings card

UNPUBLISHED

steven carroll

63 Upper Craigour
Edinburgh
EH17 7SE

t. 0131 658 1975
f. 0131 658 1975

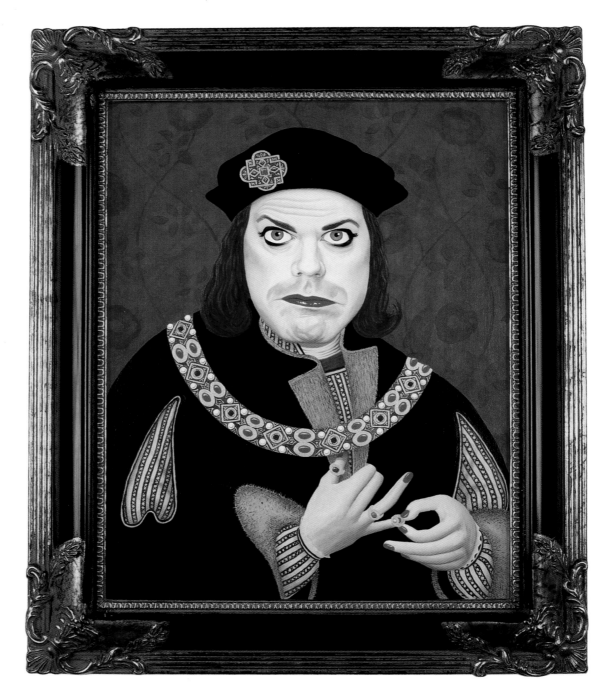

title
I wanna do Richard III

medium
Alkyd paints

purpose of work
Experimental Self promotional

brief
To portray Eddie Izzard as King Richard the third; a role in which he himself has expressed an interest.

grant carruthers

1 Woodburn House
Woodburn Place
St Andrews
Fife KY16 8LA

t. 01334 476866

title
Goodbye To Berlin
medium
Mixed (collage /
3D / photographic /
ink)
purpose of work
Unpublished
personal project

brief
To design a book
jacket for the
Christopher
Isherwood novel
"Goodbye To
Berlin"

simon john davies

16 Leicester
Crescent
Wharf View Road
Ilkley
West Yorkshire
LS29 8DX

t. 01943 608562

title
Yorkshire Dales -
wet & cool

medium
Collage

purpose of work
Speculative / Self
Promotional

brief
To present a series
of walks within the
Yorkshire Dales,
charting the
constantly changing
conditions: warm
to cold, wet to dry,
sun to snow

title
That perfect Greek
isle

medium
Acrylic

purpose of work
Speculative / Self
Promotional

brief
A travelogue
exploration seeking
that perfect Greek
isle, via the travel
brochures ("believe
me, this is the
one")

peter davies

36 Lower North
Street
Exeter
EX4 3EU

t. 01392 430174
f. 01392 430174

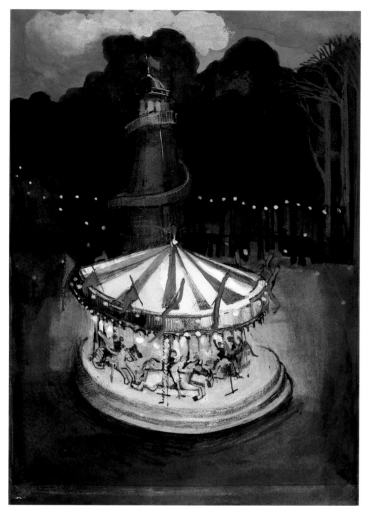

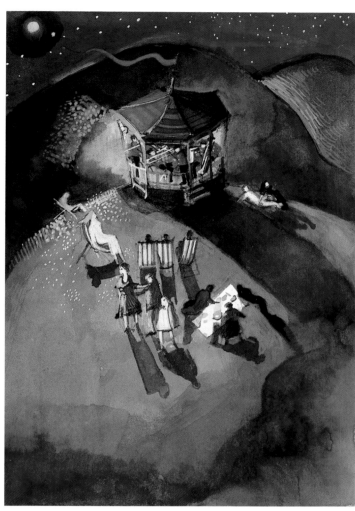

title
Merry-go-round
medium
Mixed media
purpose of work
Self promotional -
greeting cards

brief
Imagery inspired by
travelling
fairgrounds
directed
speculatively
towards the
greeting cards
market

title
The Bandstand
medium
Coloured inks
purpose of work
Self promotional -
greeting cards

brief
From a series
placing figures in
landscape directed
towards the
greeting cards
market

joanne davies

36 Lower North
Street
Exeter
EX4 3EU

t. 01392 430174
f. 01392 430174

224
GB

title
The town crier announces all productions of Topsham Amateur Dramatic Society and runs the fish van

medium
Gouache

purpose of work
MA project

brief
Page from book based on characters living in Topsham village in Devon

joanne davies

36 Lower North
Street
Exeter
EX4 3EU

t. 01392 430174
f. 01392 430174

title
Roy the Dog only
likes going for a
walk in the car
medium
Gouache
purpose of work
MA project
brief
Page from book
based on
characters living in
Topsham village in
Devon

title
Miss Dors has a
bad leg so no man
will have her
medium
Gouache
purpose of work
MA project
brief
Page from book
based on
characters living in
Topsham village in
Devon

nick dewar

UK
Eastwing
98 Columbia Road
London
E27 QB

t. 0171 613 5580
f. 0171 613 2726

USA
Kate Larkworthy
Apt 4D
32 Downing Street
New York 10014

t. 001 212 633 1310
f. 001 212 633 1310

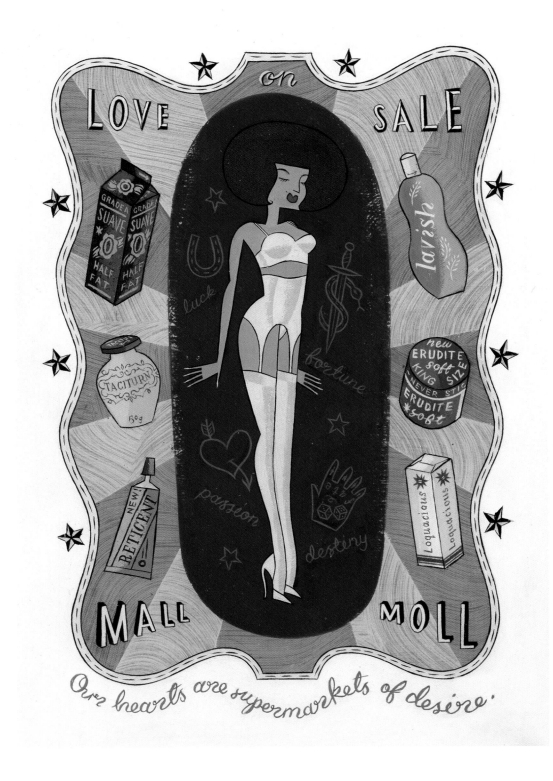

title
Mall Moll

medium
Acrylic

purpose of work
Promotional in USA

heidi donohoe

16 Ellenborough Close
Bracknell
Berkshire
RG12 2NB

t. 01344 867631
mobile. 07771 698772

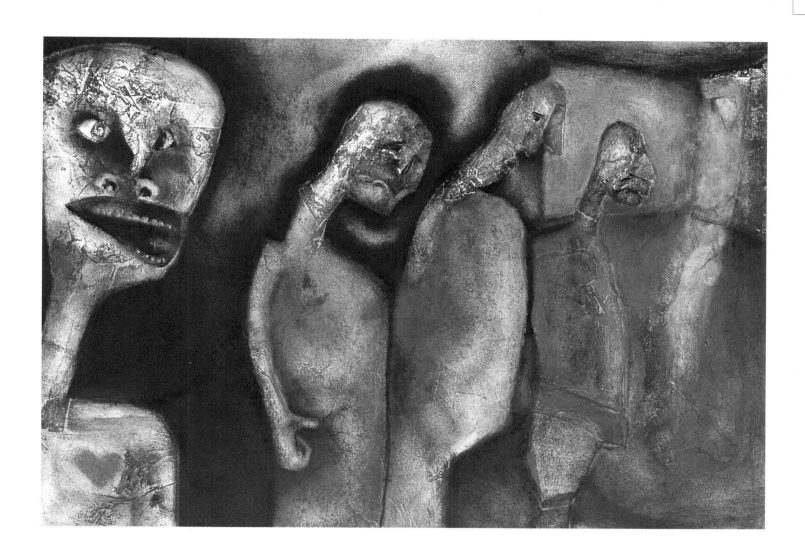

title
Strange Visitors
medium
Collograph and
pastel/liqun
purpose of work
Promotional Image
- editorial related

brief
To produce an
editorial image that
reflects the
possibility that we
are being visited by
extra-terrestrial life
forms

serena feneziani

53 Finlay Street
London
SW6 6HF

t. 0171 403 1783
f. 0171 403 1783

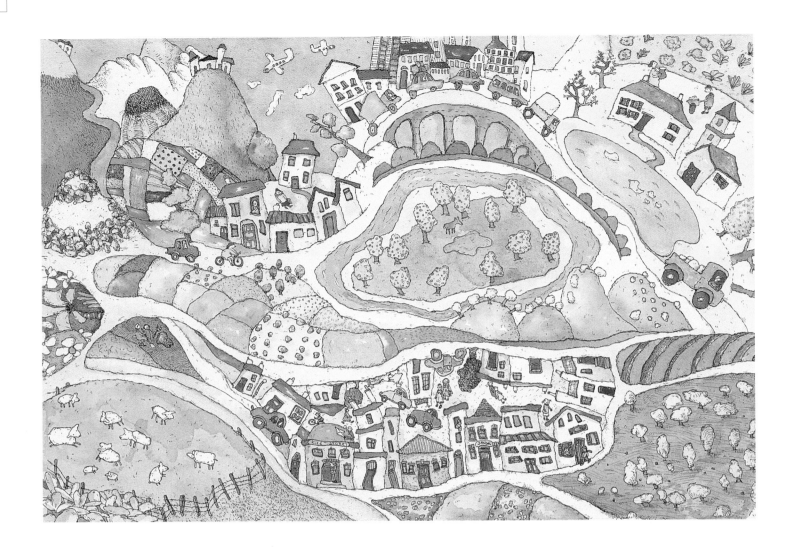

title
Countryside

medium
Watercolour and
pen

purpose of work
Picture of
countryside to be
used as
background

brief
Pop-up book

commissioned by
Sue Tarsky

ged garner

t. 01348 831831
mobile. 07970 623692

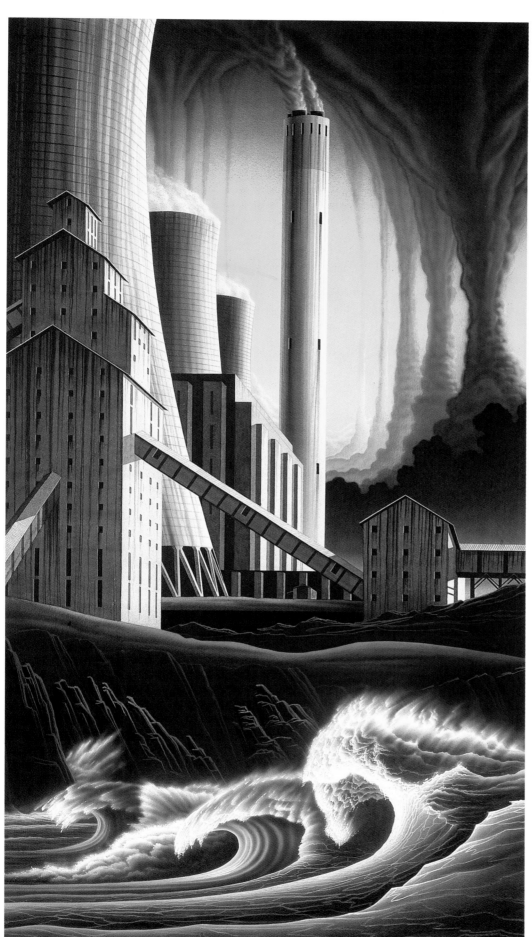

title
Global Warming

medium
Acrylic dyes /
gouache

purpose of work
Self promotional

brief
To depict a mood
of foreboding from
the effects of
greenhouse gas
emissions on the
environment,
contributing to
changing weather
patterns and rising
sea levels

elena gomez

Stonelands
Portsmouth Road
Milford
Surrey
GN8 5DR

t. 01483 423 876
f. 01483 423 935

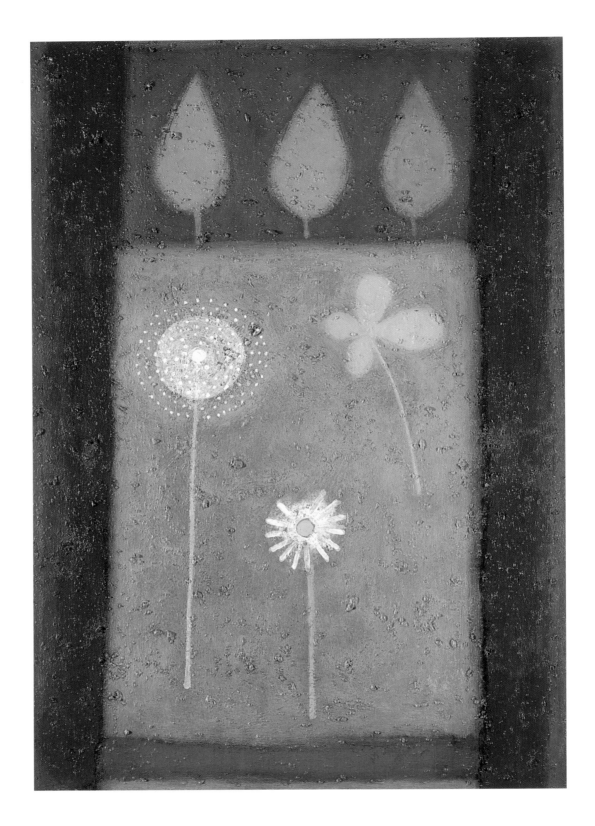

title
Meadow
medium
Acrylic
purpose of work
Self promotional
brief
Self promotional
piece for print or
card

nicolette green

96 Stanford Avenue
Brighton
East Sussex
BN1 6FE

t. 01273 506875
f. 01273 506875
e-mail. nickies@pavilion.co.uk

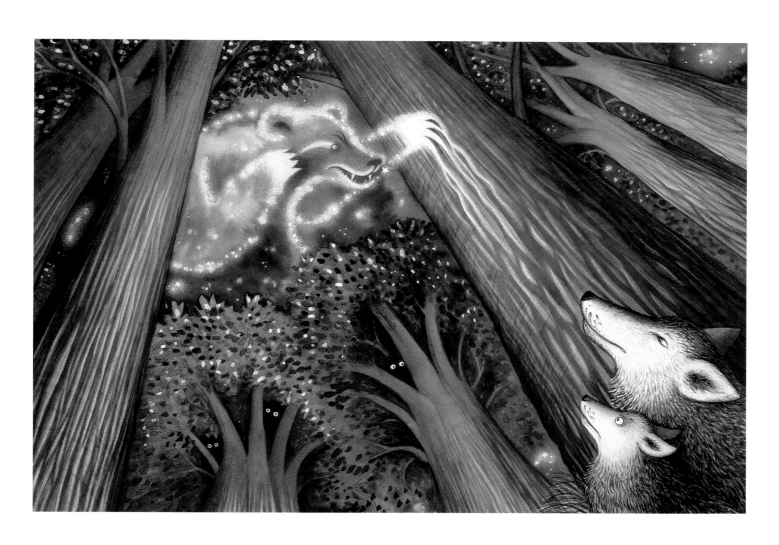

title
What are those
lights Papa Wolf?

medium
Watercolour /
bleach / pencil
crayon

purpose of work
Double page
illustration for a
proposed picture
book with author
Paul Stewart

brief
To show the young
wolf's fear of the
towering trees,
bear shapes in the
stars and staring
eyes in the dark

brian grimwood

c/o CIA
36 Wellington Street
London WC2

t. 0171 240 8925
www.briangrimwood.com

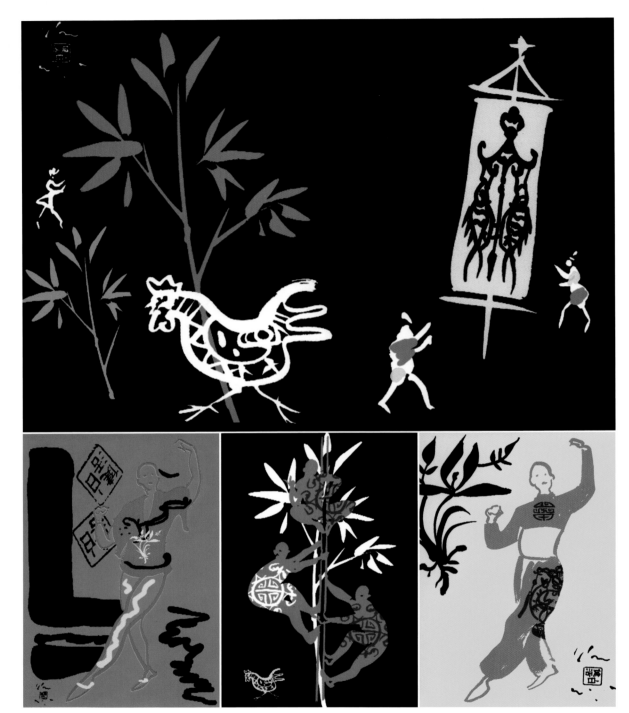

title
Chinese Landscape

medium
Computer
generated

purpose of work
Presentation for
Disney Promotion

brief
Proposed idea for
stage set

commissioned by
Shane Greeves

company
Enterprise

sally grover

Studio 358
Clerkenwell Workshops
27 Clerkenwell Close
London
EC1R 0AT

t. 0956 609157
t/f. 0171 336 7053

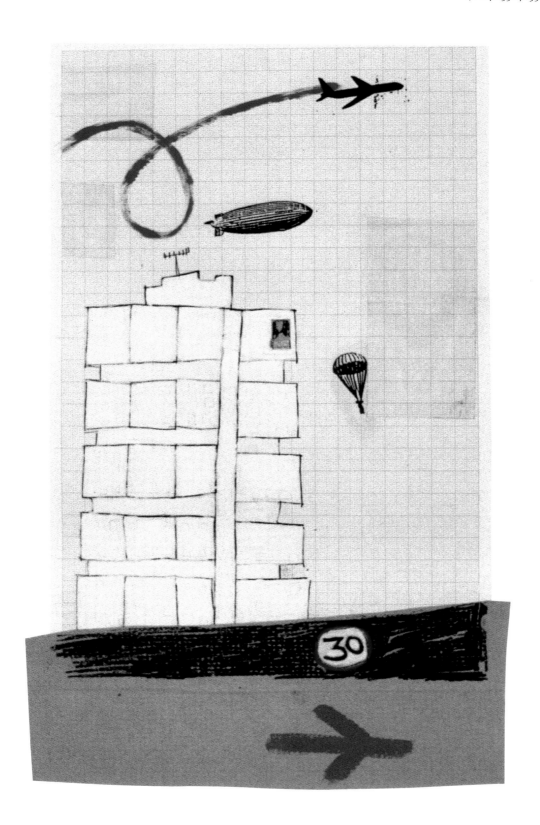

title
Princess Ida

medium
Mixed media

purpose of work
Self promotional - poster

brief
To illustrate the opera Princess Ida by Gilbert & Sullivan for a production by the Royal College of Music

andrew harris

8a Birdhurst Rise
South Croydon
Surrey
CR2 7ED

t. 0181 681 0310
e-mail. n.anderson@btinternet.com

234

GB

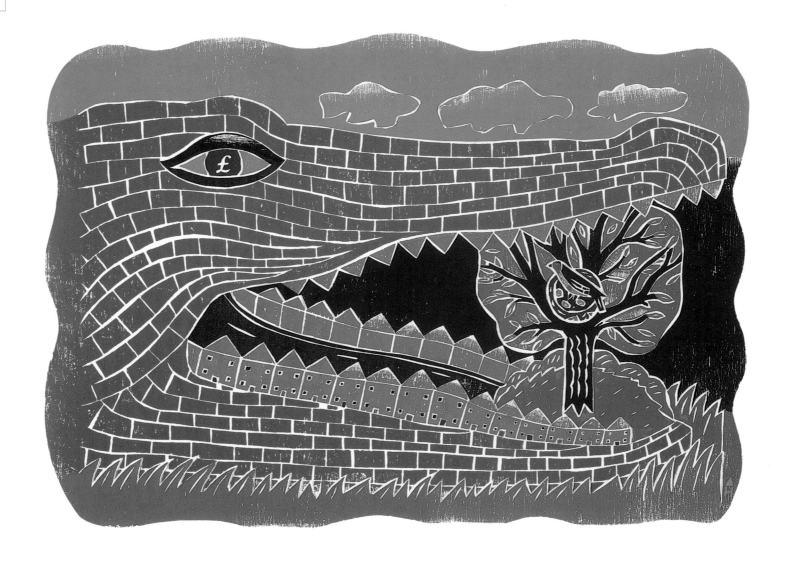

title
Snapping up the
Greenbelt

medium
Woodcut

purpose of work
Self promotional

MAGNET
ARTISTS

Piero (hernan pierini)

5 Bedford House
61 Lisson St
London
NW1 5DD

t. 0171 724 4592
f. 0171 724 4592
e-mail. piero@dial.pipex.com

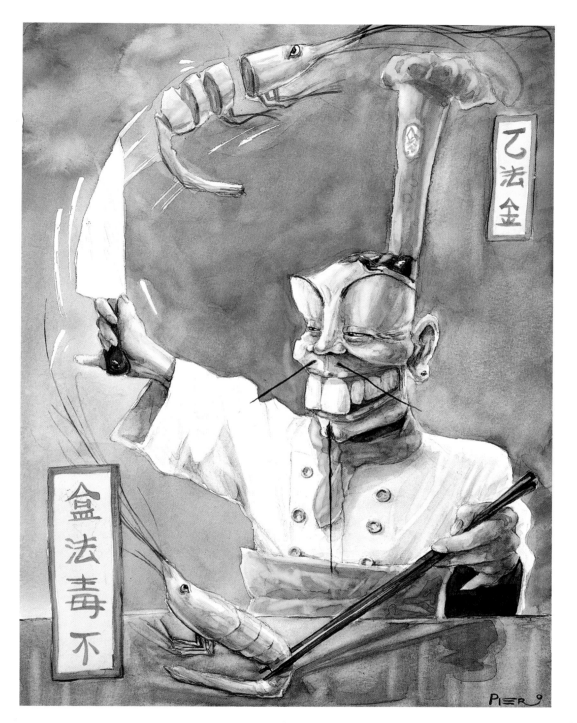

title
Cook

medium
Watercolour

purpose of work
Cookery brochure

brief
To create illustrations about creative cookery with a touch of humour, funny situations

p i e r o
illustrator

valerie heskins

15 Stratford Court
Westover Gardens
Westbury on Trym
Bristol
BS9 3NE

t. 0117 950 1162
f. 0117 950 1162

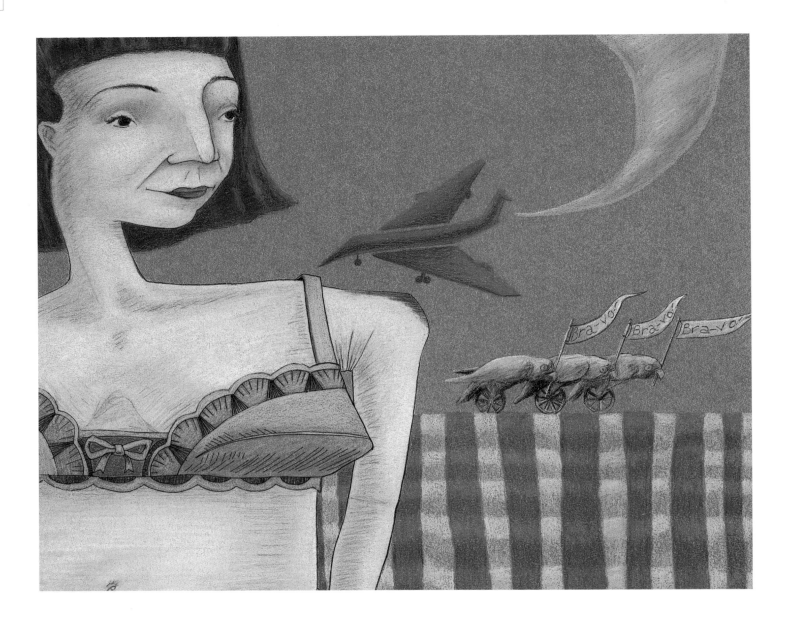

title
Bra-vo
medium
Coloured pencil
purpose of work
Self promotional
brief
To illustrate an
article on the
technical
innovations in the
history of the bra

sophie joyce

Flat 8
39 St James St
Brighton
East Sussex
BN2 1RG

t. 01273 695626
f. 01273 695626

title
Man and Dog
medium
Pastel
purpose of work
Self promotional

brief
Originally done as
a self promotional
piece, this image
has since been
used by Ling
Design as part of
an occasional and
everyday greetings
card range

alison lang

Suite 7
24 Warwick Road
London
SW5 9UD

t. 0171 598 1037
f. 0171 598 1037

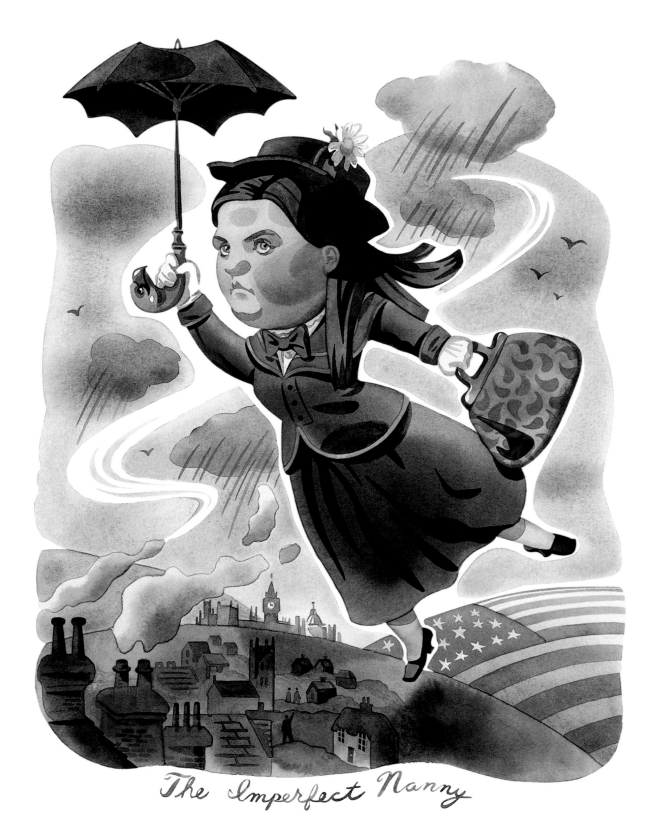

The Imperfect Nanny

title
The Imperfect
Nanny

medium
Watercolour

purpose of work
Self promotional

brief
To depict Louise
Woodward as Mary
Poppins in a
topical personality
series

stewart lees

47 Greevegate
Huntstanton
Norfolk
PE36 6AF

t. 01485 542061
f. 01485 542061

title
Martha
medium
Oils
purpose of work
Self promotional
agent
Folio
10 Gate Street
Lincoln's Inn Fields
London
WC2A 3HP
t. 0171 242 9562

frank love

The Dairy
5-7 Marischal Road
London
SE13 5LE

t. 0181 297 2212
f. 0181 297 2212

title
City Dogs
medium
Mixed media
purpose of work
Self promotional

brief
A business image
without little
people doing big
things together
agency
Eastwing
98 Columbia Road
London
E2 7QB
t. 0171 613 5580

frank love

The Dairy
5-7 Marischal Road
London
SE13 5LE

t. 0181 297 2212
f. 0181 297 2212

title
Lust pants
medium
Mixed media
purpose of work
Self promotional

agent
Eastwing
98 Columbia Road
London
E2 7QB
t. 0171 613 5580

jan lewis

1 Coombe End
Whitchurch Hill
Pangbourne
Berks
RG8 7TE

t. 01189 842590
f. 01189 842590

title
The Princess and
the Halibut

medium
Watercolour / ink

purpose of work
Children's story
(unfinished)

brief
A variation on a
theme! This
illustration is taken
from a story for
children which tells
the tale from the
point of view of an
enchanted halibut!

anne magill

See Agent

t. 0468 362420

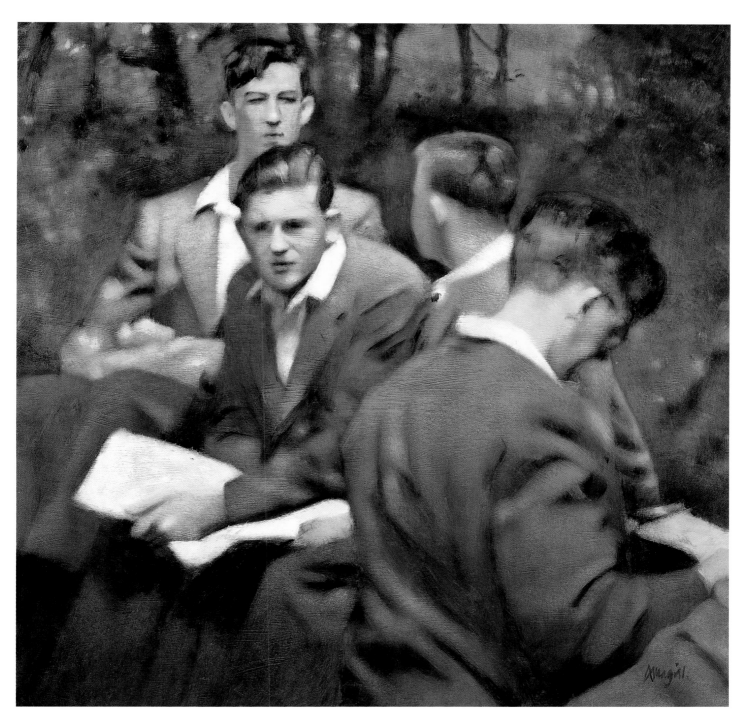

title
A Day Out

medium
Acrylic on board

purpose of work
Self promotional

brief
To produce a figure
study, working on
a larger scale than
normal and
utilising more
texture

agent
The Inkshed
98 Columbia Road
London
E2 7QB
t. 0171 613 2323

brigitte mcdonald

40 Knightlow Road
Harborne
Birmingham
B17 8QB

t. 0121 429 8655
f. 0121 429 8655

title
Love Bird

medium
Water colour and
gouache

purpose of work
Speculative
greetings card / self
promotional

brief
To illustrate a
range of cards
using a Love theme

shane mcgowan

23A Parkholme
Road
London
E8 3AG

t. 0171 249 6444
f. 0171 249 6444

title
Fatboy rides again
medium
Gouache, ink
purpose of work
Self promotional
Christmas card
brief
Do something jazzy
agent
The Organisation
69 Caledonian
Road
London N1
t. 0171 833 8268

belle mellor

Flat 3,
12 Lansdowne Street
Hove
East Sussex
BN3 1FQ

t. 01273 732604
f. 01273 732604
mobile. 0973 463942

title
Horse Woman

medium
Pen and Ink, gold
powder, rubber
stamps

purpose of work
Self promotion

brief
Produce a card to
inform clients of
my return from
India

rosalyn mina

20 The Castle
Horsham
West Sussex
RH12 5PX

t. 01403 217230

title
Autumn
medium
Mono - print and
pastel
purpose of work
Self Promotional

brief
'Autumn' is part of
a self promotional
series illustrating
the four seasons.
My main aim was
to create rich
textures and
vibrant colours

george parfitt

51 Melody Road
London
SW18 2QW

t. 0181 874 5314

248
GB

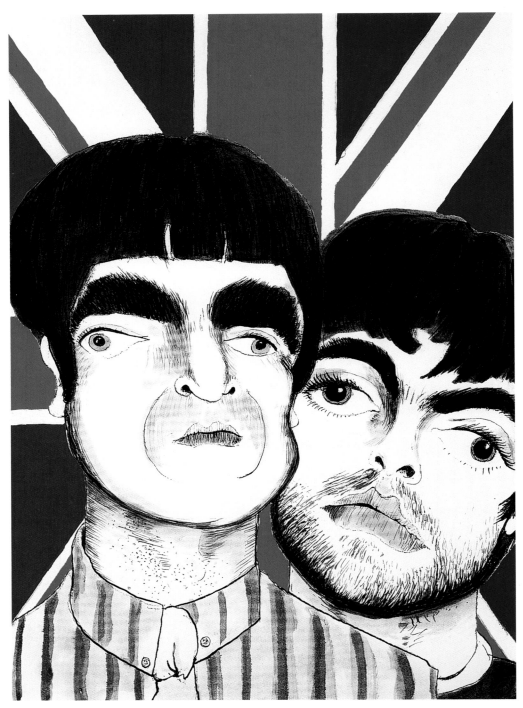

title
Noel and Liam
medium
Pen, ink, gouache
purpose of work
Self promotional

brief
A caricature portrait
of Liam and Noel
Gallagher, of the
group 'Oasis'

sophia please

185 Peperharow
Road
Godalming
Surrey
GU7 2PR

t. 01483 421596

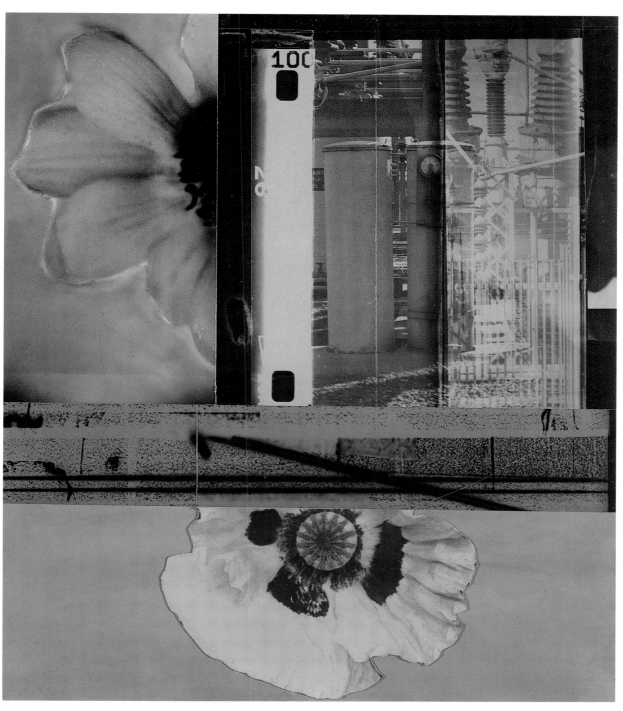

title
Let a Thousand
Flowers Bloom

medium
Photography

purpose of work
Article for
New Scientist

brief
To produce a
colour image for an
article on how
flowers can
detoxify
contaminated
industrial sites

ian pollock

171 Bond Street
Macclesfield
Cheshire
SK11 6RE

t. 01625 426205
f. 01625 261390

250
GB

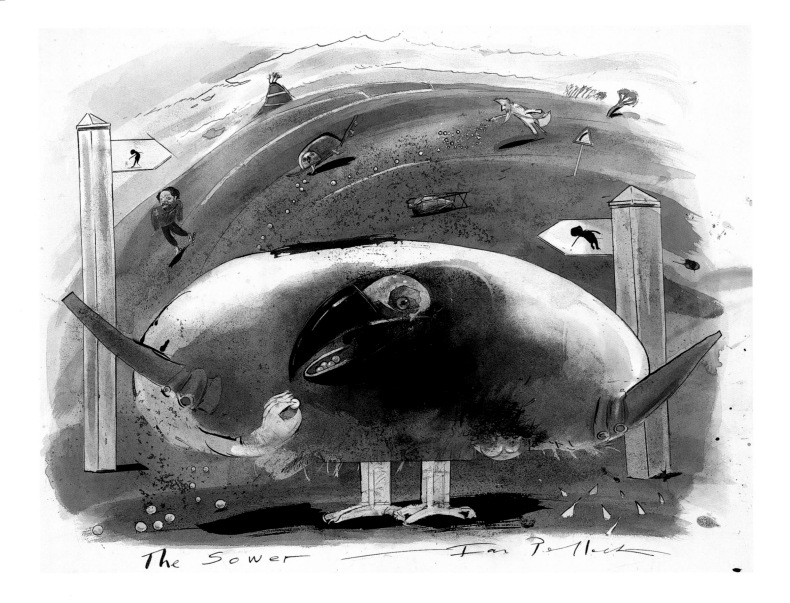

The Sower — Ian Pollock

title
The Sower
medium
Watercolour ink
and gouache

brief
One of 40
illustrations for
"The Parables of
Christ"
agent
The Inkshed
98 Columbia Road
London
E2 7QB
t. 0171 613 2323

paul powis

Four Seasons
74 Battenhall
Avenue
Worcester
WR5 2HW

t. 01905 357563
f. 01905 357563

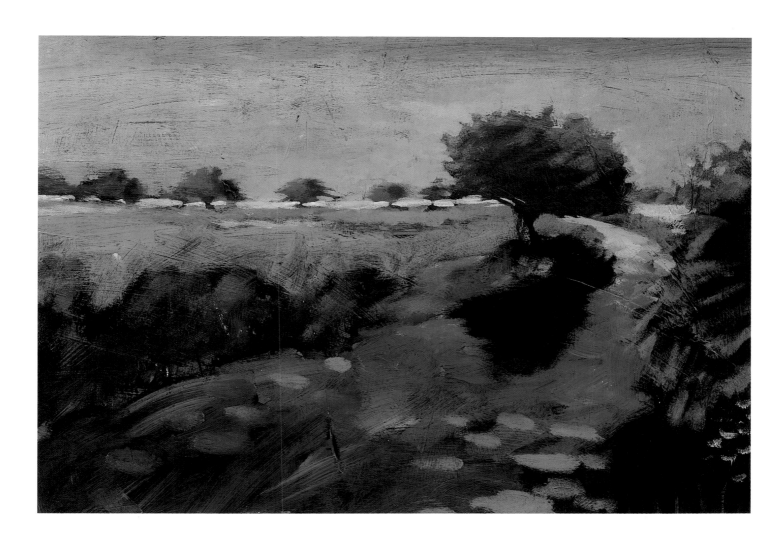

title
River

medium
Acrylic

purpose of work
Self Promotional

brief
To capture summer
landscape and river

matthew richardson

Garden Cottage
Penpont
Brecon, Powys
LD3 8EU

t. 01874 636269
f. 01874 636269

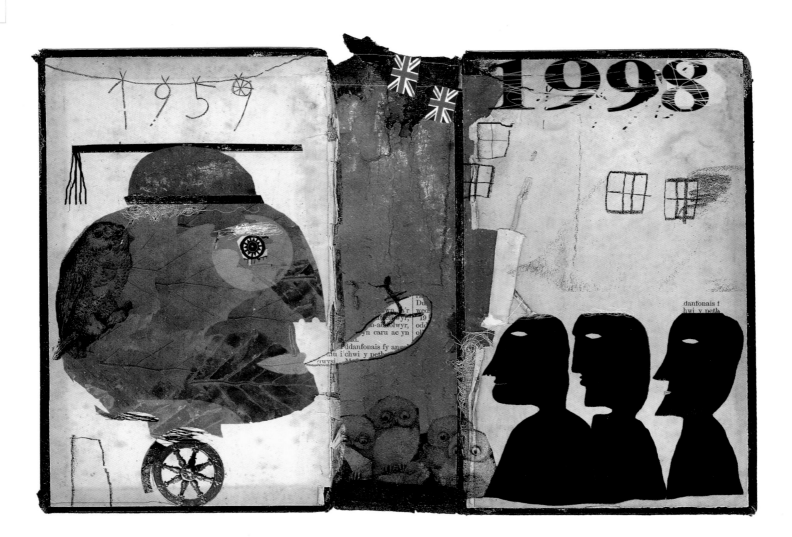

title
School Ties

medium
Mixed

purpose of work
Editorial illustration

brief
Illustrating a piece about a college reunion which turns into a lecture and demand for college funding

matthew richardson

Garden Cottage
Penpont
Brecon, Powys
LD3 8EU

t. 01874 636269
f. 01874 636269

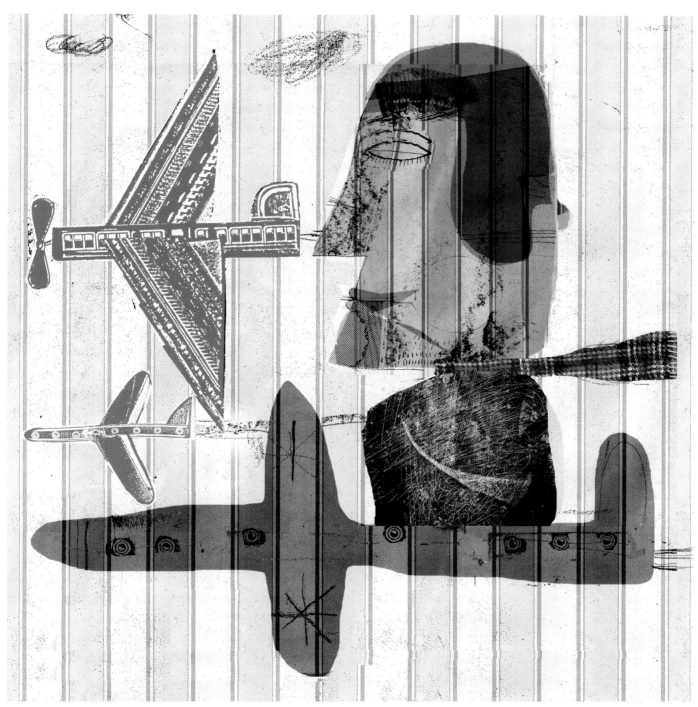

title
Fly - Boy

medium
Mixed

purpose of work
Self promotional

brief
Experimental and
developmental

johanne ryder

The Dairy
5-7 Marischal Road
London
SE13 5LE

t. 0181 297 2212
f. 0181 297 2212

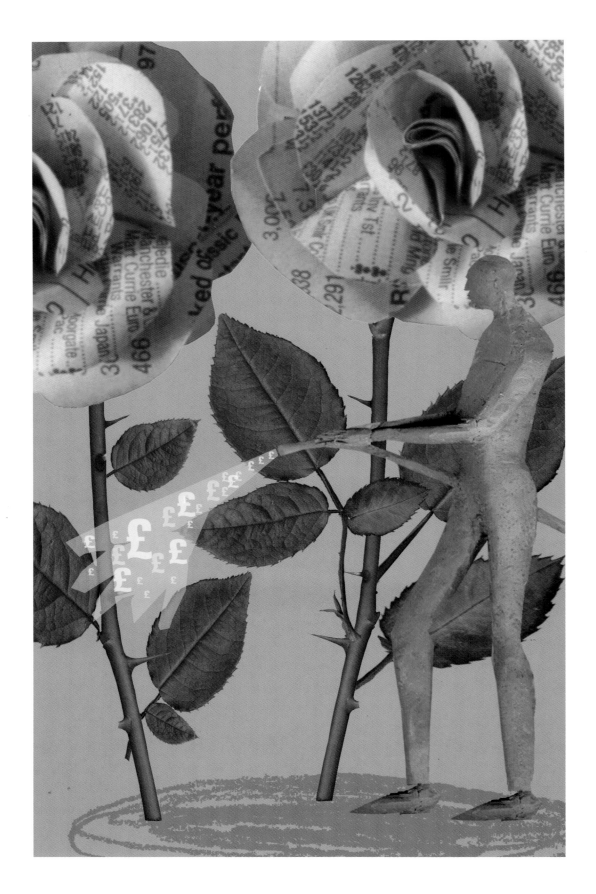

title
Financial Growth

medium
Clay, paper,
Photoshop 4

purpose of work
Self promotional

brief
Developing
personal work

peter till

11 Berkeley Road
London
N8 8RU

t. 0181 341 0497
f. 0181 341 0497

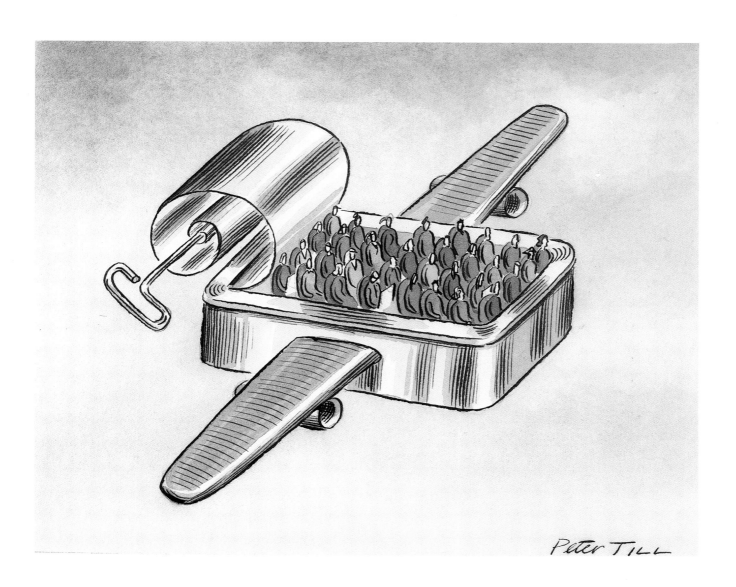

title
Sardine Airlines
medium
Pen, ink and
watercolour
purpose of work
To illustrate article

brief
Piece about
overcrowded
planes
commissioned by
Deborah De Staffan
company
Town and Country

helen wakefield

36 Courtenay Ave
Belmont Heights
Sutton
Surrey
SM2 5ND

t. 0181 643 0040
f. 0181 770 1884

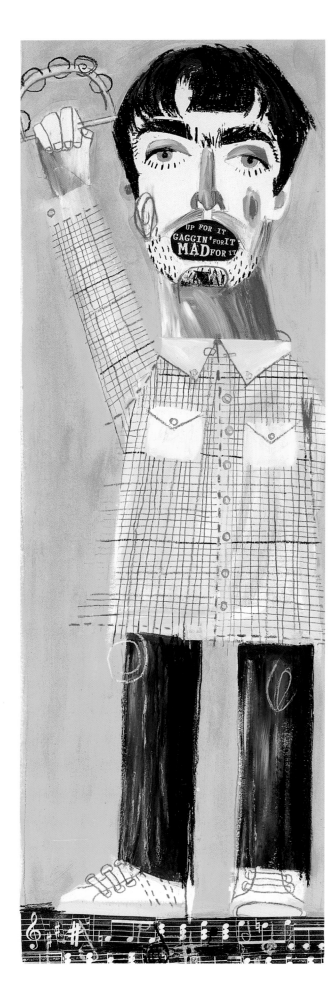

title
Mad for it

medium
Mixed Media

purpose of work
Self promotional

brief
Portrait of Liam
Gallagher

alan young

2 Chapel Cottages
Dunks Green
Tonbridge
Kent
TN11 9SF

t. 01732 810652
f. 01622 621100

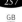

title
Shadow of the
Forest

medium
Watercolour

purpose of work
Self promotional

brief
To respond to the
idea of culture and
wilderness in
Finland

AOI membership benefits & costs

RONALD SEARLE

Membership of the AOI is open to all illustrators, illustration students, agents, lecturers and illustration clients.

All categories of membership receive the following benefits:

- Monthly journal
- Discounted rate at events
- Discounted rate for *Images* – call for entries, hanging fees and annual pages
- Contact details on office database for enquiries from clients
- Access to the portfolio insurance scheme
- Portfolio stickers
- Discounts from material suppliers
- Regional group contacts
- Purchase of artwork stickers

In addition we provide the following services for particular types of membership:–

Full Membership

This category is for professional illustrators who have had work commissioned and accept the AOI code of conduct.

- Legal advice on contracts and book publishing agreements
- Hotline information on pricing and professional practice
- Free annual portfolio surgery
- Reduced rate account with couriers
- Discounted rate on selected hotel accommodation in London
- Purchase of editorial and publishing directories
- Business advice – an hour's free consultation with a chartered accountant on accounts, book–keeping, National Insurance, VAT and tax
- Full members are entitled to use the affix 'Mem AOI'
- Full members are supplied with a list of agents and advice about agents

Associate Membership

This one-year category is for newcomers and illustrators on their first year out of college who have not published work. In exceptional circumstances this membership can be extended.

- Hotline information on pricing and professional practice
- Free annual portfolio surgery
- Discounted rate on selected hotel accommodation in London
- Purchase of editorial and publishing directories
- Business advice – an hour's free consultation with a chartered accountant on accounts, book-keeping, National Insurance, VAT and tax.

Student membership

This service is for students on full-time illustration or related courses

- See above services for all AOI members

Corporate Membership

This service is for agents and clients from the illustration industry

- Free copy of the *Images* catalogue
- Invitation to the *Images* private view
- All corporate members' staff and illustrators will receive discounts on events and *Images*

For an application form and cost details contact:

Association of Illustrators
1-5 Beehive Place
London SW9 7QR
Tel: +44 (0)171 733 9155
Fax: +44 (0)171 733 1199
E-mail: sb@a-o-illustrators.demon.co.uk
Website: www.aoi.co.uk

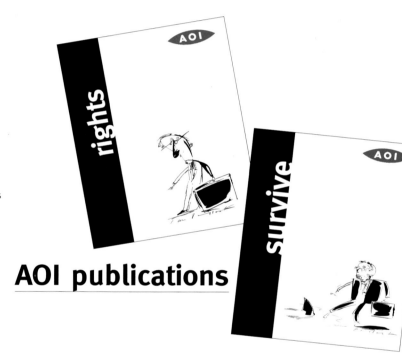

AOI publications

Survive: The illustrators Guide to a Professional Career

The new, revised and enlarged, edition of this essential publication is now available. Published by the AOI, *Survive* is the only comprehensive and in-depth guide to illustration as a professional career. Established illustrators, agents, clients and a range of other professionals have contributed to this fourth edition. Each area of the profession including portfolio presentation, self promotion and copyright issues are looked at in detail. The wealth of information in *Survive* makes it absolutely indispensable to the newcomer and also has much to offer the more experienced illustrator.

Rights: The illustrators Guide to Professional Practice

This is the only comprehensive guide to all aspects of the law specifically related to illustration. It includes information about copyright, contracts, book publishing agreements, agency agreements, advice about seeking legal advice, how to calculate fees and guidance on how to write a licence.

Rights is the result of a number of years of research. It has been approved by solicitors and contains the most detailed and accurate model terms and conditions available for use by illustrators or clients.

AOI website

www.aoi.co.uk

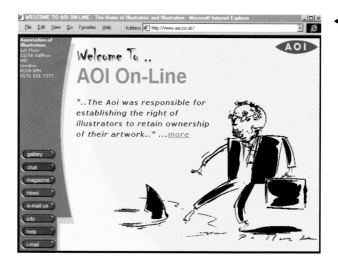

AOI On-Line has arrived

This year heralds an important new development for the Association of Illustrators. In collaboration with Warp Interactive we have formed AOI On-Line to produce the Association's very own Website.

We believe that this is an important step in the continuing promotion of illustration. The site is unique in that it has been specifically constructed to meet the needs of the commissioner and also to provide a valuable resource for illustrators both nationally and internationally.

Guide to AOI On-Line

The first stop

On arriving at the site the user is presented with a brief introduction and offered a choice of areas to visit. These include:-

The virtual gallery

Searching

Powerful search facilities allow users to pinpoint exactly what they are looking for. After a user has logged on to the site they can enter criteria for a search. Broad searching criteria bring up the most images. A particular name search will bring up work by that artist.

Artists portfolios

Initially images appear as thumbnails with the artist's name attached. When an image is clicked on an enlargement can be viewed. When the artist's name is clicked on all their submitted images appear together with their contact details. Here, the user can also access the artist's biography.

The personal image folder

When the user has viewed the results of a search, chosen images together with any written comments, can then be stored in a private folder.

The shared image folder

Two or more users can set up a shared image folder with its own password. Any written comments will appear on the screen with the selected images. This is a particularly useful tool for art buyers who may be in different locations and are sourcing illustrations for a project.

About the AOI

Here, users can find the latest news about the AOI and its events together with details of AOI publications and membership.

News

Fresh, up to date Industry news is recorded regularly. Archive news items can be accessed on a month by month basis using a search facility. Users are encouraged to submit relevant items.

Illustrator

The Association's monthly magazine on-line. Archives of articles from earlier issues can be accessed by a search facility.

The discussion forum

A topic relevant to illustrators can be chosen and users can participate in the debate. A place to receive hints and tips and exchange ideas, with others around the world.

Other features

AOI Patrons

Patrons of the AOI are included in the virtual gallery and portfolios featuring images and biographies.

Personal Web addresses

The site also allows illustrators to have their own personal Web address leading to their portfolio.

I-mail

An internal secure e-mail system for users to contact each other.

How to submit work

The site is open to all members of the illustration community. Illustrators and agents wishing to submit images can find complete details on-line at:
www.aoi.co.uk
or they can contact the AOI.

Contacts

Warp interactive:
Tim Deighton or Mark Jones on
0171 978 9869 or 0171 346 0060

Index